The Transl tage

Literatures, Cultures, Translation

Literatures, Cultures, Translation presents a new line of books that engage central issues in translation studies such as history, politics, and gender in and of literary translation, as well as opening new avenues for study. Volumes in the series follow two main strands of inquiry: one strand brings a wider context to translation through an interdisciplinary interrogation, while the other hones in on the history and politics of the translation of seminal works in literary and intellectual history.

The Translator on Stage

Geraldine Brodie

To Heather
with lots of love
from
Geraldine
X X

Bloomsbury Academic
An imprint of Bloomsbury Publishing Inc

B L O O M S B U R Y
NEW YORK · LONDON · OXFORD · NEW DELHI · SYDNEY

Bloomsbury Academic

An imprint of Bloomsbury Publishing Inc

1385 Broadway	50 Bedford Square
New York	London
NY 10018	WC1B 3DP
USA	UK

www.bloomsbury.com

BLOOMSBURY and the Diana logo are trademarks of Bloomsbury Publishing Plc

First published 2018

© Geraldine Brodie, 2018

Library of Congress Cataloging-in-Publication Data
Names: Brodie, Geraldine, author.
Title: The translator on stage / Geraldine Brodie.
Description: New York : Bloomsbury Academic, 2017. |
Series: Literatures, cultures, translation |
Includes bibliographical references and index.
Identifiers: LCCN 2017026068 (print) | LCCN 2017037740 (ebook) |
ISBN 9781501322129 (ePub) | ISBN 9781501322136 (ePDF) |
ISBN 9781501322105 (pbk. : alk. paper)
Subjects: LCSH: Drama–Translating. | Translating and interpreting. | Theater.
Classification: LCC PN886 (ebook) |
LCC PN886 .B67 2017 (print) | DDC 792.1–dc23
LC record available at https://lccn.loc.gov/2017026068

ISBN: HB: 978-1-5013-2211-2
PB: 978-1-5013-2210-5
ePub: 978-1-5013-2212-9
ePDF: 978-1-5013-2213-6

Series: Literatures, Cultures, Translation

Cover design: Daniel Benneworth-Gray
Cover image © Flickr

Typeset by Newgen KnowledgeWorks Pvt. Ltd., Chennai, India.
Printed and bound in the United States of America

To find out more about our authors and books visit www.bloomsbury.com. Here you will find extracts, author interviews, details of forthcoming events and the option to sign up for our newsletters.

For my parents, to whom I owe my love of theatre and performance

Contents

List of Figures viii
List of Tables x
Acknowledgements xi

1 Introduction: The Role of the Translator on the London Stage 1
2 London Theatre: Contexts of Performance 15
3 Eight Productions and Their Translation Teams 45
4 Agents of Translation 105
5 Conclusion: Translation Theory in the Theatre 155

Appendix 1: Sample Play Data 165
Appendix 2: Archives 173
Bibliography 175
Index 189

List of Figures

2.1 The Royal National Theatre, South Bank, London. Photograph copyright: Geraldine Brodie (2017) 23

2.2 The Royal Court Theatre, Sloane Square, London. Photograph copyright: Geraldine Brodie (2017) 27

2.3 The Duke of York's Theatre, St. Martin's Lane, London. The theatre also houses the London offices of the Ambassador Theatre Group. Photograph copyright: Geraldine Brodie (2017) 31

2.4 Theatres along Shaftesbury Avenue, London, include the Lyric and Gielgud Theatres. Photograph copyright: Geraldine Brodie (2017) 33

2.5 The Almeida Theatre, Islington, London. Photograph copyright: Geraldine Brodie (2017) 36

2.6 The Donmar Theatre, Covent Garden, London. Photograph copyright: Geraldine Brodie (2017) 37

3.1 *The House of Bernarda Alba* by Federico García Lorca in a new version by David Hare. Set designed by Vicki Mortimer; Royal National Theatre, 2005. Photograph copyright: Catherine Ashmore 53

3.2 Michael Sheen as Martin Gammon in *The UN Inspector* by David Farr, freely adapted from *The Government Inspector* by Nikolai Gogol; Royal National Theatre, 2005. Photograph copyright: Manuel Harlan 57

3.3 *Hedda Gabler* by Henrik Ibsen in a new version by Richard Eyre; Eve Best (right) as Hedda Tesman and Lisa Dillon (left) as Thea Elvsted; Almeida Theatre 2005. Photograph copyright: Geraint Lewis 64

3.4 Katharina Schüttler as Hedda Tesman in *Hedda Gabler* by Henrik Ibsen, translated into German by Hinrich Schmidt-Henkel. Directed by Thomas Ostermeier; Schaubühne Theater, Berlin, 2006. Photograph copyright: Arno Declair 65

3.5 *Festen*, adapted by Davis Eldridge; Jonny Lee Miller as
Christian; Jane Asher as Else. Directed by Rufus Norris;
Almeida Theatre; 2004. Photograph copyright: Geraint Lewis 73

3.6 *Don Carlos* by Friedrich Schiller in a version by Mike Poulton;
Derek Jacobi as King Philip II of Spain; Claire Price as
Queen Elizabeth. Lighting by Paule Constable. Designed by
Christopher Oram. Directed by Michael Grandage; Crucible
Theatre, Sheffield, UK, 2004; Photograph copyright: Ivan Kyncl/
ArenaPAL; www.arenapal.com 80

3.7 *Hecuba* by Euripides, translated by Tony Harrison for the Royal
Shakespeare Company. Set and costumes designed by Es Devlin;
Albery Theatre, London, 2005. Photograph copyright: Es Devlin 88

3.8 Vanessa Redgrave as Hecuba for the Royal Shakespeare
Company; Brooklyn Academy of Music Opera House,
New York, 2005. Photograph copyright: Richard Termine 89

3.9 John Barrard in *Way To Heaven* by Juan Mayorga, translated by
David Johnston; Jerwood Theatre Upstairs, Royal Court, 2005.
Photograph copyright: Tristram Kenton 93

3.10 *The Woman Before* by Roland Schimmelpfennig, translated
by David Tushingham; Tom Riley as Andi; Saskia Reeves as
Claudia; Helen Baxendale as Romy; Nigel Lindsay as Frank;
Royal Court Theatre, 2005. Photograph copyright: Alastair Muir 100

List of Tables

1.1 Translated plays advertised by the Society of London Theatre,
7 April to 26 June 2005 10

1.2 Distribution of interview subjects 12

2.1 Annual Arts Council England grant awarded by organization 19

2.2 Box office receipts of organizations belonging to the Society of
London Theatre also in receipt of Arts Council England funding 20

2.3 Top five Arts Council England grants awarded by organization 39

3.1 Comparison of Poncia's first line in *The House of Bernarda Alba*
as conveyed by Federico García Lorca, Simon Scardifield and
David Hare 49

Acknowledgements

This book examines the collaborative teams and networks of translation in London theatre and could not have been written without the generous support of my own collaborators and networks over many years. In particular, I am deeply grateful to Theo Hermans and Maria Delgado for their continuing advice and feedback once their formal supervision duties had come to an end. I would also like to thank the many friends, colleagues and family members who have provided further support and encouragement, among them Stephanie Bird, Catherine Boyle, Julia Brodie, Emma Cole, Kate Eaton, Jane Fenoulhet, Amanda Ferronato Jones, Marie Nadia Karsky, Margherita Laera, Timothy Mathews, Christine Plastow, Mark Shuttleworth and Kathryn Uhde, along with the staff and students of the Centre for Multidisciplinary and Intercultural Inquiry and the School of European Languages, Culture and Society at University College London.

Special thanks are due also to Brian James Baer and Michelle Woods, the editors of this Bloomsbury series Literatures, Cultures, Translation, and Haaris Naqvi and Katherine De Chant of Bloomsbury Press. I am also grateful to Éditions Québécoises de l'Oeuvre (collection Vita Traductiva), Bloomsbury Continuum Publishing, an imprint of Bloomsbury Publishing Plc, Taylor and Francis Group, and the Centre for Translation and Intercultural Studies, University of Manchester, for permission to reproduce material from earlier chapters and articles.

Lastly, and most importantly, I thank my husband Chris Brodie, without whose unfailing devotion this book would never have been written.

1

Introduction: The Role of the Translator on the London Stage

Translation in theatre

In theatre, where is the translator? Identity and position feature largely in the projection of performance. The title of a play, the author, the actor, the director, perhaps others, will be squeezed into the publicity for a new production. This implicit recognition of the significance of agency and collaboration often extends in translated theatre to the name of the translator. But who and what does that name represent? The prominent acknowledgement of an individual intervening between the source playwright and the target audience differentiates theatrical practice from other sites of translation. In a published literary text, for example, the name of the translator may appear on the book jacket but is more frequently to be found somewhere in the opening pages, often tucked away in small print. The conspicuousness of the translating agent in theatre, however, comes at the expense of the visibility of translation as a practice and a process: the proffered production is often labelled a 'version' or an 'adaptation', terminology which disguises translational activity. Furthermore, the named 'adaptor', contributing theatrical reputation, or 'celebrity', to the production's credentials may not command the language of the original text. In these cases, a further agent is called upon to provide a 'literal translation', an expansion of the translation procedure which is habitually overlooked by practitioners and public alike. How, then, should the translator be identified?

This book investigates the agency of the translator in theatre, with specific reference to plays in performance on the mainstream London stage. By mainstream, I refer to a grouping of theatres situated around the West End theatre district of London which stages a broad range of productions from different periods and genres, aiming to attract a wide audience made up of both regular and occasional theatre-goers. Although this activity is frequently assumed to be the preserve of commercially owned theatre, there are

a number of high-profile theatres, among which the Royal National Theatre[1] is prominent, subsidized by a combination of public funding and private donations. These organizations produce work which competes in the main-stream sphere, and may go on to appear in commercial venues if successful critically and at the box office. Thus, even when such theatres are not com-mercially owned, they are commercially operated and therefore motivated to find audiences – and sell tickets – for their productions. The translators of the plays shown in these theatres are the subjects of my enquiry, because their names signal to the audience that an act of translation has taken place. That sign may, nevertheless, be indecipherable – in spite of the named agent – due to terminology, the collaborative nature of theatre production and the gen-eral context in which the play is presented. During the course of this book, I analyse the complexities behind these issues and ask, what do they reveal about the relationship between theatre and translation? What can we learn about the processes and perceptions of translation by studying the translator on stage?

Theatrical visibility, celebrity and terminology

Theatre is a constant projection of image, not only of what is seen on stage but also in metatheatrical exposition, for example, the photographs of perform-ers in programmes or what Michael Caines summarizes as 'the metaphorical costume that is called celebrity' (Caines 2010). Actors have their place in the theatrical constellation but so too do their co-practitioners, especially writers and directors. It is common practice in mainstream London theatres to com-mission a well-known name from this cohort to be attached to the translation of a play. Frequently a writer, playwright or director with a track record in commercially and critically successful productions, this person's predomi-nant contribution is theatrical expertise. Knowledge of the language of the original text is advantageous, but its absence may not preclude appointment. If this writer does not command the source language, and the production budget is sufficiently accommodating, a theatre's literary department will commission a new literal translation in preference to using an extant theatri-cal or academic translation. This is because the literal translator, in providing substantial notes on linguistic, cultural and theatrical features in the text, to some extent, as Manuela Perteghella notes, performs the function of drama-turg (2004b: 119). There are issues of status and recognition attached to the

[1] The Royal National Theatre (its official title) more frequently refers to itself as the 'National Theatre' or 'NT'. These terms are used interchangeably in this book.

holders of these different occupations: their celebrity and visibility. *Literal* is a label regularly applied by theatres to denote the type of translation I describe, but distinctions are rarely made between writers who command a play's source language and those who do not. I therefore employ the terms *direct* translation to describe those created without an intermediary linguist and *indirect* to denote those which have been prepared using a literal translation.

In choosing to describe the two-step translation process as indirect, I am borrowing a contested translation term which circulates in theoretical terminology alongside an extensive list of terms such as 'compilative', 'pivot' and 'relay' with overlapping definitions and inconsistent usage. As Alexandra Assis Rosa, Hanna Pięta and Rita Bueno Maia point out, 'this metalinguistic instability hinders efficient communication', which contributes to the 'rather weak visibility' of these types of mediated translations (2017: 118). These researchers propose an 'open definition' of indirect translation, suggesting 'translation of a translation', but they recognize that 'such a degree of flexibility may raise the problem as to where exactly indirect translation ends and, for example, retranslation begins' (2017: 120–22). Is the two-step process a 'translation of a translation'? It is certainly an interpretation of a translation, and the end product – the performed playtext – is an interlingual representation of its ultimate source. It is the variety of intervening text(s) and processes that complicate the categorization of theatre translation practices for researchers and practitioners alike. Theatrical vocabulary contains a range of terms to describe the translation process, none of which are used with any consistency or precision. The terms *version* and *adaptation*, and their variations, are most commonly relied upon by theatres to describe an English-language refraction of an original text from another language, whichever translation process is operated, and these terms are supplemented by an increasingly imaginative vocabulary, such as 'free adaptation', 'revised by', 'based on', 'English text by', 'a modern take on' or 'a remix of', all of which I interpret as an attempt to highlight the creativity of the translation process. Not all translations shun the name, as this book reveals. There is, however, no consensus on the definition or application of these terms.

Academically, there is a body of research around adaptation theory, although this tends to encompass a broader area of intersemiotic movement – for example, from book to cinema or television – without necessarily involving an interlingual codeshift. A continuing debate explores where and whether translation might be located within a definition of adaptation. Linda Hutcheon identifies a 'reception continuum' of fidelity to the prior work that situates literary translation at one end and spin-offs, sequels and prequels at the other. She finds this model too limiting, however, preferring to theorize the paradoxical nature of adaptation that she characterizes as 'repetition

without replication, bringing together the comfort of ritual and recognition with the delight of surprise and novelty' (2013: 170–73). J. Douglas Clayton and Yana Meerzon also prefer to steer away from precisely locating dramatic adaptation 'somewhere between the actual translation of the play from one language into another … and the creation of a new work inspired by the original', opting for the term 'mutation' (2013: 8). Katja Krebs, however, argues for a 'focus on similarities between both translational and adaptational processes and products, to investigate each other's methodologies and assumptions' (2012: 50), while Márta Minier finds that points of connection in the discourse of translation and adaptation studies already exist that 'problematise the kindred features of the two modes of creative and critical rearticulation of texts' (2014: 31).

Margherita Laera, focusing on adaptation in theatre, sketches 'a taxonomy of adaptation as intertextual practice'. For Laera, translation is one among many elements of the appropriative nature of adaptation; it may be encompassed within categories such as intercultural adaptation (which she also terms translocation) and intertemporal adaptation (actualization), but the 'different mediums, genres, cultures, and historical periods that are involved in the act of stage transposition' thwart attempts to delineate the various modalities of adaptation (2014: 5–8). Perteghella has given consideration to the definition of adaptation in its relation to theatre translation, but concludes that a comprehensive definition is an 'impossibility', offering her own solution whereby adaptation 'critically supplements the source with subjective and cultural interpretations' (2008: 63). These approaches do not solve the difficulty that arises in any attempt to draw a line between translation and adaptation, and when other terminologies are thrown into the mix – notably the label of 'version' – complications multiply.

Lorna Hardwick identifies a major trend in the treatment of ancient classical texts in the second half of the twentieth century as the 'creative blurring of the distinction between different kinds of translations, versions and adaptations and more distinct relatives' (2000: 12), later reaching the conclusion that 'it is not always helpful to try to distinguish too rigidly between theoretical models for analysing "translations" and "versions". The processes of arriving at an acting script and then realising this in performance show how porous the boundaries are' (2010: 195). Mark O'Thomas similarly prefers to move away from distinguishing degrees of translation, seeking instead to examine the practice of translation/adaptation and, crucially, performance through an analogy with jazz and its improvisations and quotations. He takes the view that the 'inherently adapted, culturally heterogeneous and dynamic *mode* of jazz … offers a methodological model for translators and adaptors working in theatre practice' (2013: 8).

Academics have at least agreed to disagree on the appropriate usage of translation terminology. Theatre practitioners I interviewed varied considerably in their definitions. I found some agreement that a version might be closer to the original than an adaptation, but with little precision or consensus applied. At times, opposing definitions were advanced. Christopher Campbell, the literary manager of the Royal Court Theatre, gave expression to what is probably a general sentiment when he said, 'Although it might be difficult to write a description of the difference, I think you know it when you see it'.[2] Several of the translated plays addressed in this study were given differing labels, often varying between published playtext, printed programme and promotional publicity. On investigation, it appeared that this variance was a product of negotiation between interested parties rather than oversight. It would seem then that the use of translation/version/adaptation terminology serves more as a reminder that translation is a site of contention than providing a precise description of the creative processes involved. I therefore consider all these terms to apply to the translational act, and engage with them on that basis in this book.

Translation agency and collaboration

The theatrical practices I have just described, and which my investigation illuminates, mark a departure from literary translation practices recognized by standard Western theory. In basic terms, the translator who addresses the poles of 'word for word' or 'sense for sense', a conflict debated since at least the time of Cicero, is an identifiable if sometimes nameless individual. Such individuals are often seen as mediators, pushing their own creativity to one side in the service of a rapprochement between the original source text and its target-language readers. More recently, the power relations inherent in the translation process have been questioned, not least by Lawrence Venuti, who points out in *The Translator's Invisibility* that the very transparency of the translator paradoxically masks the cultural dominance of the English language. In producing a translation which reads comfortably for the anglophone, an invisible translator may perpetuate the culturally violent negation of the source text and its heritage (2008: 1–20). In London theatre translations, however, a translator can share equal billing with the original author, making the act of translation visible, although the visibility of such translators is in contrast to other translating agents. Literal translators in particular

[2] Christopher Campbell, interview with Geraldine Brodie (London, 10 January 2011).

may remain entirely invisible, and others receive only limited recognition. The motivations for this two-step indirect translation procedure are often assumed to be driven by market-force economics, as forcibly articulated by Susan Bassnett, who considers that audience size and ticket price are prioritized over an ethics of translation. Bassnett is not alone in seeing this system as an 'extreme' instance of power distortion (1991: 102). Cristina Marinetti, discussing the use of literal translation in British theatre, considers that 'unlike in many other countries in Europe, the literal translator in the UK is considered a technician at best', which leads her to the conclusion that the two-step process and its focus on performability 'has led to a marginalization of drama translation in practice' to the point where she feels obliged to ask, 'Is translation becoming obsolete in the theatre?' (2013: 30–32). However, examples of a range of calibrations along the visibility scale are highlighted in the course of my discussion, which suggest a nuanced combination of reasons for the adoption of specific translation methods, including financial and performability issues. Furthermore, a translated performance is produced in collaboration not only with the literal translator but also with other practitioners involved in the production, including the director, actors, musicians and designers, many of whom are not primarily concerned with translation even though they contribute to its ultimate transmission. While this can result in different visibility issues, it nevertheless shifts the emphasis onto collaborative translation practices. This book focuses on the identification and mapping of these processes, along with the sites and managerial cultures in which they function.

Commissioning theatres operate different policies for translations, requiring changing degrees of collaboration. Often, such policies are unformulated or passively applied, but in some cases expression is given to the process by which a translation will take shape. Colin Chambers, a former literary manager of the Royal Shakespeare Company (RSC), describes the commissioning practice at the National Theatre as 'to hire somebody who speaks [the source] language but who isn't a playwright to put it into a version known as a "literal", and then to bring in a playwright to work on it in order to make it performable' (Royal National Theatre 1992: np). This procedure is most commonly found in mainstream theatre. The Royal Court Theatre, on the other hand, is distinguished by its preference for appointing translators who are experts in the source language, signalled by its regular use of the term *translation* to describe the relevant production. However, the distinction between these two approaches and theatrical cultures is revealed on investigation to be blurred and even transgressed, so that the associated collaborative practices may not necessarily align with a specific translation method.

How do the translators themselves see their role in the process? David Johnston, who engages deeply in both the theory and practice of theatre translation, takes the view that 'translators of drama are impelled by a passion that is partly unconditional love for a work distant through time and place, but – crucially – whose vision connects most intimately with their own experience of the world, and partly a sense of grandeur ... of their role as mediators ... between [the original authors] and their public today' (1996: 8). Passion and love are notoriously resistant to theory, supporting Johnston's view that 'there can be no hard and fast rules concerning translation for the stage' (1996: 7). However, Johnston's words not only reflect on his personal practice (his assumption that 'passion' is shared by all translators overlooks the monetary value of translation), but also theorize theatre translation, despite its disinclination to conform to rules.

My principal approach in this volume is to interrogate the agency of the translator within the collaborative field of theatre translation. Johnston's recognition that theatre translators aspire to be mediators may reflect what theatre practitioners and their public are likely to expect from a translated play. Mona Baker, however, rejects this view of translators; she writes from the perspective of both translator and academic, 'We do not build bridges nor bridge gaps. We participate in very decisive ways in promoting and circulating narratives and discourses of various types ... None of us is immune to this process' (2005: 12). No matter how theatre translators see themselves, their degree of visibility in the collaboration and their responsibility to the author and to the audience, their presence in the performance process is more than a neutral mediation: translators make their distinctive mark on the performed play. This book unpicks the processes whereby that agency operates, investigating the 'positioning' of the translator(s) in their translations (Hermans 2007: 81) and considering its implications for theatre and for translation.

Sample selection

In aiming to investigate the processes of theatre translation in actual occurrence, charting the findings for analysis, my methodology owes something to Gideon Toury's descriptive translation studies, which seeks 'to distinguish trends of translation behaviour, to make generalizations regarding the decision-making processes of the translator and then to "reconstruct" the norms that have been in operation' (Munday 2012: 171). However, I shy away from attempting to frame a typology of theatre translation categories, partly because Perteghella's *Descriptive Framework for Collaboration in Theatre Translation* has already identified 'nine different

types of theatre translation agency'[3] and three different types of collab-
orative practice,[4] encapsulated in a graphic framework which she has
illustrated, drawing on her own experience as a linguist and translator
(2004b: 114, 197, 246–309). Perteghella's analysis consists of valuable
and intricate contextual detail, but prompts me to reconsider two issues.
First, translation agents frequently fall into more than one of Perteghella's
nine categories, suggesting the complexity of the process; Richard Eyre,
for example, might be described as a 'privileged-monolingual-director-
adaptor-translator' using her typology. Second, her illustrations of collab-
orative practice, carried out over a geographically and historically broad
field of genres, languages and sites, provide informative examples of the
wide possibilities of collaborative translation but less of an indication of
the distribution of the types of translation taking place on a regular basis.

In considering my own approach, I was mindful of Bruno Latour's anal-
ogy of a cartographer 'trying to record the shape of a foreign coast':

> She might exert herself to fit the various reports sent by explorers into
> some existing geometrical format – bays have to be circles, capes trian-
> gles, continents squares. But after noticing the hopeless mess created by
> these records, none of which exactly fall into pre-determined shapes, she
> will eagerly accept any proposition to displace the quest for geometrical
> rigor with a totally abstract Cartesian grid. Then she will use this empty
> grid to patiently record the coastline itself, allowing it to be drawn in as
> tortuous a way as geological history made it to be. (2005: 23–24)

Wishing to map the processes of translation in the specific arena of the
London mainstream stage, I have followed Latour's Actor-Network-Theory
example, '*recording* not filtering out, *describing* not disciplining' (2005: 55).
Rather than pick out what I considered to be a representative collection of
translations, thus imposing ready-formed assumptions on my data, I adopted
an approach learned in my practice as a financial auditor and identified a
time-based corpus that would yield a random sample. I looked back to 2005
as a year that was recent enough to be current and fresh in the memory but
far enough away for publications and archival material to be available, and
identified the months of April, May and June as appropriate for study, on
the basis that they were least likely to be distorted by Christmas or summer

[3] Playwright–translator, specialized translator, privileged translator, scholar–translator,
 literal translator, dramaturg, adaptor, monolingual playwright–adaptor, monolingual
 adaptor, director–translator.
[4] Literal draft rewritten by playwright–adaptor, cooperative translation, playwrights'
 partnerships.

special programming. I then analysed theatre listings advertised as *The Official Guide of the Society of London Theatre*, published in the *Sunday Times Culture* section (and other national and London newspapers) every week, and extracted any translated plays, discounting opera and musicals because the translation processes in these two genres are subject to additional translational and operative constraints, as Helen Minors and her contributors examine in *Music, Text and Translation* (2012). My review produced a list of eight translated plays performed in major London theatres (and therefore available to and likely to be attended by large and varied audiences).

There was a ninth play with potential for inclusion in the sample: the Kneehigh Company touring production of *Tristan and Yseult* in performance at the National Theatre Cottesloe venue, directed and adapted by Emma Rice, written by Carl Grose and Anna Maria Murphy (Grose et al. 2005). The multilayers of translation and adaptation, based on an undefined source text from the Celtic oral tradition, would certainly repay investigation. When I made my choices, however, I was intending to compare an original source text with a performance text. As classicists will testify, the concept of an 'original' text is problematic as narratives can be pretextual, such as the Homeric chronicles or, indeed, Celtic legend. Studies of ancient texts tend to refer to 'originary' sources, highlighting the difficulty in identifying a 'first' text. It is not necessary for millennia to have passed to render a source text unidentifiable; this is particularly the case in theatre, where texts are expected to shift according to the user and the audience. As I was to discover, none of my translations could be related back to one particular source text. For historical texts like those of Schiller and Ibsen, a definitive text is generally one that has been authorized by scholarship and is not necessarily the text used as a starting point for translation. Furthermore, playwrights acknowledge the fluidity of their work: Henrik Ibsen was prepared to adapt *Hedda Gabler* for a German audience; Juan Mayorga considers that his plays are never completely fixed. And, as it turned out, there were two competing sources for David Eldridge's play from the film *Festen*. Nevertheless, the eight translations shown in Table 1.1 are those I discuss in detail throughout this book, examining the mission and site of the company that commissioned the translation, the context of the productions and the contributions and interactivity of the individual agents participating in the performance.

This systematic collection of plays, ranging from classical tragedy to contemporary drama, would rarely be discussed as a body, but in fact is representative of the variety regularly available on the London stage. As my book illustrates, this apparently diverse collection has many commonalities, not least the identities of the agents practising in the translation field across theatrical boundaries. Their influential status in the wider realm of theatre

Table 1.1 Translated plays advertised by the Society of London Theatre, 7 April to 26 June 2005. Bold data indicates information that was presented in the small advertisements

Source Language	Title	Author	Translator	Translation type	Literal Translator	Theatre	Director	Other
Ancient Greek	*Hecuba*	**Euripides**	**Tony Harrison**	Direct **Version**	n/a	Albery (from **Royal Shakespeare Company**)	Laurence Boswell	Actor: **Vanessa Redgrave**
Danish	*Festen*	Thomas Vinterberg, Mogens Rukov and Bo hr. Hansen	David Eldridge	Indirect	Bo hr. Hansen, author of English playscript	Lyric (from **Almeida**)	Rufus Norris	
German	*Don Carlos*	Friedrich Schiller	**Mike Poulton**	Indirect **Adaptation**	Undisclosed	Gielgud (from Crucible)	**Michael Grandage**	
German	*The Woman Before*	Roland Schimmelpfennig	David Tushingham	Direct	n/a	Royal Court Downstairs	Richard Wilson	
Norwegian	*Hedda Gabler*	**Henrik Ibsen**	**Richard Eyre**	Indirect **Version**	Karin and Ann Bamborough	Duke of York's (from Almeida)	Richard Eyre	
Russian	*The UN Inspector*	Nikolai Gogol	David Farr	Free adaptation of *The Government Inspector*	Charlotte Pyke	National Olivier	**David Farr**	
Spanish	*The House of Bernarda Alba*	**Federico García Lorca**	**David Hare**	Indirect **Version**	Simon Scardifield	National Lyttleton	Howard Davies	
Spanish	*Way to Heaven*	**Juan Mayorga**	David Johnston	Direct	n/a	Royal Court Upstairs	Ramin Gray	

provides further evidence about the complexities of translation, its terminologies and visibilities, in theatre today.

Interviews, archives and accounts

Theatre is a collaborative medium in which translation is only one aspect of the interpretive process communicated by a range of individuals selected for their unique contributions to the collective activity. This mix of 'unique' and 'collective' presents a challenge for the researcher wishing to conduct an objective study of translation procedures. Objectivity is considered to be a desirable element of rigorous research. But is it reasonable to make generalizations when most of the procedural agents have been engaged precisely for the idiosyncrasies of their creative approaches? And how is it possible to identify trends of decision-making when the translated product, a staged theatrical performance, is the outcome of participative activity that is both broadly based and hierarchical? I chose to gather my data as I had selected my sample, employing the auditing methods of interview, investigation of the archive and scrutiny of financial accounts. Although the sample selection was semi-random, the interview process follows Jennifer Hochschild's definition of 'the elite interview', as each subject was 'chosen by name or position for a particular reason, rather than randomly or anonymously' (2009).

The source material used to construct my sample supplied an initial list of eight living individuals: two original authors, five writer/translators and one director. Published playtexts and the production programmes of the translations in the sample provided information regarding further theatre practitioners to approach for interview, and yet more prospective participants emerged as the interviews took place. In all, I requested interviews from thirty-seven individuals connected with the productions, ranging throughout the translation process from commissioning artistic directors and commercial producers, via the source language writers or their representatives, to the literary managers and translators. A few subjects declined to be interviewed, and a larger number did not respond to my invitation. Ultimately, however, I recorded interviews with eighteen theatre professionals – around half of the number requested – as shown in Table 1.2.

For all my attempts to create a balanced, objective sample, the profile of the interviewees is not evenly distributed among the eight productions. However, every production is represented, and some of my interviewees filled more than one role – such as Michael Grandage, who was both artistic director and director for the *Don Carlos* production. Other practitioners, Christopher Campbell, for example, had worked on more than one

Table 1.2 Distribution of interview subjects

Principal theatre practitioner role	Number of interviewees
Artistic directors	1
Producers	2
Literary department personnel	5
Directors	2
Indirect translators	2
Direct translators	2
Literal translators	3
Playwrights	1
Total interviewees	**18**

production or were able to discuss their experiences of working practices in multiple theatres in my sample. Thus my interview process was, as Maria Delgado and Paul Heritage found in their earlier collection of interviews, 'neither entirely random nor wholly prescribed' (1996: 12). Nevertheless, the sample covers a comprehensive range of the activities of theatre practitioners in the field of translation. Inevitably, each subject approached the interview questions and the overall topic of the conversation according to their personal role and interests, so that, ultimately, no two interviews are alike or immediately comparable. They are, however, of a sufficient number to permit some insight into the processes obtaining in the practice of theatre translation. They also provide a practical demonstration of the multiple voices in translation, including my own.

The other source of information for this project was archival material. Theatre archives in the United Kingdom are not centralized and can range from collections with a dedicated space and archivist, such as the National Theatre Archive and Royal Shakespeare Trust, to a forgotten box in the corner of a backstage office. Locating documents and then gaining access provoke reflection on the theoretical issues of curating and gathering an archive. What is revealed and what concealed? Jacques Derrida identifies this problem as 'archive fever', asking, 'Have we ever been assured of the homogeneity, of the consistency, of the univocal relationship of any concept to a term or to such a word as "archive"?' (1995: 33). Some of the productions in this study were well documented by recordings, prompt books, records of designs, directors' notes, correspondence, even invoices. Others have left little trace of their trajectory. Similarly, some theatres, principal among them the Royal National Theatre, respond to their public accountability with an extensive searchable website, archive catalogue and financial records. Others are less accessible, or simply not sufficiently resourced to maintain organized records

and make them available to outsiders. The fact that I was able to access sufficient material to produce this study is largely due to the cooperation and interest of many theatre practitioners, not all of them named in this book. The collaborative aspect of theatre is such that there is always more than one opinion, a variety of responses, a range of perspectives. My research and discussions reflect the shifting nature of the subject itself; theatre translation is a field of mutability and sometimes unexpected liminality. It is also very exciting.

Mapping theatre translation

This book examines the role of the translator on stage by investigating the collaborative translation process from commission to performance. Chapter 2 scrutinizes the physical and economic conditions within which the plays were produced; it conducts an analysis of the theatres where the plays were commissioned and performed, including a review of their funding and management practices. The variety of theatrical site and organization provides a rich context for the decision-making functions around translation which, as the chapter demonstrates, extend beyond physical and geographical boundaries. The third chapter takes a close look at my sample of translated productions, examining the translation procedures of the eight productions, the collaboration of the translation and theatre practitioners in creating the performance and their development from original text to translated performance, along with the reception of the productions in the form of reviews. Where relevant, I also consider earlier translations, investigating the transformative combination of translation, language and performance over time. The translating agents themselves are analysed in Chapter 4. Based on my interviews discussing the processes and terminologies of translation, I chart the approaches adopted by practitioners involved in various stages of development of the translation project, from inception to public performance; these include producers, directors, literary managers, translators and writers. My final chapter steps back to reflect on what this systematic mapping reveals about theatre translation processes in London, and how this may be relevant to theatre, translation and communication more generally within society.

As a chartered accountant, I was trained to examine the overall presentation of a set of financial accounts: establishing and mapping the processes whereby the results were obtained, reviewing the context, analysing the functions, questioning the agents, testing selected elements and ultimately 'taking a view' of the accuracy of their representation. This volume is my view of the translation practices pertaining to mainstream London theatre in 2005. It

looks behind genres, periods and languages at the individuals who engage in the translation project and the theatres where they are situated. It systematically records the methods whereby these agents of differing visibility and celebrity collaborate to produce performable translations. And, within the limitations of the inevitable subjectivity both of myself and the theatre practitioners under review, it endeavours to assess the actual and potential contribution of theatre to raising awareness of the translator's role in society at large.

2

London Theatre: Contexts of Performance

Theatrical site and mission

Each of the productions examined in this study is represented by a published playtext. That text provides a snapshot of the translation process in performance at a given moment, often the point shortly before the production is due to open to the public, when changes and amendments may still be taking place. The published text only provides a very limited impression, through stage directions, of the performance elements on stage. And yet the physical performance itself, alongside the verbal and textual content, is the vehicle through which translation is conceived and expressed. Catherine Boyle, in her dual role as translator and academic, sees performance as the 'embodiment' of a translation (2007: 62). Site participates in the concretization of translation through performance, as is shown by the emergence of site-specificity in theatre practices and performance theory. Site-specific performance, 'devised to exploit the particular qualities and associations of a specific, invariably non-theatrical, place' (Pickering and Woolgar 2009: 198), has influenced the devising practices of experimental and, increasingly, mainstream theatre – for example, the director Rupert Goold's 2011 production *Decade*, produced in association with Chichester Festival Theatre and the National Theatre, created in London's Dockland a facsimile of the Windows on the World restaurant in the World Trade Center to explore personal reactions to 9/11. In such instances, site contributes actively to performance.

And not only site. The organization which inhabits that site has its own ethos, which impinges on the development of a translated play. Marvin Carlson notes that 'the framing of the theatre experience has become a calculated part of that experience' (1989: 207). Theatrical site is part of the frame that influences a production – not only through the building itself, but also through the culture it houses. The tone of the translation is affected by the commissioning and performance policies of the prevailing theatre company and, where relevant, the procedures of the organization managing the building in which a play is performed. In this chapter, I contextualize the theatres which commissioned the translations in my sample and which staged the performances, considering their production and theatrical histories, the

points where they meet within the theatre field and the ways in which they differentiate their performance offering. I examine elements of the financial, management and organizational structures of each of the relevant theatres, surveying the mission statements and cultures of each entity, and identifying the features which separate and link the physical structures and their personnel.

The Society of London Theatre: what is mainstream?

The organization which binds together the eight productions under discussion, and which indeed was the source of that sample, is the Society of London Theatre (SOLT). This body was founded in 1908 by the actor-manager Sir Charles Wyndham, and 'is the trade association that represents the producers, theatre owners and managers of the major commercial and grant-aided theatres in central London' (Society of London Theatre 2011). SOLT aims 'to champion theatre and the performing arts' by means of a range of services for its trade members (full and affiliate) and 'to promote theatregoing to the widest possible audience' (Society of London Theatre 2017a). Its outward-facing activities include the publication of the *Official London Theatre Guide*, a free fortnightly booklet which 'contains listings for shows playing in the West End, dance and opera productions, and a selection of Off-West End shows' (Society of London Theatre 2017b) and, of more commercial importance, the Official London Theatre website which sells tickets for listed shows. SOLT also sponsored the newspaper theatre listings which I compared to identify the translations examined in this book. These activities are crucial for the promotion and sales of its members' productions, but SOLT also conducts further services which benefit and unite its membership, including advice on legal, general and industrial relations matters; managing the process of collective bargaining with the entertainments trade unions; providing further commercial services such as coordinating the sale of theatre tokens, operating of discounted theatre ticket shops and providing access to prospective investors; representing the theatre industry to public and other relevant authorities; and researching and collecting relevant data. All these activities are focused on 'strengthening and connecting the theatre community' (Society of London Theatre 2017a). These operations demonstrate the extent of SOLT's presence in the London theatre environment, particularly with regard to the mainstream houses aiming to attract larger audiences. However, SOLT's impact extends beyond these boundaries, making it an influential representative of the theatre industry in general. For example, its Theatre Tokens scheme is subscribed to by theatres across

the United Kingdom. Thus SOLT is a unifying body for its members and any other theatres availing themselves of its ticket sales operations, industrial relations or legal issues guidance.

SOLT produces an annual box office data report and also commissions other periodic reports, such as a London theatre report. These reports provide detailed statistical analyses of open and closed theatres, numbers of performances, attendances, capacities, ticket prices, types of productions and theatrical trends which underline the significance of the theatre industry to the national economy. Furthermore, SOLT's representations of its members in the public sphere include interventions such as the submission of evidence to a governmental enquiry 'into the nature and adequacy of public support for theatre in Britain' (Society of London Theatre and Theatrical Management Association 2005). However, SOLT's significance extends beyond the central London theatres it represents. In 2004, for example, a report into the economic impact of UK theatre was commissioned by Arts Council England, the quasi-governmental body whose function is to distribute funding from government and the UK National Lottery to the arts in England. This particular report, by Dominic Shellard of the University of Sheffield, presented an analysis of data under the two headings of 'SOLT venues' and 'UK-based venues (excluding SOLT venues)', finding that SOLT contributed £1.5 billion (or 58%) of the total £2.6 billion economic impact of theatres in the United Kingdom (Shellard 2004: 16). The SOLT theatres are therefore major participants in the UK theatrical economy.

Commercial and subsidized theatre interests are frequently intertwined, both financially and creatively. Although public and academic perception generally distinguishes, albeit imprecisely, between commercial and subsidized theatrical practices, denoting the first as privileging profit over art, or popular over high culture, and the second conversely, the industry has many similarities across its range of activities, and many points of convergence between commercial and subsidized entities. For example, well-sold productions from subsidized theatres move to commercially owned theatres for extended runs, while commercial theatre companies contribute to the registered theatre charities Stage One and the Theatre Development Trust, which invest in commercial productions and management. SOLT is therefore an appropriate site to perform an initial view of overarching London theatre structures.

SOLT's 2009 Annual Report refers to its breadth of membership, consisting of 'almost all the major theatre interests in Central London. Most Members represent commercial theatre but membership also includes representatives of subsidised dramatic and lyric theatre organizations operating in Central London, including the four great "National Companies". The Society

also welcomes Affiliate Members drawn from subsidised companies based elsewhere in London' (2009: np). These members are individual members, rather than organizations. The 2009 Annual Report gives the examples of Sir Cameron Mackintosh and Lord Lloyd Webber, members since 1973 and 1983 respectively, whose organizations are also represented by other senior personnel (2009: 11) and between them control a significant number of commercial theatres in the West End. I assume, as no definition can be found in the report, that the 'National Companies' referred to are the National Theatre, Royal Opera House, English National Ballet and English National Opera, the latter two based at the London Coliseum. Moreover, a further four theatres represented among the SOLT full membership also received public subsidies (although the Donmar Warehouse Theatre,[1] a regular recipient of grants-in-aid, is classified by SOLT as a commercial theatre). These organizations between them were awarded Arts Council England grants in the period to 31 March 2005 of 20 per cent of all grants awarded nationally, as set out in Table 2.1.

Thus of the forty-nine theatres represented by SOLT in 2005, the seven theatres[2] named in Table 2.1 were of major importance in the subsidized arena, as demonstrated by their receipt of a significant proportion by value (20%) of all grants to nationally subsidized theatres. This demonstrates that SOLT's services are required by both commercial and subsidized theatres, and that distinctions between the two may not be as easily drawn as might at first sight appear. The SOLT box office data reports distinguish between commercial and subsidized theatres, providing separate analyses of their ticket prices. Average ticket prices between the two sectors do not appreciably differ: the average price paid (as opposed to asked) in 2005 was £31.01 in commercial theatres and £31.95 in subsidized theatres, the higher average for subsidized theatre explained by the disproportionately high cost of opera and ballet tickets in that sector (Andrews 2006: 48–49). The box office data reports annually point out that the commercial sector is relatively much larger than the subsidized sector (contributing around 83% of the revenues for the combined sectors in 2005); nevertheless, it is clear that the two sectors operate on models that are similar enough for their pricing mechanisms to be broadly similar, their sales platforms to be shared, and their productions to move between the two sectors.

[1] The Donmar Warehouse Theatre is the base of the theatre company Donmar Warehouse Projects Limited. Its name is frequently shortened to Donmar, Donmar Warehouse or Donmar Theatre. These terms are used interchangeably in this book.
[2] London Coliseum is represented twice as home to English National Ballet and English National Opera.

Table 2.1 Annual Arts Council England grant awarded by organization

Organization	Annual ACE grant awarded	Percentage of total grant awarded
'National Companies' who are members of SOLT:		
National Theatre	£16,390,026	5
Royal Opera House	23,110,841	7
English National Ballet (based at London Coliseum)	5,715,338	2
English National Opera (based at London Coliseum)	16,078,500	5
Total	*£61,294,705*	*19*
Other subsidized theatre companies who are full members of SOLT:		
Barbican Theatre	104,000	>1
Donmar Theatre	350,000	>1
English Stage Company (based at Royal Court Theatre)	1,907,218	>1
Sadler's Wells	1,734,000	>1
Total	*4,095,218*	*1*
Total grant-in-aid awards received by SOLT members	65,389,923	20
Total grant-in-aid grants awarded	*£316,089,653*	*100*

Source: 2005 Annual Review Grant-in-Aid Accounts (Arts Council England 2005: 79–94)

Arts Council England grants and the corresponding strength of the subsidized companies can be contextualized by comparing them to gross box office revenue for 2004 of £343,674,090 (Andrews 2008: 99). Table 2.2 sets out the comparable box office receipts of the subsidized organizations which are also members of SOLT for the period in question, using information taken from published accounts. These data can only be used as a guide as the financial periods under consideration differ, and the content of box office receipts may vary between institution (for example, the National Theatre includes touring income in box office receipts whereas the Royal Opera House shows it separately).

While Table 2.1 demonstrates the importance of the SOLT subsidized companies among subsidized theatre nationally, Table 2.2 explains the significance of the subsidized theatre grouping within SOLT itself. Around 2005, these eight companies accounted for 14 per cent of the theatres represented in the membership and 19 per cent of the box office receipts. When Arts Council England grants and additional sponsorship are taken into account – for example, the Royal Opera House raised £15.8 million

Table 2.2 Box office receipts of organizations belonging to the Society of London Theatre also in receipt of Arts Council England funding

Organization	Relevant period	Box office receipts	Percentage of total gross box office revenue
National Theatre	Year ended 3 April 2005	£13, 528,000	4
Royal Opera House	Year ended 27 March 2005	27,200,000	8
English National Ballet (based at London Coliseum)	Year ended 31 March 2005	3,072,426	1
English National Opera (based at London Coliseum)	Year ended 31 March 2005	7,102,000	2
Barbican Theatre	Year ended 31 March 2005	2,135,000	1
Donmar Theatre	Year ended 31 March 2005	1,520,583	>1
English Stage Company (based at Royal Court Theatre)	Year ended 31 March 2005	920,059	>1
Sadler's Wells	Year ended 31 August 2005	10,762,000	3
TOTAL		*£66,240,068*	*19*
Total Gross Box Office Revenue	**Year to 31 December 2004**	**£343,674,090**	**100**

Source: SOLT Box Office Data Report 2008 (Andrews 2008: 99) and published financial accounts for the theatre organizations

of 'donations, legacies and similar incoming resources' in the year ended 27 March 2005 (Royal Opera House 2006: 116) – calculations suggest that these subsidized theatres are in possession of significant financial resources.

Further analysis of the membership of SOLT in 2005 indicates that the commercial theatres also form sizeable interest-groups, with ownership of twenty-eight of the theatres distributed among four organizations in 2005: the Ambassador Theatre Group (nine theatres), Delfont Mackintosh (seven theatres), Really Useful Group (seven theatres) and Nimax (five theatres). It is clear that a significant level of control of the theatres represented by SOLT resides in relatively few organizations that between them are likely to be highly influential in directing the course of London theatre. Furthermore, subsidized theatre is well represented among these groupings, with the National Theatre, Royal Opera House and London Coliseum as significant theatrical organizations. This chapter examines both commercial and subsidized theatres connected with the eight translations discussed. Most of the theatres I discuss have voluntarily entered into the SOLT industrial grouping, although the Almeida Theatre has chosen affiliate status, and two further companies are ineligible, being based outside London: the RSC and the Sheffield Theatres.

A contextual approach to London theatre organizations demonstrates the financial hybridity of theatrical structures. Subsidized and commercial theatres operate side-by-side, with a degree of interchange between the two sectors. Several of the translated productions examined in this book move between theatres belonging to different groupings, as do many of the theatre practitioners. Susan Bassnett claims that market-force economics influence translation in British theatre 'where the key factor is the size of the audience and the price they are willing to pay for tickets'. In her opinion, 'ethical considerations are diminished' in this climate. Furthermore, Bassnett considers that 'English language translators, directors and impresarios' seeking a 'more respectable' explanation for their economically driven decisions, use 'the notion of "performability" … to excuse the practice of handing over a supposedly literal translation to a monolingual playwright' (1991: 102). In my view, theatrical translation decisions stem from a nuanced blend of management and creative compulsions. This chapter reviews the financial and administrative structures and organizational cultures of the organizations producing these eight translations, investigating the motivations and contexts that influence decision-making in the theatrical translation commissioning process.

The Royal National Theatre: a theatrical service to the nation[3]

The House of Bernarda Alba and *The UN Inspector* were both performed at the Royal National Theatre complex on the south bank of the Thames in central London.

The mission statement of the National (as it is popularly known), under the artistic directorship of Nicolas Hytner (2003–2015), placed the theatre complex, geographically and ideologically, at the centre of British theatrical culture:

> The National Theatre is central to the creative life of the country ... It aims constantly to re-energise the great traditions of the British stage and to expand the horizons of audiences and artists alike. It aspires to reflect in its repertoire the diversity of the nation's culture ... Through an extensive programme ... it recognises that the theatre doesn't begin and end with the rise and fall of the curtain. And by touring, the National shares its work with audiences in the UK and abroad. (Royal National Theatre 2009)

Under Hytner's successor, Rufus Norris, these sentiments continue, epitomized in the phrase 'the work we make strives to be as open, as diverse, as collaborative and as national as possible' (Royal National Theatre 2017). In short, the National seeks to live up to its name and provide a holistic theatrical service to the nation. Although this aspiration apparently encompasses a broader British nation, with references to Britain and the United Kingdom, the theatre is funded by Arts Council England, one of three separate funding bodies responsible for the allocation of arts funding to England, Scotland and Wales. National Theatres of Scotland and Wales were created in 2006 and 2009 respectively, and there has also been an official review in the Northern Ireland Assembly to discuss the development of a National Theatre of Northern Ireland. Nadine Holdsworth points out that the 'primary challenge' in a debate about national theatre is 'the question of whether a single theatre, normally in a national capital, can legitimately claim to serve as a theatre of and for the nation as a whole' (2010: 34). This challenge has been particularly pressing for a national theatre in London since the Scottish and Brexit referendums, but ever since the National Theatre was founded in 1963 there have

[3] This section is substantially based on my chapter 'Theatre Translation for Performance: Conflict of Interests, Conflict of Cultures' in Brigid Maher and Rita Wilson (eds) *Words, Images and Performances in Translation*, 63–81, London: Bloomsbury Continuum Publishing, an imprint of Bloomsbury Publishing (2012).

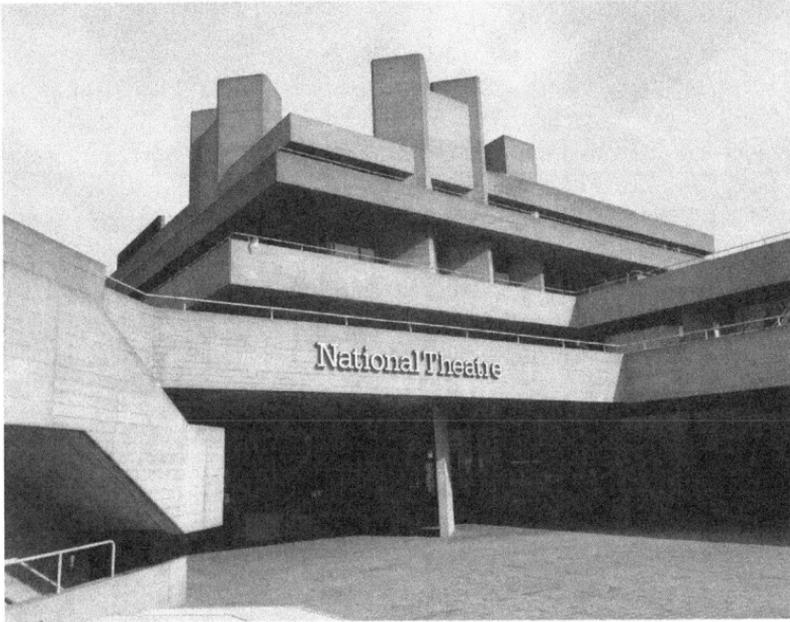

Figure 2.1 The Royal National Theatre, South Bank, London. Photograph copyright: Geraldine Brodie (2017)

been discussions, often heated, around the degree to which a London-based institution could speak for other regions and, indeed, nations.

The National Theatre's public responsibility is to some extent a prerequisite of its funding: the financial accounts for the fifty-two weeks ended 2 April 2006 (during which period *The House of Bernarda Alba* was performed) show that 44 per cent of the National's income came from Arts Council England grants, compared with 30 per cent from box office receipts and touring income. A quick calculation shows that Arts Council England subsidized each paying member of the audience during this period by £26 per head.[4] Ticket prices for around that period ranged between approximately £10 and £35; the subsidy therefore provides a substantial amount towards production costs, at least doubling the contribution of many ticket holders. That the National is the recipient of such substantial public funding inevitably provokes debate as to its duties with regard to the public it serves and the official bodies which provide sponsorship. The ambitious tone of its mission statements and the attempt to include a coherent mix of new and classical texts in its repertoire, while addressing issues of diversity and tradition, reveal the conflicting criteria

[4] Calculation based on ACE grants of £17,261,000 divided by total paid attendances of 663,000 (Royal National Theatre 2006: 41–42).

which a commissioning director must try to satisfy. The inclusion of translated plays within these boundaries raises additional questions.

The National Theatre generally uses the two-step literal-indirect route when staging plays in translation. Katalin Trencsényi considers that 'this choice is not happening out of necessity but is part of the theatre's artistic policy' which aims to meet the criteria of 'accessibility, audience engagement and performability' (2015: 53). Both of the National Theatre translations considered in my sample were created via a literal translation, with indirect translators whose names would have resonated with the theatre-going public for differing reasons. The inclusion of two canonical plays by Lorca and Gogol in the National repertory was presumably intended to conform to the aims of the mission statement 'to re-energise great traditions' by commissioning new translations, and to 'expand the horizons' by approaching works from outside the English language. In both cases, these two plays had previously been extensively translated and performed for English-speaking theatre, and have each since been produced in several further retranslations. The key marketing descriptions of these productions are 'new' (*The House of Bernarda Alba*) and 'freely adapted' (*The UN Inspector*), which give an indication of the National's claim to possession of these productions and explain their inclusion in the season's programme.

Nicholas Hytner, in his artistic director's report for the fifty-two weeks ended 2 April 2006, claimed an 'inherent worth' for all the work carried out by the National, placing *The House of Bernarda Alba* within a group which 'involved the re-investigation of great plays that will always be staged for the universal truths that they embody' (Royal National Theatre 2006: 5). This gives some indication of what might have been expected in arranging a match between a well-known establishment playwright and an international classic. The National's approach to translation extends beyond its own boundaries. Many of the theatre practitioners included in this study, certainly at least one practitioner for each of the eight plays discussed, will have been associated with the National in some way during their career. Each translation therefore bears a trace of the National's influence, even if this manifests itself in the adoption of an opposing, or at least differentiated, stance to translation.

A further consideration for translations at the National arises in the physical theatre setting. The theatre building complex comprises three theatres, with a fourth studio for developmental projects under one mile away. The translations in this study were staged in the two highest-capacity theatres. *The UN Inspector* was shown in the largest, the Olivier, a theatre seating 'well over 1000 people in a semi-circular sweep inspired by ancient Greek amphitheatres' (Royal National Theatre 2011b). The Lyttleton Theatre's proscenium arch accommodated *The House of Bernarda Alba*, with an 890-person capacity. The size and design of stage, be it traditional or open-style, affects the

choice of play and translator, but the number of seats is also significant to the translation: unlike commercially owned theatres in London's West End theatre district, the National does not cancel a play if critical reviews are poor and ticket sales suffer; there is therefore pressure to fill seats every night of a pre-assigned time-scale. Contrary to expectations, subsidy does not provide a cushion to compensate for unpopular programming. Although the National's income stream substantially supplements ticket sales by means of public grants and private donations, the theatre's management is still required to demonstrate successful outputs and impact in funding reports and applications, drawing on metrics which include audience numbers and composition. London theatre audiences are local, national and international, with a mix of long- and short-term residents and tourists; National programmes must take this broad constituency into account when planning productions.

Such exigencies, along with the formal setting, may be seen as an incentive to produce a certain type of translation to make it accessible to a wide audience, to acknowledge the heritage and tradition of a play while also re-energizing it and making it new. The choices faced by the National's commissioning teams are evidenced in its own productions, but also relevant to other theatre decision-makers, who are likely to be affected by National approaches, both in following its lead in addressing their own funding demands and in calculating how to operate in a theatrical field in which the National Theatre is highly influential. Reaction to the National Theatre approach can generate alternative modes of addressing programming and translation choices, as is demonstrated by a comparison with the Royal Court Theatre.

The Royal Court Theatre: writers' theatre[5]

There were also two translated plays in production during the period at the Royal Court Theatre[6] in Chelsea, an affluent residential and commercial inner suburb in west London, about three miles from the National Theatre.

The Woman Before was staged in the main Jerwood Theatre Downstairs, a more conventional space intended for plays which attract larger audiences, and the main reason for the Royal Court's participation in SOLT. *Way to Heaven* was presented in the ninety-seat Jerwood Theatre Upstairs, a smaller, more flexible space designed to accommodate different staging and seating

5 This section is substantially based on my chapter 'Theatre Translation for Performance: Conflict of Interests, Conflict of Cultures' in Brigid Maher and Rita Wilson (eds) *Words, Images and Performances*, 63–81.

6 The Royal Court Theatre is the home of the English Stage Company. Both the theatre company and the theatre building are generally referred to as the Royal Court, a practice which is followed in this book.

configurations.[7] The Royal Court's website around that time outlines the the-
atre's principal purpose as follows:

> The Royal Court Theatre is Britain's leading national company dedicated
> to new work by innovative writers from the UK and around the world.
> The theatre's pivotal role in promoting new voices is undisputed – the
> New York Times described it as 'the most important theatre in Europe' …
> The Royal Court's success has inspired confidence in theatres across the
> world and, whereas new plays were once viewed as a risk, they are now at
> the heart of a revival of interest among artists and audiences alike. (Royal
> Court Theatre 2009a)

This outlook is not dissimilar from that of the National in as much as it pro-
motes a central, national role for the theatre and aims to expand its influ-
ence beyond the United Kingdom. Where it differs is in its emphasis on
new writing: the Royal Court is quite clear in its attention to the voice of the
playwright, stressing the theatre's standing among artists and other theatres,
including its international status.[8] As its governing council reports, 'It is an
artistically led theatre that creates the conditions for writers, nationally and
internationally, to flourish' (English Stage Company 2006: 6). The focus on
the writer creates a degree of risk with regard to audience numbers, as can be
surmised from an examination of the accounts.

Calculations based on information supplied in the annual report for the
year ended 31 March 2006 (during which *Way to Heaven* was staged) show
that Arts Council England grants represented 54 per cent of the theatre's
total incoming resources while only 19 per cent of those resources came
from box office and associated income.[9] More in line with the National
Theatre, however, is the Arts Council England subsidy per head of audi-
ence: approximately £27.[10] Clearly, both institutions are dependent on
the public funding allotted to them by Arts Council England and as such
need to be aware that they will be monitored for 'artistic quality, manage-
ment, finance and public engagement' (Arts Council England 2009a). The

[7] The name Jerwood was added to the title of these two spaces in 2000 in recognition of a
 capital grant by the charitable Jerwood Foundation towards their redevelopment.
[8] Rufus Norris reorganized the National Theatre's literary department on assuming the
 artistic director position in 2016, renaming it 'New Works'. This is intended to include not
 only new writing but also devised and other non-textual approaches to theatre-making.
[9] Calculations obtained by comparing ACE revenue grant: £2,000,000 (24 n. 3) and box
 office and associated income: £681,998 (25 n. 5) to total incoming resources (consoli-
 dated statement of financial activities, 19) (English Stage Company 2006).
[10] Calculation based on ACE grants of £2,000,000 (see above) divided by the total atten-
 dance for the year of 74,185. Top price tickets during the period were reduced to £25
 (English Stage Company 2006: 7, 10).

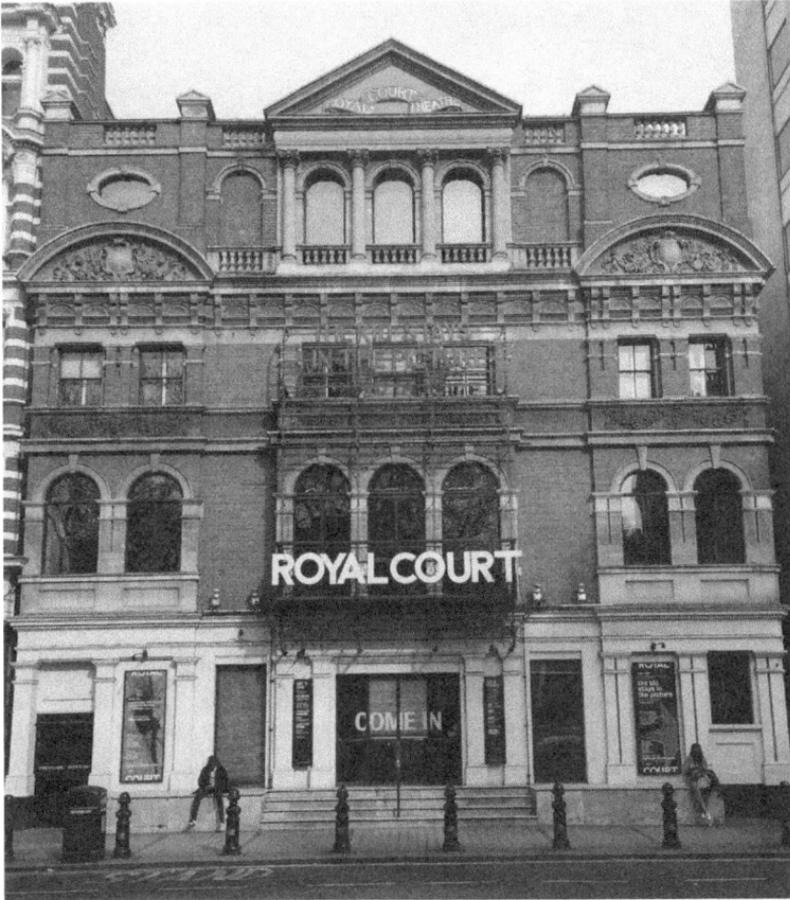

Figure 2.2 The Royal Court Theatre, Sloane Square, London. Photograph copyright: Geraldine Brodie (2017)

National Theatre, a major recipient of funding, amounting to £18,715,431 in 2008/9 (Arts Council England 2009c), undertakes a full range of theatrical activities in line with its public image. In contrast, the Royal Court, granted £2,189,627 in 2008/9 (Arts Council England 2009b), receives funding because it is 'an exemplary centre for the development and production of new writing for theatre. It has strong Young Writers and International programmes and a commitment to developing theatre practice with writers at the centre' (Arts Council England 2009b). Its public offerings are thus differentiated from those of the National Theatre by the prominence specifically given to new writing.

Where writers are at the centre of theatrical strategy and there is a clear emphasis on the development of new, unknown work, the audience may be less easily identifiable. The Royal Court recognizes this problem, the council's report in 2006 explicitly stating in a section headed 'Factors affecting performance':

> The work produced by the Royal Court is often risky, challenging and experimental, which can, by its very nature, make it difficult to market ... Whilst this diversity and originality is part of the Royal Court's reputation for producing pioneering drama, it also presents a challenge to the Press, Marketing and Development departments, even more so this year when a significant amount of the repertoire would not necessarily attract mainstream audiences. (English Stage Company 2006: 12)

These challenges can affect translation strategies. This statement may also explain *Way to Heaven*'s appearance in the Jerwood Theatre Upstairs, a space employed for plays more suited to an intimate audience (whether for reasons of theme, experimentation or financial risk), which gives an indication of the Royal Court's expectations for the play. It is also notable that the Royal Court distinguishes its membership of SOLT between its theatres, Jerwood Theatre Downstairs being registered as a full member and Jerwood Theatre Upstairs as an affiliate. Affiliate members are noted in the SOLT box office data reports as 'playing an important role in their local communities while maintaining a national (and international) profile, often for challenging new work' (Andrews 2006: 78).

In view of the prominence given to international writing, it is not surprising to learn that, in contrast to the National Theatre, the Royal Court has an international department[11] with its own dedicated director, Elyse Dodgson, whose stated aim is 'to bring international plays into the core programme and present these alongside home-grown plays' (Little and McLaughlin 2007: 331). The international department sets out its translation policy on the Royal Court website: 'The department has pioneered the use of theatre practitioners as translators and the integral involvement of the translator in the play development and rehearsal process' (Royal Court Theatre 2009b). This practice extends beyond the international department. Katalin Trencsényi notes that although the Royal Court and National Theatre have similar aims with regard to the performability of translation, 'the Royal Court's artistic policy not to work from literals, but to commission translators' marks a difference in the way this theatre sets out to achieve such performability

[11] The Royal Court's international department is the subject of Elaine Aston and Mark O'Thomas's full length study *Royal Court: International* (2015).

(2015: 55). The Royal Court is often cited among the theatre translation community for its unusual approach, commissioning language experts to create a direct translation for performance. Although Christopher Campbell, the literary manager, considers that this approach permits the theatre to draw its translators from 'a wider range of people' (Trencsényi 2015: 55), the translators commissioned by the Royal Court tend to be sourced from a group who regularly translate for the theatre and have other dramaturgical experience, as is evident with the two Royal Court translators who feature in this study, David Johnston and David Tushingham.

Way to Heaven was described in the published text, which also functions as a programme, as 'part of the Royal Court's International Playwrights series' (Mayorga 2005: np). *The Woman Before* was presented without an international label, simply stating 'by Roland Schimmelpfennig' in the promotional headline. In both cases, the translator's name was prominently displayed, and the rubric 'translated by' offered the firm assurance that these were indeed direct translations, as would be expected from the Royal Court. These two productions were in fact the only examples in my sample in which the word 'translation' was unambiguously and overtly used to describe the transfer process which had taken place. This is a distinguishing feature of the Royal Court, and an area in which it stands out not only from the other theatres in my sample, but also from other more marginal theatres presenting translated work. The Arcola Theatre in east London is an example of a highly respected low-budget fringe theatre that frequently presents plays in translation, offering a range of translation possibilities. These include indirect translation, such as Henrik Ibsen's *An Enemy of the People* 'in a version by Rebecca Lenkiewicz from a literal translation by Charlotte Barslund' (2008); direct translation, for example Roland Schimmelpfennig's *The Golden Dragon* 'translated by David Tushingham' (2011) and co-translation, as in Anton Chekhov's *Uncle Vanya* 'in a new version by Helena Kaut-Howson and Jon Strickland' (British Theatre Guide 2011). In the latter case, Kaut-Howson, the director, is a Russian-speaker and collaborated with Strickland, the actor playing the title role. This is in contrast to the focused translation approach adopted by the Royal Court.

Since the formal inception of the international department in 1996, this has been the approach adopted by the Royal Court towards plays in translation. A striking exception, however, is the last play directed by the outgoing artistic director Ian Rickson in early 2007: *The Seagull* by Anton Chekhov in a new version by Christopher Hampton from a literal translation by Vera Liber (2007). Not only was this prize-winning production widely praised, but it also 'generated the Court's highest ever box office advance' (Little and McLaughlin 2007: 447) and later transferred to the Walter Kerr Theater, New York. This

production seems at odds with the usual emphasis on translation and 'new' voices, Chekhov being a staple of English-speaking theatre and Christopher Hampton a long-established playwright and translator (from French and German). The popular nature of its appeal was enhanced by a cast of actors known from film and television, for example, Kristin Scott Thomas and Art Malik. It was an unusual legacy and in its devising and reception served as an in-house illustration of the traditional treatment of a classic international play which the Royal Court usually leaves to other theatres.

This production established the breadth of Ian Rickson's capabilities in directing, which he was subsequently to put to use in commercial West End productions, such as Harold Pinter's *Betrayal* and Lillian Hellman's *The Children's Hour*, both at the Comedy Theatre in 2011 (shortly before this venue changed its name to the Harold Pinter Theatre). Additionally, his direction of *The Seagull* strengthened Rickson's credentials for staging canonical texts, demonstrated by the sell-out production of *Hamlet* at the Young Vic in 2011, with another leading film and television actor in the title role, Michael Sheen. Sheen played the title role in *The UN Inspector* at the National Theatre, one of the translations in my sample. Between that production and his appearance at the Young Vic in 2011, he consolidated his reputation as a film, theatre and television actor, in particular with his film roles in the Oscar-winning *The Queen* (2006) and Oscar-nominated *Frost/Nixon* (2008). This is illustrative of the networks that connect theatre practitioners and circulate around mainstream London theatres. The commercial, high-profile career which Rickson went on to pursue following the production of the Royal Court translation of *The Seagull* perhaps explains the motives for adopting a default style of translation, one which the Royal Court as a writer's theatre tends to eschew, but which transfers more easily into commercial production in the West End.

West End theatres: multiple managements

The four West End theatres in my sample are typical of the commercial theatre groupings within SOLT. The Duke of York's, the theatre to which *Hedda Gabler* transferred from the Almeida Theatre, is part of the Ambassador Theatre Group, one of the largest theatre-holding and theatre-operating groups in the United Kingdom. A second play originating from the Almeida, *Festen*, moved on to the Lyric Theatre, a member of the Nimax Theatres organization. The Albery (since renamed 'Noël Coward') and the Gielgud, hosting *Hecuba* and *Don Carlos* respectively, belong to the Delfont Mackintosh Theatres empire.

A cursory investigation into the details of these theatre-owning businesses reveals both a complexity of group structures and an interaction of personnel and assets which prevents a clear analysis of the administrative and organizational procedures operating within these companies. The Ambassador Theatre Group Holdings Limited, for example, notes forty-eight subsidiary undertakings in its financial statements for the period ended 28 March 2015. These are a mix of theatre operating, ticketing, production and holding companies in London, other regions of the United Kingdom, United States, Australia and Germany (2015: 27–28). This international group has offices in London, situated above the Duke of York's Theatre (pictured in Figure 2.3), which is part of its portfolio.

According to these 2015 accounts, Ambassador Theatre Group Holdings Limited is funded by long-term bank loans, 'senior debt' (where the lender takes priority over other creditors in the event of the distribution of a company's assets in liquidation) and finance leases in the amount of £502 million

Figure 2.3 The Duke of York's Theatre, St. Martin's Lane, London. The theatre also houses the London offices of the Ambassador Theatre Group. Photograph copyright: Geraldine Brodie (2017)

(2015: 30). Interest payable by the company in respect of its borrowings was £40 million, after an operating profit for the year of £9 million (2015: 12). Clearly, since the profit earned from trading is less than the amount of interest payable, this theatre group is dependent on the support of its ultimate owner, Providence Equity Partners, a global alternative investment firm based in the Cayman Islands (2015: 6, 36). In such circumstances, management decisions are likely to be affected by the necessity of meeting the group's financial covenants (the payment of interest on the loans). In view of the long-term nature of the debt, and the amount of interest payable in relation to the group's operating profits, this entails an ability to produce accurate forecasts for several years into the future, placing additional pressure on programming successful productions.

Another of the theatres in my sample, the Gielgud, provides a case study of the interaction of principals and assets within the SOLT grouping. According to a note in the *Don Carlos* programme, written by the manager of the Gielgud, Louise Guedalla, the theatre's 'classical facade has dominated Shaftesbury Avenue since 1906' (Gielgud Theatre 2005: np). The building's freehold had been owned by Christ's Hospital, a charitable foundation which principally supports a charitable boarding and day school, for children aged 11–18 'from all backgrounds', near Horsham, West Sussex (Christ's Hospital 2011). This freehold was sold to Delfont Mackintosh in spring 2002 (Delfont Mackintosh Theatres 2011). Prior to this sale, however, it appears that a long leasehold had been granted to Cameron Mackintosh Limited, the parent of Delfont Mackintosh Theatres, in 1999 (Gielgud Theatre 2005: np). A short leasehold must have at some stage been created from the long leasehold, as this lease was purchased by Andrew Lloyd Webber's Really Useful Theatres (subsequently renamed and reorganized as the Really Useful Group) from Stoll Moss, another theatrical group, in 2000, when the leases were shortly due to come to an end. The short lease reverted to Delfont Mackintosh in March 2006, at which point Delfont Mackintosh became the owner and operator of the building and the theatrical business it housed. Thus the Really Useful Group and Delfont Mackintosh both had an interest in the Gielgud Theatre in 2005. Furthermore, the third commercial theatre-holding organization in my sample, Nimax, can also be connected to this case-study: Nica Burns is listed in the *Don Carlos* programme as the production director for Really Useful Theatres. She formed Nimax Theatres in September 2005 with Max Weitzenhoffer, a theatre producer in New York and London, when they purchased four theatres from Really Useful Theatres (Nimax Theatres 2011), among them the Lyric Theatre, which also forms part of my sample. The Gielgud Theatre (shown, along with the Lyric Theatre, in Figure 2.4) thus provides an example of the multiplicity of agents involved in the

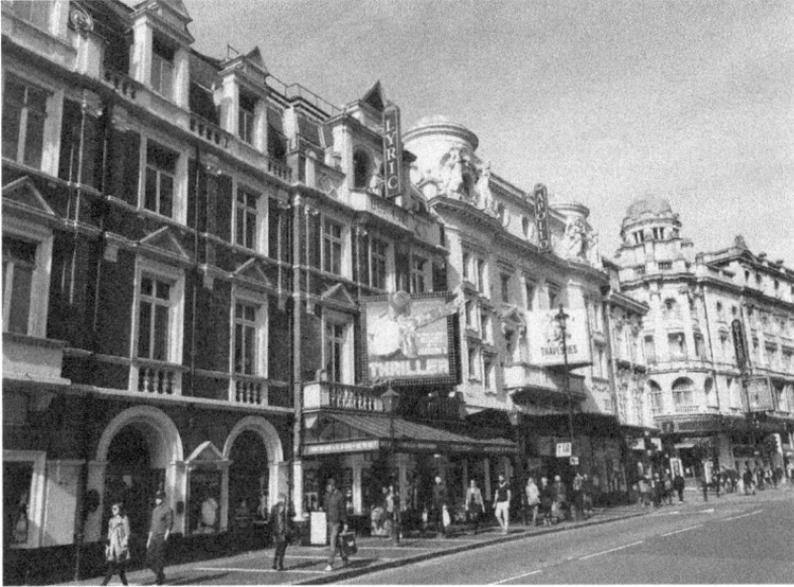

Figure 2.4 Theatres along Shaftesbury Avenue, London, include the Lyric and Gielgud Theatres. Photograph copyright: Geraldine Brodie (2017)

investment and management of the physical site of any production. My later analysis of the production housed in this site, *Don Carlos*, will demonstrate how this variety extends to the translation itself.

These four theatres, the Duke of York's, Lyric, Albery and Gielgud, all housed productions from my sample which originated in subsidized theatres that were not full members of SOLT: two from the Almeida Theatre in London, which had opted for affiliate membership of SOLT, and two from outside London. I now move on to consider these theatres in order of their distance from the West End, both geographical and cultural.

The Almeida Theatre: beyond the boundaries

The Almeida Theatre in Islington, north London, provided the base for two of the plays in my sample: *Festen* and *Hedda Gabler*. However, they were both in production on the commercial West End stage during April to June 2005, having transferred from successful runs at the Almeida. The Almeida was in fact showing a translated play during my base period, Lorca's *Blood Wedding* in a version by Tanya Ronder from a literal translation by Simon Scardifield (the literal translator of Lorca's *The House of Bernarda Alba* at the National, which is included in my sample) and directed by Rufus Norris,

the director of *Festen*. It can be seen from these few details that the Almeida operates in artistic circles which are closely linked to the London theatres in my corpus and, indeed, Tanya Ronder has since written versions of translated plays, such as Pirandello's *Liolà* (2013), that have been staged at the National Theatre, while Rufus Norris has taken over from Nicholas Hytner as the National's artistic director. *Blood Wedding*, however, was not picked up by my sample because the Almeida's productions did not feature in the SOLT-sponsored newspaper listings.

News about Almeida productions appears on the Official London Theatre website (sponsored by SOLT), but it is not possible to buy tickets through the website for productions staged at the theatre. Tickets for shows that have transferred to the West End, like the two productions in my sample, are available for sale through this platform, however. It seems to me that, by choosing affiliate membership of SOLT, the Almeida is seeking to differentiate itself from other theatres with which it might be compared. Other theatres located outside the boundary of the West End theatre district are full members: Sadler's Wells Theatre, less than a mile from the Almeida, and the main Royal Court Theatre, which is also a similar distance from the West End. Membership of SOLT only stipulates a London postcode. The Almeida's decision to adopt only limited participation in the principal umbrella organization of London theatres is perhaps an indication of an image the Almeida might wish to project, and which can be explored further by examining the theatre's own material.

In an online video on the 'About Us' page on the theatre's website, Michael Attenborough, the then artistic director, describes the theatre as a 'one-room space' which is appropriate for Shakespeare or musicals or 'a play with only two people in it' (Almeida Theatre Company 2010a). The website sets out the theatre's artistic vision as 'the presentation of bold and adventurous play choices staged to the highest possible standards, in productions which reveal them in a new light' (Almeida Theatre Company 2010b). These statements suggest a desire to differentiate the Almeida from its possible competitors. Among these potential rivals, my own view is that the theatre most similar to the Almeida in size, audience and output is the Donmar Theatre. This theatre, located in Soho and therefore at the heart of London's theatre district, is a full member of SOLT and claims for itself 'a diverse artistic policy that includes new writing, contemporary reappraisals of European classics, British and American drama and small scale musical theatre' (Donmar Warehouse 2010). Michael Grandage, its artistic director from 2002 to 2011, was also the director of *Don Carlos* in my sample. The Donmar's mission under his leadership can be compared with two of the Almeida's stated aims 'to use our unique theatre to stage the best British and international drama, presented to

the highest possible standards in productions which reveal the plays in a new light; to present a varied and challenging programme, including new plays and contemporary opera' (Almeida Theatre Company 2009). Comparing the Donmar and Almeida statements, prominent themes of *new*, *contemporary*, *British*, *European/international*, *opera/musical theatre*, *reappraisals/reveal* ... *in a new light*, and, most significantly, *diverse/varied* suggest that these two theatres have similar aims.

One point of dissimilarity is the appearance of their buildings. The Almeida, shown in Figure 2.5, is housed in an elegant 1837 building listed by English Heritage. Today's theatre company emphasizes the significance of the building's history, stating in its financial accounts that 'the Almeida began life as a literary and scientific society – complete with library, lecture theatre and laboratory. From the beginning, our building existed to investigate the world' (2015: 3). The Donmar, on the other hand, is located in a Victorian warehouse in Covent Garden, barely distinguishable from the adjoining shopping centre, as can be seen from Figure 2.6, although it also has a history as a performance venue, having been used as a studio and rehearsal space since the 1920s, including a period of ownership by the RSC. If the Almeida seeks to convey an alternative approach to theatre-making, a focus on its building and its location outside the West End is reinforced by its affiliate rather than full membership of SOLT.

Even so, the similarities between the Almeida and the Donmar, mentioned above, are noted in theatrical comment, drawing the Almeida back into the inner-London circle. This can be seen informally, for example, in an advertisement aimed at an international theatre audience: 'If you enjoy London's Almeida and Donmar theatres you'll love 59E59 Theaters in New York' (*Financial Times* 2010: 9). It is also stated in formal, academic analyses, such as Aleks Sierz's 2011 review of British theatre, *Rewriting the Nation*. When discussing the development of new writing in the commercial West End, he writes: 'Other London theatres that occasionally contribute to new writing include classy Off-West End boutique theatres, such as the Donmar and the Almeida, although they rarely stage cutting-edge work' (2011: 33–34). In his assertion, Sierz groups the two theatres together and indicates the mix of their programming.

Comparison with another London theatre further illuminates an evaluation of the Almeida's presence in a London grouping. An additional objective stated by the Almeida's trustees, 'to be brave, risk-taking and cutting edge, be it through choice of play, author, director or cast' (Almeida Theatre Company 2005: 1), resembles the Royal Court's desire for risk, but extends the scope of the risk to include director and cast (without restriction to writing). The projection of risk onto wider theatrical areas beyond text is demonstrated by both of the plays from the Almeida which appear in my sample: *Festen*

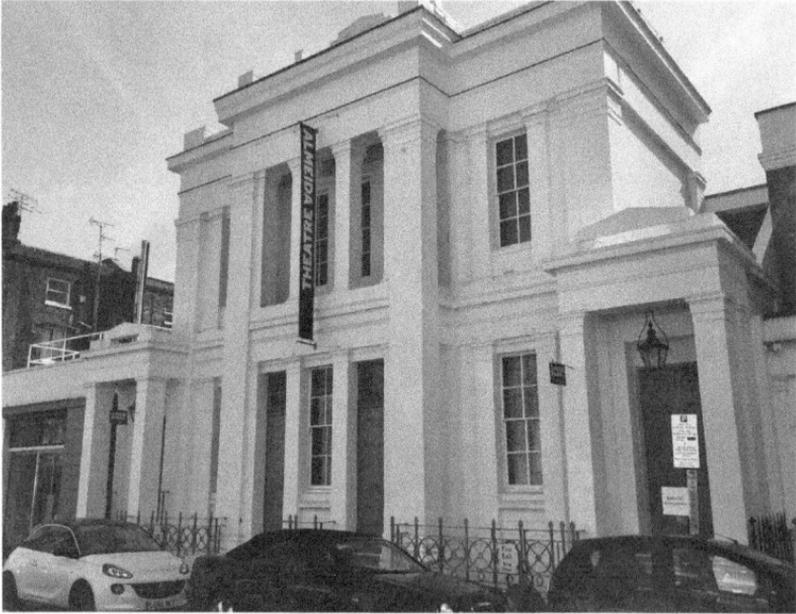

Figure 2.5 The Almeida Theatre, Islington, London. Photograph copyright: Geraldine Brodie (2017)

was developed from a Danish film of the same name, and *Hedda Gabler*, although ostensibly a classic and often-staged text in British theatre, albeit of Norwegian origin, was cast with an uncharacteristically young actor, Eve Best, in the title role. I shall return to these features when discussing the translations in Chapter 3. For now, I merely flag the point that the Almeida's translations reflect the theatre's wider objectives.

A final aim stated on the Almeida's summary information return to the Charity Commission in 2009, and developed in words and figures in its financial accounts, is 'to demonstrate sound financial planning and control'. The 2005 year-end financial statements proclaim with pride that 'the artistic programme and management of the company was delivered to the highest standard and, as importantly, on budget' (2005: 2). At the Almeida in 2005, the Arts Council England grant amounted to 23 per cent (£889,942) of its total income, the remainder coming from ticket sales and other audience income (29%), private fundraising and sponsorship (32%) and further income earned through commercial activities (Almeida Theatre Company 2005: 3, 23). The Almeida therefore has to satisfy a range of supporters that it provides good guardianship of their funds, and it aims to achieve that by careful financial performance. I witnessed one marker of this competence

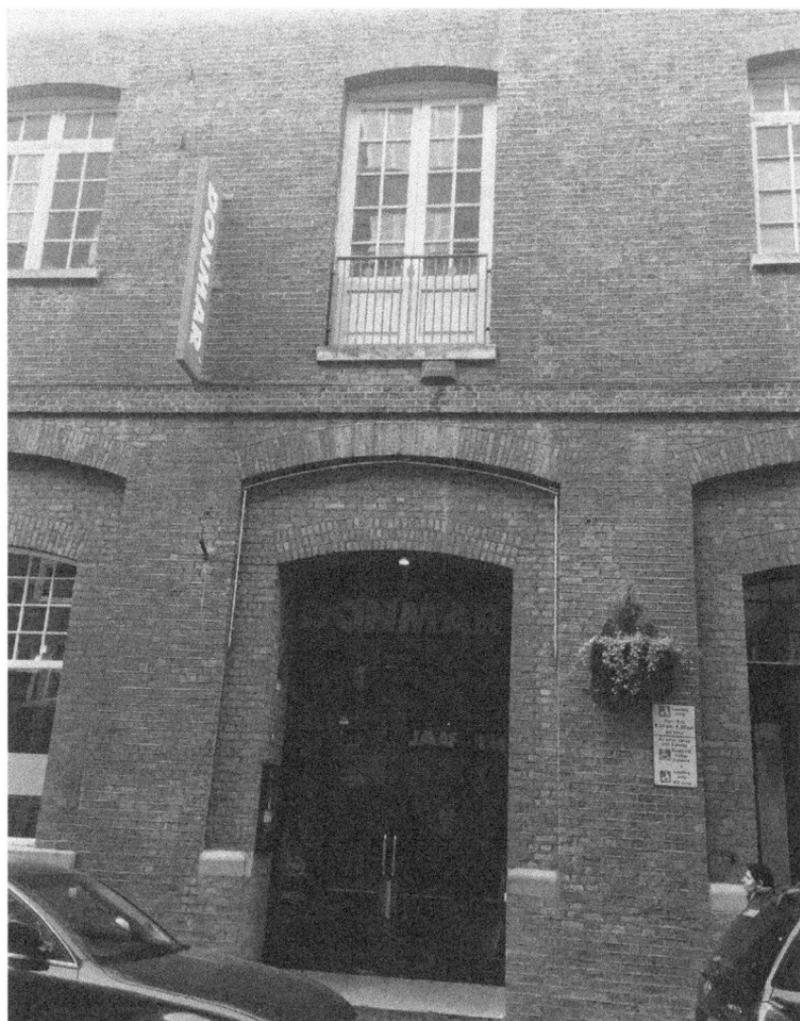

Figure 2.6 The Donmar Theatre, Covent Garden, London. Photograph copyright: Geraldine Brodie (2017)

when walking through its administrative offices (something which in itself is unusual for a visitor to any enterprise) and noting the order of the filing system on the shelves. The artistic associate was able to put her hands quickly on documents she needed to respond to my queries about theatre programming from five years earlier. I learned during my years of auditing a variety of organizations to recognize that good administrative order generally signals a similar approach to financial order. It seems reasonable to

assume that financial elements would have been taken into account along-side artistic considerations in the commissioning and production procedures for the Almeida translations in my sample. For both translations, the theatre was approached with detailed proposals for production, which would allow more accurate budgeting. Furthermore, the moves to West End commercial theatres were financed by independent production companies, relieving the Almeida of increased financial risk. Theatrical decision-making around creative activity must take into account organizational issues – this glimpse of the process at the Almeida Theatre demonstrates how the positioning of a site, geographically and structurally, informs commissioning and programming planning. The remaining theatres to be discussed, unlike the Almeida, are geographically distanced from SOLT. To what extent can their positioning be differentiated from London theatres?

The Royal Shakespeare Company: issues of heritage

Hecuba was shown in London at the Albery Theatre, part of the commercial Delfont Mackintosh group of theatres. However, the new translation and production was commissioned and performed by the RSC. This theatre company is based in Stratford-upon-Avon in Warwickshire, some hundred miles from London's West End and an international tourist attraction as the birthplace of William Shakespeare. The status of the RSC in the UK cultural hierarchy can be seen both in its name, alluding to the dramatist traditionally held in highest esteem in the English-language canon, and also in the level of funding received from Arts Council England. The Arts Council England Annual Review 2005 shows that only five organizations in that year received grants of eight-figure sums, making up 27 per cent (£86.6 million) of the total value of grants awarded (£316,089,653), as shown in Table 2.3.

The RSC is notable in this group not only for receiving the least funding but also for being the only organization based outside the centre of London, although it also occupies a suite of offices in Covent Garden (London's West End) for which it paid rent in the year ended 31 March 2006 of £94,218 (Royal Shakespeare Company 2006: 44).[12] This rent alone is more than three times the Arts Council England grant awarded in 2004 to the Arcola Theatre (£30,750), a disproportionately visible theatre in Hackney, East London, which operates three theatre spaces and

[12] Information extracted from Note 20: *Transactions with connected persons.*

Table 2.3 Top five Arts Council England grants awarded by organization

Organization	Annual ACE grant awarded	Percentage of total grant awarded
Royal Opera House (Covent Garden)	£23,110,841	7
South Bank Board (arts complex)	17,400,525	6
National Theatre	16,390,026	5
English National Opera	16,078,500	5
Royal Shakespeare Company	13,604,560	4
TOTAL	£86,584,452	27
Total grant-in-aid awarded	*£316,089,653*	*100*

Source: 2005 Annual Review Grant-in-Aid Accounts (Arts Council England 2005: 79–94)

also commissions new plays and translations. That the RSC receives public funding of this size, and spends it in this manner, provides some indication of its cultural capital. It also demonstrates the RSC's established London connections.

The existence of the London offices suggests why it is necessary to consider the background to the ethos of the RSC as commissioner when setting this *Hecuba* translation in its context. The literary department, which supervises the commissioning of new plays and translations, is based in London. The creative teams and actors are generally drawn from the London talent pool. Auditions are held in London, and actors from outside London (including the Midland area itself) must travel away from Shakespeare's birthplace to find work there. The RSC always has a London season, although during the period under review it had withdrawn from its purposely designed theatre in the capital at the Barbican Centre. Between 2001 and 2015, the RSC occupied a series of temporary London performance spaces, which I discuss in relation to the *Hecuba* translation in the next chapter. Nevertheless, the level of Arts Council England funding indicates that the RSC holds a similar position in the national cultural estimation as London-based institutions; this and the RSC's regular London administrative and performance presences suggest that the RSC could to some extent be seen as a London theatre company. This would not be unreasonable in the Shakespearean context, as Shakespeare's work was composed and performed principally in London. The advent of the reconstructed Shakespeare's Globe Theatre in the vicinity of its original site on the south bank of the river Thames in 1997, however, has reinforced the imperative for the RSC to differentiate itself as a national rather than London company.

The extent of this achievement can be gleaned from the key facts and figures page on the RSC website, which proclaims that in 2008/9, 'We attracted audiences from 70 different countries to see us in Stratford – but

drew 47% of our audience from the Midlands' (Royal Shakespeare Company 2010a). This gives an indication of the constituency of the theatre's audience – more national and international than local: less than half comes from within the region where the main theatre premises are located. In the event of *Hecuba*, the Stratford opening and subsequent run was cancelled as a result of the illness of the actor in the title role, Vanessa Redgrave. Nevertheless, the production opened in London and went on to its prearranged visits to the United States and Greece, never to appear in Stratford. Therefore, although ostensibly originating away from London, and with an overtly non-London translator (Tony Harrison is based in the North of England both in the subject matter of much of his poetry and in his residence), *Hecuba* ended as a London play, opening to London audiences.

That a company named after Shakespeare should be performing a classical Greek play is in keeping with the RSC's principal objectives, laid down in its Royal Charter, according to its 2009 annual return to the Charity Commission:

> to conserve, advance and disseminate the dramatic heritage of Shakespeare and to advance and improve the dramatic art, both in the United Kingdom and throughout the world ... These objectives are achieved by the production of plays by Shakespeare and by other classic playwrights and by the commissioning and production of new plays. (Royal Shakespeare Company 2010b: 1)

The annual return goes on to stress the importance of ensemble work, not only among its artists but also 'to engage with the world and connect people with Shakespeare through producing bold, progressive work ... and making the Company itself reflect the world we live in'. Furthermore, 'We have a strong commitment to developing new work and bringing writers back into the rehearsal room to work with actors in the way Shakespeare did' (Royal Shakespeare Company 2010b: 2). Tony Harrison's translation of *Hecuba* is in accordance with these objectives. His translation was noted for its deviance from the norms expected in a classic translation: it referred strongly to recent current events, both textually and visually. Tony Harrison was also involved at a later stage as the touring director, and the prompt book bears evidence of the rehearsal room changes made to the text, as I discuss in the next chapter.

The geographical and heritage issues which distinguish the RSC notwithstanding, *Hecuba* bears the hallmarks of a London-based translation. This is not simply because, for operational reasons, it appeared first in London, but more due to the critical and funding treatment of the RSC as a 'national' company, which consequently commissions work fitting comfortably into a

London and international artistic milieu. My eighth play originated even further from London but, as I discuss in the next section, bears some similarities with *Hecuba* in the factors which resulted in its inclusion in my sample.

The Crucible Theatre, Sheffield: London to and fro

Don Carlos received its world premiere at the Crucible Theatre on 22 September 2004, before transferring to the Gielgud Theatre, London, on 28 January 2005. It is the only production in my sample to have been performed outside the capital city prior to opening in London, although it should have been joined in this by *Hecuba*, as detailed above. Even had *Hecuba*'s Stratford-upon-Avon season taken place, *Don Carlos* would still be distinguished among my sample in its genesis from an organization without a London base. Nevertheless, it bears the hallmarks of a 'Londonized' translation, as I shall explain.

Organized culture in England, particularly with reference to theatre, tends to be London-centric. One indication of this is the destination of Arts Council England funding. As shown in Table 2.3, the top four awards in 2005 were made to London-based organizations, representing 23 per cent of the Arts Council England total funding for the year. Given that other London-based organizations are also well-represented among the lower-value awards, it is clear that funding levels serve to reinforce and perpetuate London's cultural power.[13] In contrast to these sums, Sheffield Theatres received £1,298,000 from Arts Council England in the same period (Arts Council England 2005: 91), which amounts to less than half of one per cent of total grants awarded. London's theatrical dominance can be detected beyond financial indications. *The Oxford Companion to Theatre and Performance*, for example, contains entries for the 'National Theatre of Great Britain' (417–18), the 'Royal Shakespeare Company' (523–24) and the 'Shakespeare Memorial Theatre' (551–52), and even the 'Royal Court Theatre' (522–23), but to be informed about the Sheffield Theatres it is necessary to look under 'regional repertory theatres, UK' (498–500), which discusses the development of the repertory movement, and mentions Sheffield in the context of between-the-war repertory and the thrust stage of the Crucible Theatre (Kennedy 2010).

[13] A tentative adjustment of this position was announced as this book was going to press in 2017 when Arts Council England's commitment to invest an additional £170 million outside London between 2018 and 2022, at the expense of the artistic establishments in receipt of the most funding, was greeted with considerable surprise, indicated by newspaper headlines such as '"Big Four" arts bodies face cut to funding in name of diversity' (Singh 2017).

The Cambridge Illustrated History of British Theatre's index displays many mentions of the National Theatre, the RSC and the Royal Court, and even lists the Almeida, but under 'regional theatre' it redirects the reader to 'provincial theatre', a term which, even when this volume was first published in 1994, contains dismissive undertones. None of the given links under this heading provide a reference to Sheffield (Trussler 2000: 403).

The national invisibility of the Sheffield Theatres is fairly extraordinary given that these three theatres grouped on Tudor Square in Sheffield's city centre form the most concentrated theatre area outside London, providing 2,448 seats in total, distributed as Lyric Theatre: 1,068 seats; Crucible Theatre: 980 seats; Studio Theatre: 40 seats. The total number of seats and manner of distribution is not dissimilar to the total of the three theatres at the National Theatre. Furthermore, the Crucible has international brand recognition as the long-term home of the annual World Snooker Championships, although perhaps this fact might cause some blurring of its theatrical position. Accordingly, the Sheffield Theatres, of which the Crucible is a component, proclaim on their website that they are 'one of the country's leading producing theatre venues', commissioning their own productions under the control of an artistic director (Sheffield Theatres 2011). In *State of the Nation*, his review of British theatre since 1945, Michael Billington acknowledges the Sheffield search for excellence when 'under New Labour, regional theatre was released from years of captivity. New money by itself, however, wasn't enough. There needed to be someone imaginative at the helm. And Sheffield Theatres ... showed just what could be done' (2007: 377). Billington singles out the *Don Carlos* production as a symbol of what could be achieved in regional theatre:

> An extraordinary venture: a rare revival of a German classic ... Following rave notices, it packed out the Crucible in 2004 and transferred to the Gielgud in London for a sold-out twelve-week run that could easily have been extended but for the actors' other commitments. The real point, though, was that an austere masterpiece like *Don Carlos*, demanding a cast of fourteen actors, would have been unthinkable in a regional theatre during the previous ten years when retrenchment became a way of life – or even a form of slow death. (2007: 378)

For Billington, then, Sheffield's *Don Carlos* demonstrated what was possible, but extraordinary, outside London: an atypical product from a regional theatre. The associate director of the Sheffield Theatres at the time, and the director responsible for *Don Carlos*, was Michael Grandage. *Don Carlos* opened his final season at the Sheffield Theatres and was his last production in that venue. Grandage had taken up the position of artistic director of the

Donmar Theatre in London in 2002 (Grandage 2017), and had been filling both roles simultaneously, facilitating Sheffield's concurrence with London's artistic sensibilities. According to Billington, Grandage 'enticed Derek Jacobi to Sheffield' in order to appear in two productions (2007: 378). The origins of this production of *Don Carlos* are therefore more closely associated with London than might seem at first sight. The repercussions of this production's success, a proliferation of Schiller translations, took place away from Sheffield and were probably initiated as a result of the successful London run. I contend that *Don Carlos* can be measured as a London production even though it originated in 'provincial theatre'.

Funding and environment

An analysis of site reveals several marked trends in the contextual background of the translations I discuss in this book. First, all eight plays come from theatres which received substantial amounts of funding from Arts Council England, ranging from £893,814 (the Almeida) to £16,390,026 (the National Theatre) in the same period. Second, all plays began in theatres which prioritize commissioning and new writing. Third, all plays were developed in theatres which employ specific personnel to fill the literary management function (this feature is explored more fully in Chapter 4). The second and third points are closely related to the first because commissioning translations and new writing is strengthened by a knowledge base and additional resources, which in turn are likely to require further financial support. Fourth, the commissioning theatres were either members of SOLT, or had strong personnel or geographical links with that organization; of the non-full-members, the Almeida Theatre was affiliated to SOLT and within the geographical boundaries, the RSC has administrative offices in Covent Garden, London, and presents its productions in SOLT theatres, and the Sheffield Theatres shared an artistic director with a full member of SOLT, the Donmar Theatre. Therefore, it could be argued that the West End theatres, which are well-represented in the SOLT organization, and where four of the plays were ultimately staged, while not directly responsible for the commissioning of those productions, are influential, even if subliminally, on their progress and outcome.

As I pointed out earlier in this chapter, the dividing line between subsidized and commercial theatre is more than blurred. This is significant because these two sectors are frequently considered to be oppositional. There is a view that only state-subsidized theatre can be truly creative, untainted by the impediments, described by Caridad Svich, of 'the emphasis on box-office

receipts, entertainment "value", and "marketable content". Svich considers that 'the inordinate pressure to bow down to an economic god' limits the imagination of the artist (2002: 17). The former director of the Leicester Haymarket, Peter Lichtenfels, and academic Lynette Hunter complain that 'there is still resolute sticking to the idea of producer and consumer, with no interaction between the two, which typifies the commercial theatre' (2002: 50–51). They do, however, acknowledge the 'unique hybridity of commercialism and state support that shapes British theatre' (2002: 41). My study demonstrates this interface in progress, as it relates to the creation of translated performance.

Eight Productions and Their Translation Teams

Translation on stage, spring 2005

How does a performance of a translated text communicate the multiciplicity of its pre-translational origins to its audience? A closer examination of these eight plays on the London stage in the spring of 2005 sheds light on the role of the theatre translator as part of a collaborative team engaged in the production of a play that was first written in a different language. In each case, I have sought to retrace the inception of the translation project. For what purpose were the respective translation agents brought together and how do they combine to transmit a targeted narrative? Investigating these several voices and influencers permits a re-examination of how the translated text in its current form, its antecedent translations and the source text itself might amalgamate, and thus the significance of translatorial agents in the performance of translated text. Although it is not possible accurately to identify the motivations of the protagonists of any project, it is possible to draw on contextual and paratextual sources for evidence of the evolution of behind-the-scenes decision-making and extended translation processes which ultimately result in a public product: the performance.

While words are predominantly the domain of the translator, the holistic nature of performance dictates that movement, sound and image also contribute to the impression received by the spectator, a phenomenon studied by Patrice Pavis in his examinations of cross-cultural theatre and mise en scène (1992, 2013). Quantitative inspection of audience reception is notoriously elusive, but, as Paul Prescott points out, there exists 'a community of professional interpreters' in the form of published theatre reviewers. Prescott suggests that such reviews not only present a professional response to a production, but also knowingly influence other theatre-goers, so that 'the review-text stands in and substitutes for the experience of performance, thus blurring the boundaries between performance and criticism, production and reception' (2005: 359). Nevertheless, the very influence of such reviews may dictate to some extent the reaction of other members of the audience while simultaneously reflecting the personal response of the reviewer. Bettina

Göbels, however, raises a further issue with respect to this combination of personal and public reaction: the reviewers 'tend to reflect the general politics and opinions of their respective newspaper' resulting in a 'double reflection of public opinion' from the perspectives of both the writer and the publisher (2008: 13). Nevertheless, the variety or, conversely, homogeneity of reactions from different reviewers at least supplies a mass of observations which can be analysed to form an impression of the range and distribution of opinions.

It is impossible to exclude my own reception. I was in the audience myself for three of the plays (*The House of Bernarda Alba*, *Festen* and *Don Carlos*); the remainder I have viewed or listened to via archive recordings of the productions. Furthermore, when in the audience, my reception of a production has the dual nature of a private spectator and a professional researcher; what Bourdieu (2000: 52) has identified as 'scholastic epistemocentrism' places me inside the research, destabilizing my position as dispassionate observer. I bring my academic background and knowledge to the text, but I also respond instinctively to the performance. Beyond my personal response, as a member of the audience I am aware of the collective reaction around me; equally, studying a recording of a live production presents the opportunity to gauge non-verbal indications of reception such as laughter or applause. In one case, *The Woman Before*, a post-show audience discussion had been recorded in which the self-selecting group of theatre-goers who chose to stay on voiced their opinions of that evening's performance. However, even with such material, any analysis of reception can only be subjective, both in my own reading and in the audience's willingness to display their reaction. Within these limitations, each of the eight following analyses attempts to uncover the processes which brought these eight productions onto the stage, focusing on translation practices, the 'intent' behind the selection of each play and the extent of the reception and recognition of that intent by the audience, revealing a theatre translation dynamic within which the translator plays a central part.

The House of Bernarda Alba: the Hare effect[1]

Federico García Lorca's *The House of Bernarda Alba* was presented as a 'new English version by David Hare' on the proscenium stage of the 890-seat

[1] This section expands on my article '*The House of Bernarda Alba*: Translation as Political Metaphor' in *CTIS Occasional Papers*, 6: 54–66, 2010, and is based substantially on my chapter 'Theatre Translation for Performance: Conflict of Interests, Conflict of Cultures' in Brigid Maher and Rita Wilson (eds) *Words, Images and Performances in Translation*, 63–81, London: Bloomsbury Continuum Publishing, an imprint of Bloomsbury Publishing (2012).

Lyttelton auditorium at the National Theatre from 5 March to 30 July 2005. This is Lorca's last play, written in 1936 shortly before his assassination at the hands of Nationalist elements at the outbreak of the Spanish Civil War. Lorca, identified by Gunilla Anderman as approaching Ibsen and Chekhov in the group of 'honorary British dramatists' (2006: 8), merits a place in the British classic repertoire. Hare, popularly considered 'one of the great post-war British playwrights' (Faber and Faber 2009), and a regular contributor at the National, can be expected to fill seats. This production was also supported by accompanying pre-show performances of lesser-known Lorca works and screenings of Carlos Saura's 1981 film adaptation of Lorca's play *Blood Wedding*, so that enthusiastic followers would have the opportunity to 'immerse' themselves in Lorca's general oeuvre. The most recent Lorca production at the National prior to this run was *Blood Wedding* in a translation by Gwenda Pandolfi at the smaller Cottesloe Theatre thirteen years earlier, in 1991. David Hare, on the other hand, had been represented at the National as writer or adaptor six times in the same period (including twice in 2004, the previous year).[2] Even so, the programming of supplementary Lorca offerings make clear the respect accorded to the original author alongside the presence of one of the most high-profile of contemporary British playwrights. There was no danger of the reviewers failing to mention the fact that this piece was an English version from a Spanish original, or naming the agents responsible. All clearly distinguish between Hare and Lorca, although they remain largely silent as to the third agent in the translation process, the literal translator. Simon Scardifield, an actor and experienced theatre translator from French, German and Spanish, composed the detailed annotated literal translation from which Hare created the final version for performance.

Scardifield is credited in the programme, albeit between the design associate and the research assistant in the smaller print of the second page, and acknowledged by Hare in his adaptor's note to the published text (García Lorca 2005a: vi). In theory, any queries Hare might have in relation to the original text when working on his own drafts could be addressed initially to Scardifield as the language expert. However, it is apparent from the annotations in the (unpublished) literal translation held in the National's archives that the literal translator was at pains to pre-empt such queries by providing substantial linguistic and cultural detail. A comparison of the literal translation and Hare's text suggests to me that Hare had read and was influenced by

2 As playwright: *The Absence of War* (1993), *Skylight* (1995), *Amy's View* (1997), *The Permanent Way* (2004) and *Stuff Happens* (2004). As adaptor: *Mother Courage and Her Children* by Bertolt Brecht (1995).

earlier translations, as, indeed, he acknowledges in his adaptor's note, referencing Tom Stoppard's 1973 English version and Nuria Espert's 1986 production – although Hare does not mention that Espert's production was based on a translation by Robert James Macdonald (García Lorca 2005a: vi).

Scardifield is an experienced translator, with literal and performed translations to his credit. As the author of an expressly commissioned literal translation for Hare, he was well aware of what would be expected of the work he provided. When I discussed the translation process for *The House of Bernarda Alba* with Scardifield, he did not remember being consulted by Hare with additional queries on the translation during Hare's writing process, although he would have been happy to provide such a service.[3] This lack of communication, however, cannot be taken as a measure of Hare's engagement with Scardifield's translation. This annotated translation addresses not only translational but also cultural and staging issues in the text relevant to Hare's London audience. Scardifield clearly sets out his aim in a brief introduction to his translation 'to reflect the original version's interplay of imagination and convention' (García Lorca 2005b: 1). This introduction provides information about the source text preferred by Scardifield (the earlier Losada text performed by Margherita Xirgu in Buenos Aires shortly after Lorca's death) and also discusses the differing nature of the Spanish spoken by Bernarda, 'the tension between its poetry and metaphor, and its blistering bluntness', and the 'small seeds of their rebellion [that] creep into [her daughters'] speech' (García Lorca 2005b: 1). Further to this informative summary, Scardifield provides 227 footnotes throughout the translation, anticipating potential queries and furnishing Hare with a personalized translation resource. Supplied with a literal translation of this quality, Hare would be less in need of further discussions.

Scardifield's extensive knowledge of the source text coupled with his competence in theatrical writing in some ways offers Hare the opportunity to make informed decisions about his adaptation choices, but might also add to the implicit challenge to Hare to differentiate his version from those that had gone before. A comparison of Hare's text with Scardifield's translation demonstrates how Hare draws on this resource alongside his own further research to create his new representation of Lorca's text. One example is the second line of the play, delivered by Bernarda's senior servant–confidante, Poncia, as she prepares for the family to return from the funeral of Bernarda's husband. Table 3.1 sets out Lorca's line with Scardifield's translation and Hare's version.

[3] Simon Scardifield, interview with Geraldine Brodie (London, 30 June 2010).

Table 3.1 Comparison of Poncia's first line in *The House of Bernarda Alba* as conveyed by Federico García Lorca, Simon Scardifield and David Hare

García Lorca (2004: 82)	Llevan ya más de dos horas de gori-gori.
Scardifield (2005b: 2)	They've been wailing [note 6] away for more than two hours. [Note 6: *Gori-gori* is a conventional onomatopoeic rendering of the sung Latin responses at a funeral.]
Hare (2005a: 3)	Two hours already. Ceaseless incantation.

This line was criticized by the Lorca scholar Gwynne Edwards on the basis that 'it is hardly likely' that 'an uneducated and down-to-earth village woman' would use the phrase 'ceaseless incantation' when referring 'disparagingly to the two-hour church service' (2005: 387). Hare flags the strangeness of the onomatopoeic 'gori-gori' with a less colloquial but, in my opinion, intentionally incongruous 'ceaseless incantation' which, when spoken by a servant, maintains the degree of surprise in the original while parodying the formal ecclesiastic language to which it refers.

Edwards is dissatisfied by the 'Englishness' of Hare's adaptation, citing the 'highly polished, educated southern English accents, regardless of the social status of the characters' (2005: 387). The recording of the National production supports his reception. This delivery, however, is representative of Hare's plays in general. His tendency is to level out class distinctions, one example being the transformation of the Soldier and the Prostitute in Arthur Schnitzler's *Reigen (La Ronde)* into the Cab Driver and the Girl in his adaptation *The Blue Room* (Hare 1998). His focus is elsewhere: communicating via middle-class intonation and vocabulary the uncomfortable issues, as he sees them, of contemporary existence. Hare's Poncia conforms to this manner of representation. At home in the impressive surroundings created by the set designer Vicki Mortimer, Poncia's clothing and demeanour portray her more as a middle-class housekeeper than a servant, and her language reflects this presentation. Hare's version corresponds with Lorca's original through the literal translation, but addresses the linguistic challenges in his idiosyncratic manner.

The use of a literal translator is the source of heated disagreement in translation circles, one of the reasons given being the low value in which the literal is held, both financially and in terms of status (as exemplified by the inconsistency of the programme credits). The fact that Scardifield's literal translation was commissioned especially for this production rather than using one of the many existing academic or theatrical texts, denotes its cultural if not monetary value. Hare's indirect translation required a tailored literal

translation, and potential access to the translator. Provided with this linguistic support, Hare was in a position to create a version that spoke in his own voice. These circumstances, however, create a conflict of interests: To what extent should Hare claim authorship of this version in relation to the original playwright and the literal translator? He is unable to consult the author, but the privileged position of Lorca in the canon should make it possible for Hare to present this work as his own reading of Lorca's play without fear of compromising the standing of the original.

Nevertheless, Hare's personal narrative is well-known at the National, to practitioners and audience alike, and his name attached to this translation would act as a pointer to the way in which the work would be presented. Hare's identity is that of an explicitly political playwright; 'I went into the theatre with political aims', he explained in an interview with John Tusa (BBC 2004). In the previous year, 2004, the National had presented two new plays by Hare: *The Permanent Way* provided a critical account of the 1990s privatization of the railway system in the United Kingdom while *Stuff Happens* examined international political developments leading up to the 2003 Iraq War. His interpretation of *The House of Bernarda Alba* as a 'stunningly clear' metaphor for the political situation of its time, still relevant today (García Lorca 2005a: v), enables him to absorb Lorca's work into his curriculum vitae, adding it to Brecht, Chekhov, Pirandello and Schnitzler in his list of adaptations. Thus Lorca and Hare experience a symbiotic relationship, each enhancing the status of the other in the canon for the British audience. The conflicts of culture and interest in this translation are consequently laid out overtly to the onlooker.

Even Hare's legal ownership of the translation is explicitly jointly held: unusually, the published playtext includes a post-publication addendum stating that the copyright is held by 'David Hare and Herederos de Federico García Lorca' (the Lorca family trust) (García Lorca 2005a: v). The standard position is that the copyright for an original is owned by its author while translators may claim rights over their own translation. The shared copyright in this case suggests that the Lorca family exercises an interest in any additions to its intellectual property, and the question arises as to whether this interest extends beyond the legal to artistic decisions. This would act as a reminder to the reader of the text that Lorca is present in the translation itself and not only the original. It may also put Hare on notice that he has a responsibility to Lorca while working on a version that bears his own name. Hare is, however, very aware that he must negotiate the conflict between his own and another voice when reworking a classic text. Discussing his version of Gorky's *Enemies*, he noted that it is important to allow the identity of the original author to be presented (Hare 2006). In a later retrospective analysis

of his work on translated plays, Hare displays his awareness of the linguistic and authorial conflicts in the process, with regard to both the literal translation and the original author:

> When remaking a classic, the adapter aims to judiciously choose which aspects of the literal translation to emphasize and which to downplay … No one tongue perfectly parallels another … For that reason fluency in the original language may well be a huge bonus in theatrical transposition … but it is not essential. My job is to pitch a play so that the resonances intended by the play of words in one tongue seem still to be sparking in an entirely different time and culture. (Hare 2016: 2)

Hare thus stakes a claim for the legitimacy of his own reading of a text in the progression of translation and retranslation.

Hare's view that Lorca's play 'is not at all some timeless, literary version of Spain' (García Lorca 2005a: v) explains his approach, moving away from the usual treatment of the tyrannical mother enclosed with her five daughters in a stifling, black-clad, white-walled environment. He was supported in this by non-verbal nuances from other members of the production team. As Figure 3.1 shows, Mortimer's design was far removed from the customary setting. Bernarda's house, described in a review as 'a handsome Moorish-style mansion, with gilt, lofty ceilings and stained glass' (Hepple 2005), made a comfortable prison for its inhabitants, who were themselves dressed in fashionable and relatively colourful thirties costumes in the second act, even though still supposedly in mourning. Penelope Wilton portrayed Bernarda as a physically fit woman in early middle age, smoking and dancing; Bernarda's trademark stick made only a limited appearance as a weapon, not required as a walking aid. By such means, the production reinterpreted the repressive elements of the play, downplaying the Andalusian *pueblo* surroundings and presenting the characters as women who speak and behave in a way that is recognizable to modern audiences.

While this reading reduces an element of cultural distancing, calling for a more immediate empathy from Hare's audience and echoing the 'universal' appeal lauded by Nicholas Hytner in his 2006 Annual Report (Royal National Theatre 2006: 5), it moved too far for at least one critic, who complained that it 'seems to parachute us into the sexual morality of Cheltenham Ladies College [a traditional girls-only boarding school] as it must have been thirty years ago, rather than into the stifling aridity of conservative Spanish Catholicism at its worst' (May 2005). Gwynne Edwards similarly considers the set 'misconceived' and complains that 'because the production was conceived for a southern English audience, it is likely too that, set in the 1930s, it was somewhat influenced by the bourgeois English plays of that period'

(2005: 384). This reception reveals an unwillingness on the part of some viewers to accept an overt retelling aimed at a modern audience not necessarily familiar with Spanish culture and history; but it also acknowledges the cultural issues arising from translation and indicates that the audience engages with the translation debate. The intervention of Hare, his documentary style of writing and the cumulative effect of his earlier work is significant in its recognition by the critical reviews. In spite of, or perhaps, paradoxically, because of, its overt acknowledgement of an English audience, *The House of Bernarda Alba* is a visible translation differentiating itself from the original, and the conflicts within its translation framework were readily identified by the audience. This can to some extent be attributed to the specific identity of the named translator, David Hare, and the wider theatrical context in which he was operating.

Hare's standing in the theatre in general and the National in particular permit the conjecture that he was a principal participator in devising this translation project. As is usually the case, the commissioning procedure for this production is not transparent, but it is reasonable to assume that an individual with Hare's social capital and reputation would enter negotiations at high levels of management rather than making a first approach through the literary department (since restructured as the 'new work department'), which carries out the research and transactional management for the commissioning and progression of most of the projects at the National. In identifying Hare's production as part of a 're-investigation of great plays that will always be staged for the universal truths that they embody' (Royal National Theatre 2006: 5), Nicholas Hytner presents *The House of Bernarda Alba* as the type of cultural product which can be expected to originate at the National. As such, this 'Hare effect' provides a yardstick against which to measure the remaining plays in my sample. While not claiming it as a typical example of mainstream translation, since the plays I examine within this time frame demonstrate the variety inherent in the translation process, the National *House of Bernarda Alba* represents what audiences might expect when buying a ticket to see a mainstream translated play: a reinvestigation of a classic text by a contemporary writer with a reputation that will chime with some aspect of the original, whether it be the genre, the author, the content or the originating culture. Looking back on this project, Hare confessed, 'I always felt a long way off the pace, grasping hopelessly for a surrealist tone that was beyond my reach' (Hare 2016: 1). This admission demonstrates Hare's awareness of the multivocality of translation: he was not satisfied that his voice could satisfactorily coexist with the presence of Lorca within the text. In my opinion, Hare is overly self-critical. This production was by no means a surrealist

Figure 3.1 *The House of Bernarda Alba* by Federico García Lorca in a new version by David Hare. Set designed by Vicki Mortimer; Royal National Theatre, 2005. Photograph copyright: Catherine Ashmore

rendering of the text; it nevertheless presented Lorca's play from an overtly political perspective, inviting the audience to respond accordingly. Hare's distinctively personal authorial style, applied shortly before the copyright period was due to end, heralded a new wave of approaches to *The House of Bernarda Alba*, investigating oppression through the prism of mother–daughter conflict in a range of political and social contexts from Glasgow to Iran.[4] The 'Hare effect' demonstrates the potential of translation in retelling texts for new audiences.

The UN Inspector: distance and freedom

Produced in the largest of the three theatres at the National, the Olivier, *The UN Inspector* was advertised as a 'free adaptation of *The Government Inspector* by Nikolai Gogol'. David Farr, at the time the artistic director of the Lyric Theatre Hammersmith, directed his own adaptation from a literal translation

[4] The Citizens Theatre, Glasgow, production of *The House of Bernarda Alba* in 2009, set in contemporary Glasgow, used a revised text by Rona Munro of her 1999 version for Shared Experience Theatre Company. The Almeida Theatre presented a version of the play set in Iran in 2012, using Emily Mann's revised version of her 1999 text. Mann discusses her revision process in 'Multiple Roles and Shifting Translations' (2017: 263–75).

by Charlotte Pyke, an actor and Russian translator. The genesis of this project is unclear. According to the Stagework website,[5] the playwright Patrick Marber suggested, at a regular planning meeting of the 'NT Associates', putting on a modernized production of *The Government Inspector*. Then David Farr, 'after throwing the idea around and suggesting it to different directors... decided to take on the dual role of both director and adapter' (Stagework 2005). Patrick Marber's involvement in programme planning demonstrates the breadth of experience and ideas drawn upon by an artistic director (in this case, Nicholas Hytner). The associate directors listed in the National's financial statements for 2003/4 and 2004/5 (the possible periods in question) were Howard Davies and Tom Morris, but a further list of around sixteen 'NT Associates' indicates where Hytner might look for advice: high-profile theatre practitioners from a variety of roles.

As far as the idea of updating *The Government Inspector* is concerned, Patrick Marber, a writer, actor and director who started working in television and radio, turning to theatre later in his career, could be expected to provide inventive guidance. His play *Closer* (1997), subsequently made into a Hollywood film starring Julia Roberts, is described by Michael Billington as making the 'wittiest use' so far of new technology, recognizing its 'tremendous dramaturgical possibilities' (2007: 409). The play achieves this by including a scene in which two of the characters engage in obscene and mendacious chatroom conversation in real time, shown to the audience by means of a large back-projection. The use of multimedia technology in theatre is now commonplace, but Marber's early integration of digital effects into theatrical narrative demonstrates his innovative theatre-making.

David Farr has a similar reputation for taking a fresh approach to the traditional repertoire, having written such adaptations as *Crime and Punishment in Dalston* (2002 at the Arcola Theatre), another link with Marber, whose *Don Juan in Soho* was presented at the Donmar Theatre in 2006. This latter production is an additional example of the extension of the National Theatre network across London theatres: Marber's literal translation of Molière's text was supplied by Simon Scardifield, this time working from French. Farr's and Marber's adaptations are overt updatings and localizations of classic and well-known literary works. *The UN Inspector* expands this genre. Its title, accompanied in promotional material by the rubric 'freely adapted from *The*

5 A website commissioned by Culture Online, part of the Department for Culture, Media and Sport and produced in conjunction with the National Theatre. Culture Online is now available as a limited selection of snapshots in the UK Government Web Archive, part of the National Archive. The last snapshot, taken on 3 July 2009, can be seen at http://webarchive.nationalarchives.gov.uk/20090703120012/http://www.cultureonline.gov.uk/index.html.

Government Inspector by Nikolai Gogol', makes clear to the ticket-purchaser that they will be viewing a modernized version reflecting current events, but can nevertheless expect to identify the original.

Marber may have identifiable points of similarity with Farr, underlying his involvement with the development of the project, but his role is hazy. The education pack for *The UN Inspector*, written by Hanna Berrigan for the NT Education department, attributes the inspiration for the updated play to a different source, crediting the artistic director, Nicholas Hytner: 'Having seen David Farr's highly-successful adaptation of Dostoyevsky's Russian classic novel *Crime and Punishment*, he asked David to think about weapons inspections in the Middle East as the subject of a new version of Gogol's play' (Berrigan 2005: 5). The fact that alternative versions are available of how the project took shape points to team involvement in a translation project. Ideas are discussed, passed around and evolve in the process, so much so that the shape they eventually form can scarcely be credited to any one individual.

The finished adaptation (Figure 3.2) is in fact not set in the Middle East, but in an unnamed former Soviet republic, thus maintaining a Russian intertextuality. The bogus inspector is believed to have been sent by the United Nations, commissioned to investigate the use of international funding in the new country. The accompanying theatre programme includes an essay on the Orange Revolution (in the Ukraine), by Timothy Garton Ash and Timothy Snyder, reprinted from the *New York Review of Books*, and the published text dedicates the play 'to the memory of the anti-government journalist Georgi Gongadze whose headless body was found in the year 2000 in the Ukraine' (Farr 2005: np). The transfer of the setting from a remote Russian provincial town to somewhere not dissimilar from the Ukraine is not as distant as the move to the Arabian Gulf, which Hytner originally suggested, and therefore retains a geographic resemblance to the original – as indeed to Gogol, the original author himself, who was born in the Ukraine. Most of the characters' names are also maintained in a simplified form, the most notable exception being that of the counterfeit inspector, Ivan Alexandrovich Khlestakov, according to Pyke's literal translation. He becomes Martin Gammon in Farr's version. As Pyke explains in her translator's notes, the connotations of the Russian name are 'whipping, beating, slapping, gurgling and pouring (. . . obviously it is a soundscape ... perhaps this points at prattling)' (Gogol 2005: np). To convert this 'prattling' to Gammon, with its connotations of 'ham' (which might be understood, particularly in the theatre, as 'overacting', 'declamatory' or 'fake') is again not moving so far from the original when the name of this key character is required to give some kind of indication of his motivation. Furthermore, it appears from the Stagework web pages that an early name for this character was Michael Remmington Gammon

(Stagework 2006). This preserves, in a manner, the Slavonic adoption of three names, but also may refer to a 1980s US television character, Remington Steele, a charming rogue impersonating a fictitious detective. These are two examples which show that a 'free' adaptation's movement away from the original may be limited.

Indeed, the translation of proper nouns in respect of Gogol's original has been loosely interpreted ever since the first translation, as can be seen from the title itself. Early translations transposed the Russian into English as *The Inspector-General* and *The Inspector*, although the work is now best known as *The Government Inspector*. The Russian title, *Ревизор* (*Revizor*), translates as *auditor*, a term still used in modern English to denote an appropriately qualified individual appointed to examine books and records for external verification. Arguably, this title would be more expressive today than the more archaic term of *Inspector*, which has Victorian associations, particularly when coupled to *Government*. The title *The UN Inspector*, then, is hardly a radical translation, switching *Government* to *UN*, and referring back to the accepted English title with *Inspector*. Although billed as a 'free' adaptation, this version does not appear significantly more 'free' than other translations (including some of those discussed in this chapter). This appellation may be appropriate to signal the inclusion of a subplot concerning a murdered journalist, which did not appear in the original but could be argued to be commensurate updating, providing a 'back-story' to contextualize the invasion of the townspeople (now 'activists') towards the end of the play.

A comparison between the published playtext and Pyke's translation reveals that departures from the literal translation owe more to modernization than to appropriation. For example, Osip's opening speech of Act Two, bemoaning his hunger, commences in Pyke's translation: 'The devil take it, I'm so desperately hungry, my stomach is rumbling so much it feels like a whole regiment has just started blowing their trumpets in there' (Gogol 2005: np). Farr's character, Sammy, wails: 'Christ I'm hungry. [I am utterly famished.][6] It's like the Iraq war is taking place in my stomach' (2005: 23). In this case, the imagery has been retained but updated. However, where an image retains its immediacy, Farr appears to respect his source, such as at the beginning of the play when his President describes a nightmare: 'I knew something was up. I had a dream last night. There were these rats, giant blue rats, sniffing round my sleeping body, sniffing, sniffing' (2005: 4). This adheres closely to Pyke's interpretation: 'It's as if I had a presentiment. Last night I had a dream about two extraordinary rats. Seriously, I have never seen rats like them – black and enormous. They came in, sniffed around a bit, and

6 This line was cut in performance.

Figure 3.2 Michael Sheen as Martin Gammon in *The UN Inspector* by David Farr, freely adapted from *The Government Inspector* by Nikolai Gogol; Royal National Theatre, 2005. Photograph copyright: Manuel Harlan

then disappeared' (Gogol 2005: np). A subsequent version of Pyke's translation by David Harrower for Warwick Arts Centre and the Young Vic in 2011 conveys the lines as follows: 'Two black rats. A premonition I had last night. I dreamt about two black rats – massive rats – *monsters*. Never seen rats that size' (Gogol 2011: 5). Harrower's version was not described as 'free', but his variations from the literal when compared with Farr's display similar propensities of omission and sentence reduction while retaining the core image. It is debateable whether a 'free' adaptation can be measured in any dispassionate sense. However, describing a play as 'freely adapted' enables the adaptor to assert his rights as original author while referring to a canonical text. This may be another example of marketing technique to generate recognition in the widest possible audience, but it also provides an illustration of the power struggle inherent in translation.

When evaluating the incidence of the 'freedom' of the translation, it should be taken into account that *The Government Inspector* has historically been the subject of wide-ranging interpretation, even in its original language. In a much-referenced production by Vsevolod Meyerhold in 1926, the play was used to demonstrate 'the director as interpreter and orchestrator of both the mise en scène and the text with a confidence that caused shockwaves', according to Paul Allain and Jen Harvie: 'Critics balked at [Meyerhold's] heavily altered adaptation of the play, which he divided into fifteen episodes

and interpolated with lines from other works by Gogol' (2006: 96). It is thus in the tradition of this particular text to play around with the structure and to interpolate items which a theatre practitioner deems appropriate. On closer examination, therefore, it seems that Farr is more respectful of the piece's history than would at first appear, and is in fact following in the footsteps of Meyerhold, 'placing the onus of interpretation on himself as auteur rather than on the writer' (Allain and Harvie 2006: 96). This is not an unusual operation in the field of theatre translation, as can be seen from most instances in this chapter. Farr's presence as translator *and* director allows him to take control over decisions concerning both translation and staging elements, but in combining the two roles, Farr demonstrates an activity which in other cases takes place collaboratively between two and more individuals.

What of the role played by the literal translator, Charlotte Pyke? Even though the programme is explicit in its identification of the play as a reworking of the original ('freely adapted'), it does not mention the translated source of the adaptation or the name of the literal translator. Nor is any reference made in the published text (copyright David Farr), even though a page is taken to dedicate the play to Georgi Gongadze and to thank eleven contributors, including Patrick Marber, Nicholas Hytner and Nikolai Gogol. The education pack similarly omits reference to a literal translator, even though it includes a section on 'Adapting Gogol' (Berrigan 2005: 5). However, the National's website page for *The UN Inspector* commences with the words: 'Freely adapted from Gogol's *The Government Inspector* by David Farr. From a literal translation by Charlotte Pyke' (Royal National Theatre 2005). I have not seen Pyke's collaboration acknowledged elsewhere by the National or David Farr. In our interview, she explained the website reference as a late addition at her specific request.[7] She acknowledged that this was her first literal translation and she therefore did not have the experience to insist on recognition, but that, on subsequently discovering that her involvement was not credited, she had contacted the literary department requesting identification. Her name was then added to the production's website page. The online catalogue for the National Theatre Archive, however, does not list Pyke among the creative roles for the production, and a search on Pyke within the catalogue credits her with two acting roles and two literal translations: Maxim Gorky's *Philistines* in 2007 (in which she also played the role of a passer-by – a rare example of the translator actually performing on stage) and Mikhail Bulgakov's *The White Guard* in 2010. This suggests that failure to acknowledge the literal translator does not stem from unwillingness but rather from a lack of protocol running through theatre as a whole, although

[7] Charlotte Pyke, interview with Geraldine Brodie (London, 14 July 2010).

it does also point to a pervasive overlooking of the literal translation and its creator.

As the archive catalogue records, Charlotte Pyke has gone on to produce further literal translations, some of which have been substantially acknowledged. The credits page of the Almeida programme for *Enemies*, for example, is headed: 'ENEMIES (large print) / By Maxim Gorky / A New Version By David Hare (medium print) / From a literal translation by Charlotte Pyke (smaller print)' (Almeida Theatre 2006: np) before listing the remaining cast and creative credits. The programme also includes a biography and photograph of Pyke, on the same page as the sound, casting and assistant directors, facing the page for adaptation, director, designer and lighting. This treatment indicates the different conduct that can be accorded to literal translations. It also demonstrates Pyke's increasing confidence and awareness as a translator.

Pyke's presence in her literal translation of *The Government Inspector* is mostly unremarkable, with relatively few footnotes and comments. As Scardifield noted, the literal translation is often the translator's only opportunity to communicate with the indirect translator (or, indeed, communicate with anyone, as the literary manager, the indirect translator and the director are the only people likely to read the literal translation). Scardifield's literal translation was therefore heavily footnoted and prefaced, in a format reminiscent of the annotated translations prepared by academics and students in university language and translation departments. The literal translations prepared by Helen Rapapport bear similar characteristics, which I discuss in further detail in my study of David Hare's and Martin Crimp's uses of her literal translation of Anton Chekhov's *The Seagull* (Brodie 2018, forthcoming). This academic-style format should not be taken to suggest that theatrical literal translation is interchangeable with academic translation. Scardifield and Rappaport both produce translations of a high scholarly standard, but both also trained as actors, like Pyke, and their translations are targeted for a theatre-specialist writer. Pyke's translation displays a similar awareness of its user; footnotes are limited but additional information is provided in the form of endnotes. Furthermore, in the last long speech of the Governor, during which he shouts, 'What are you laughing at? You are laughing at yourselves! You are laughing at yourselves!' she interpolates (in red): 'These lines are the most famous in the play and are usually spoken to the audience'. Pyke considered this intervention essential because this moment is 'what the play is all about, it goes a long way to explaining the humour of the play'.[8] The lines are maintained in the final version, with a contraction from 'you are' to 'you're' and the video recording shows that they are spoken to the audience, who

[8] Charlotte Pyke, interview with Geraldine Brodie (London, 14 July 2010).

laugh. Pyke's observation is hardly ground-breaking: this is one of the most famous lines in theatre history. But for this very reason, it would have been a serious omission not to have made this point, and it is key to the theatrical presentation of the text.

The UN Inspector differs from *The House of Bernarda Alba* in claiming to be a free adaptation rather than a version, thus suggesting a greater distance from the original. Both productions, however, resemble each other in prominently advertising their indirect translators, whose signature styles resonate through the translated text. Both productions move visually away from their originals – *The UN Inspector* is in modern dress and design, although located vaguely in the same region as the original. *The House of Bernarda Alba* is set in the same period as its original but in a very different environment from the norm. In spite of their translation classifications, *The House of Bernarda Alba* could be seen as a more radical translation, since it moves further in appearance and acting style from traditionally accepted presentations whereas *The UN Inspector* has a history of and reputation for adaptability. Even so, *The House of Bernarda Alba* is more representative of what the National tended to present as translation at the time. The play was somewhat warily reviewed, whereas the notices for *The UN Inspector* were distinctly warmer[9] and the archive recording provides evidence of frequent laughter from the audience at appropriate moments. Nevertheless, it is *The House of Bernarda Alba* which is singled out by Hytner for praise in his annual report, whereas *The UN Inspector* goes unmentioned. Is a trend in translation approaches discernible? A third production with a National background supplies further material for examination.

Hedda Gabler: the director's cut

The former National artistic director Richard Eyre adapted and directed *Hedda Gabler* for the Almeida Theatre, with a subsequent West End run at the Duke of York's Theatre. The play was advertised as a version, and the literal translators Karin and Ann Bamborough are credited in the Almeida projects pack and the published translation. The projects pack states: 'Aware that he was already working at one remove linguistically, [Eyre's] intention was to find out what the characters would say in English … and to copy as far as possible the original cadences of their voices by referring to the

[9] Of the nineteen reviews collected in *Theatre Record*, six were largely positive and twelve were not entirely convinced by the adaptation but praised the direction and performances, particularly that of the actor in the title role, Michael Sheen; only one (Lloyd Evans in the *Spectator*) was disappointed (Shuttleworth 2005b: 816–21).

Norwegian original' (Manson Jones, Dickenson and Ingham 2005: 16). It does not say how he achieved this. Recognizing a 'Norwegian original' in itself raises issues of identity. Erika Fischer-Lichte points out that the Norwegian language only became official in 1905, so that in some way, 'Ibsen's plays [the last of which was written in 1899] are all translations. There is no "original" text' (2011: 5). But Ibsen's engagement with translation is not restricted to Scandinavian language divergences. Even as he was composing *Hedda Gabler* in 1890, Ibsen was already planning the consequences of its translation into German, writing to his publisher, Philipp Reclam, 'May I ask you at some convenient time to get your translator to write to me with reference to a number of alterations which I think are desirable for a German public' (Ibsen 1966: 500)?[10] Not unlike *The Government Inspector*, *Hedda Gabler* has a background of instability which, when subjected to interrogation, can impede any claims to 'faithfulness' or, indeed, distance.

According to the Ibsen repertoire database hosted by the National Library of Norway, the first performance in English of *Hedda Gabler* was at the Vaudeville Theatre, London on 20 April 1891, the same year of the play's first production (January 1891).The play premiered in German translation; it was not staged in Norwegian until later that year, in June, for two performances only (National Library of Norway 2014). Even these few facts demonstrate the significance of translation in the history of this play. When considering the translation of *Hedda Gabler* into English, the role of the translator becomes unusually controversial in the transmission of the play to English-speaking audiences, although generally overlooked in popular summaries and histories. From the earliest appearances of Ibsen's work in English, two translators, Edmund Gosse and William Archer, were associated with the project. Their relationship was publicly combative, and this was particularly evident in the staging of *Hedda Gabler*. Elizabeth Robins, an American actor based in London, conducted negotiations with Gosse, Archer and William Heinemann, Ibsen's agent in London, in an attempt to obtain the rights to stage a production in a workable translation. According to Eric Samuelsen, 'Robins had a rudimentary knowledge of Norwegian from her mother, and had begun to translate the play herself. She soon came to realize that her Norwegian was inadequate, but in working with the role, she began to see how it might be approached from an acting perspective' (Samuelsen, Cheng-yu and Smith 1992: 9). These early details indicate that the playability of a translation, along with

[10] Letter written in German on 2 December 1890, translated by James Walter McFarlane in *The Oxford Ibsen*, Volume VII.

copyright and ownership issues, has been a feature of *Hedda Gabler* productions in English from the outset. Indeed, the intrinsic theatricality of translating *Hedda Gabler* is underlined by Maria Irene Fornes's 1998 play, *The Summer in Gossensass*, an imagined reconstruction of Robins's discovery of Ibsen and her interpretation of his play (2008). As a Cuban-born playwright and director who also translates plays, Fornes's career represents a long and productive engagement with processes of translation and linguistic transposition, endowing her with a well-informed view of Robins's potential processes. In creating his version, Eyre adopts a similar approach as a theatre practitioner, aiming to give his impression of how Norwegian should be conveyed in English while controlling the translation for his own staging.

The choice of *Hedda Gabler* as a play for production at the Almeida is itself telling in any analysis of theatrical power relations. Ibsen's status in the English-language canon is such that 'it is not always remembered that Ibsen's work is only known in English through the mediation of translation' (Anderman 2006: 8). *Hedda Gabler* is a well-known occupant of the traditional theatrical repertory, particularly popular as a vehicle for more mature actresses. The Ibsen repertoire database maintained by the National Library of Norway records that there were 484 productions of this play in English between 20 April 1891 and 17 March 2014,[11] forty-seven of which were performed in London. Robert Tanitch's review of West End productions in the twentieth century includes seventeen entries for *Hedda Gabler* in its index, fewer than *Hamlet* (forty-eight entries) but more than other plays featuring regularly in the canonical repertoire, such as *Antony and Cleopatra* (thirteen entries) or Oscar Wilde's *The Importance of Being Earnest* (fifteen entries) (2007: 323–26). This indicates the continuing popularity of this work for theatre practitioners and audiences alike. *Hedda Gabler*'s status is assured and an audience attending a new production such as Eyre's at the Almeida could be expected to hold a preconceived notion of what they would see on stage.

Why, then, would Sir Richard Eyre, former Artistic Director of the National, take such an established play to the Almeida, the home of 'bold and adventurous play choices' (Almeida Theatre 2010b)? I raised this question with Jenny Worton, artistic associate at the Almeida from 2005. As she was not a member of the Almeida team at the time of the decision to stage Eyre's *Hedda Gabler*, Worten was only able to surmise, according to her general knowledge of commissioning processes, that Eyre may have wished to signal a difference in his production of the play by casting Eve

[11] 17 March 2014 was the most recent update when the database was accessed on 25 March 2017.

Best as Hedda.[12] In her early thirties at the time of casting, Best was considered to be a 'young' Hedda. Actors who had previously played the role in their forties include Harriet Walter at Chichester Festival Theatre in 1996 and Geraldine James at Manchester Royal Exchange in 1993. However, both Janet Suzman (Duke of York's, 1977) and Juliet Stevenson (National Theatre, 1989) had played the role in their thirties, suggesting that Best was not such a controversial choice. Perhaps, though, this casting choice indicates a trend towards a younger actor in the role of Hedda, since witnessed, as I discuss later, in the productions of Thomas Ostermeier (2005) and Ivo van Hove (2016).

In fact, Eyre was the artistic director of the National in 1989 when *Hedda Gabler* was performed there – with Stevenson in the title role – and noted in his diary:

> Howard [Davies]'s production of *Hedda Gabler* has opened in the Olivier. It raises the old questions of how to use that theatre and how to do the classics. The auditorium forces Howard into an expressionistic design and the actors are pulling in the other direction. (2004: 62)

This earlier version was by Christopher Hampton, a well-established theatre translator (directly from French), later responsible for the Royal Court's version of Chekhov's *The Seagull*. Robert Tanitch amplifies Eyre's doubts around the National production, noting that the 'absurdly large set with sweeping staircase, sweeping chimney (to belch out smoke when the manuscript is burnt) and a conservatoire (with glass to be shattered by bullet) was designed to fill the Olivier stage, but architecturally it didn't make sense' (2007: 264). This detail provides a further impression of National staging requirements: a play that has to fill the auditorium of the larger theatres also has to fill the stage. *Hedda Gabler*, one of the most popular classics in the British repertoire, would be expected to sell well, which may have been a contributory factor for its programming into the largest theatre. The open-stage amphitheatre of the Olivier is described by Hytner in his online tour of the National as a suitable place for 'big debate plays, big state-of-the-nation plays, big plays about society' (Royal National Theatre 2011a). This depiction explains why *The UN Inspector*, as a critique of contemporary international behaviour, might sit well in the Olivier, but *Hedda Gabler*, a domestic drama set within the confined space of a drawing room, might not look so comfortable. Eyre's desire to reapproach *Hedda Gabler* in more intimate surroundings (Figure 3.3) differentiated it from a big-budget National production.

[12] Jenny Worton, interview with Geraldine Brodie (London, 22 June 2010).

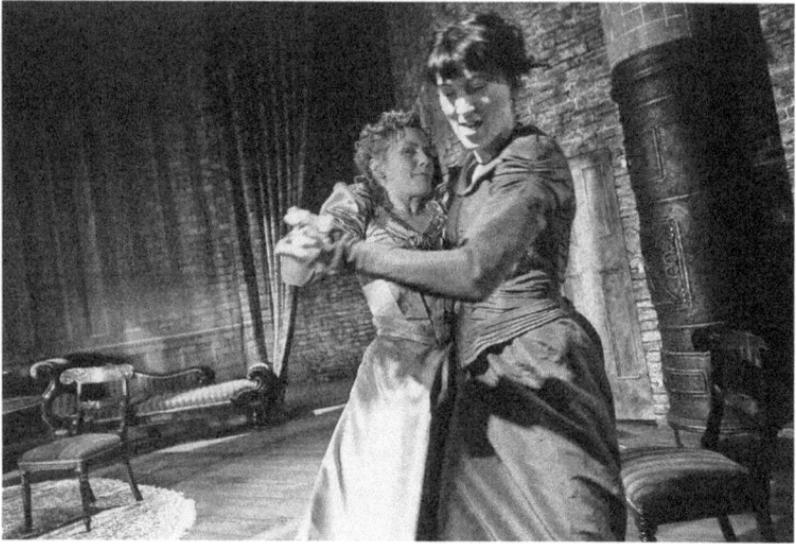

Figure 3.3 *Hedda Gabler* by Henrik Ibsen in a new version by Richard Eyre; Eve Best (right) as Hedda Tesman and Lisa Dillon (left) as Thea Elvsted; Almeida Theatre 2005. Photograph copyright: Geraint Lewis

Site apart, Worton's instincts as to the importance of the actor in the Hedda role are supported by additional evidence. Tanitch complains about the National *Hedda Gabler* production: 'Hedda was so rude and unpleasant that it was inconceivable that Tesman was not regretting the marriage as much as she was' (2007: 264). Nevertheless, Juliet Stevenson in the role was probably the actor most associated with the part at the time that Eyre was planning his version; Stevenson replayed the role in a recording for Naxos AudioBooks in 2002, in the translation by Gosse and Archer. This addition to the Classic Drama series, likely to be used for teaching and personal study purposes, illustrates Stevenson's occupation of Hedda. Indeed, on my own visit to see Thomas Ostermeier's touring production of *Hedda Gabler* in German at London's Barbican Theatre in 2008, I saw Stevenson in the audience, engaged in intense discussion with her companions after the performance. On that occasion, Hedda was played in very youthful style by Katharina Schüttler, who had been only 27 when winning an award for her portrayal in 2006. Ostermeier's reading of the play, in a contemporary set, using a laptop in place of the manuscript (Figure 3.4) and with a subverted delivery of the famous last line of the play, 'People don't do such things', was markedly different from the respectful approaches to which the English-speaking audience is accustomed.

Figure 3.4 Katharina Schüttler as Hedda Tesman in *Hedda Gabler* by Henrik Ibsen, translated into German by Hinrich Schmidt-Henkel. Directed by Thomas Ostermeier; Schaubühne Theater, Berlin, 2006. Photograph copyright: Arno Declair

It seems to me that Eyre wished to improve on the earlier National version by producing a more low-key staging using an actor who had been critically very well-received in a relatively short space of time.[13] The age of the actor in relation to the character (29, according to Ibsen) was less material than the association of being 'new'. However, viewed with the hindsight of the Ostermeier reading, Eyre was continuing very much in the mould of 'traditional' Ibsen stagings rather than offering the type of 'bold and adventurous production' which the Almeida seeks to stage. Or perhaps an Ostermeier reading was considered unacceptable to the mainstream London audience of the time. Although seen regularly in London, Ostermeier's productions are usually staged at the Barbican Theatre to audiences noted for being made up of a significant number of theatre and academic professionals. Nevertheless, Eyre has since then gone on to direct another highly successful production of Ibsen's *Ghosts* in his own version, also at the Almeida in 2013, which took a similar approach to staging. The sell-out 2016 National Theatre production

[13] Best was awarded the London Critics Circle Theatre Award for Most Promising Newcomer and the London *Evening Standard* Theatre Award for Best Newcomer for her performance in *'Tis Pity She's a Whore* (Young Vic) in 1999, and the London Critics Circle Theatre Award for Best Actress for her performance in *Mourning Becomes Electra* (National Theatre) in 2003.

of *Hedda Gabler*, on the other hand, in a new version by Patrick Marber (Ibsen 2016), offered Ivo van Hove's hyper-modern, stylized reworking of the play in which Hedda was portrayed as a victim of sexual abuse and bullying. It seems that there continues to be an appetite for a variety of readings with a growing acceptance of radical interpretations.

Eyre himself writes in the introduction to his published translation of *Hedda Gabler* that he took 'the synchronicity' of reading an article about a 'rich posh young woman' who proclaimed that she had 'a great talent for boredom' and watching a production including Best, 'who seemed born to play Hedda', as 'a sign that I should do the play and got myself commissioned by Robert Fox and by Michael Attenborough at the Almeida Theatre to do a new translation' (Ibsen 2005: 8). I take this to mean not that Best is blatantly rich, posh, young and bored but that Eyre aimed to present a revised reading consistent with current fashions. The statement is revealing in that it suggests that Eyre's plan for the production was presented fully formed to both the artistic director of the Almeida and the commercial producer who took the play to the West End. Eyre had play, translator, director and key actor in place with little left for the decision-makers to do other than reply positively or negatively. This is the prerogative of Eyre's position as a central figure of power (connected to the National Theatre, a further repository of power) within the cultural field of theatre and theatre translation.

Thus Eyre was able to write his version unencumbered by commissioning briefs from other theatre practitioners. He was translating from a position of strength. Does that manifest itself in the translation? The literal translators, Karin and Ann Bamborough, are credited, even though their literal translation was already in existence (produced for the earlier production at the National), but Karin Bamborough was not involved in the transition from literal to final version.[14] Eyre refers to the use of a literal translation again in his introduction:

> It can't properly be called a 'translation' because I speak not a word of Norwegian. I worked from a literal version by Karin and Ann Bamborough, and I tried to animate the language in a way that felt as true as possible to what I understood from them to be the author's intentions – even to the point of trying to capture cadences that I could at least infer from the Norwegian original. (Ibsen 2005: 9)

This suggests that Eyre looked at the original Norwegian. He has some experience of language work, having studied Russian at school, and so it may well be that, similar to the approach described to me by other practitioners such

[14] Karin Bamborough, interview with Geraldine Brodie (London, 8 February 2011).

as Ramin Gray and Mike Poulton, he looks at the pattern and sequences of the original language on the page and tries to replicate them in his own writing. How this affects the authenticity of the translation is an area for debate. Eyre, however, recognizes that the creation of a translation necessitates the making of choices: 'The choices we make are made according to taste, to the times we live in and how we view the world. All choices are choices of meaning, of intention' (Ibsen 2005: 9). It is a short step from this statement to Theo Hermans's view that translation 'has an evaluative attitude built into it … While translators may disclaim responsibility for the re-enactment of someone else's discourse in the form of direct speech, they can be held accountable for the diegetic aspect of their mimesis. The decision to translate, the presentation of the enactment and the value judgements that inform the performance are theirs' (2007: 85). Eyre makes it clear that he takes on this responsibility: 'What I have written is a "version" or "adaptation" or "interpretation" of Ibsen's play, but I hope that it comes close to squaring the circle of being close to what Ibsen intended while seeming spontaneous to an audience of today' (Ibsen 2005: 9). Eyre is aware that his own voice speaks through his translation.

The production was very well received, winning four Olivier awards in 2006 (Best Revival, Best Actress, Best Director, Best Set Design) and two further nominations. The reviewers acknowledged Eyre's role as director and translator, often using the terms 'version' and 'adaptation'. An overt example of a review understanding the projection of Eyre's voice through both direction and script can be seen in Toby Young's piece for the *Spectator*: 'Eyre has tweaked the part (he's credited as the author of this version) … In Eyre's interpretation [Hedda's] boredom and dissipation are depicted as the inevitable by-products of a corrupt ruling class' (2005: 702). But Adrian Hamilton in the *Independent* complained that such versions take the play 'a good stage further from the author's intentions … Richard Eyre's *Hedda Gabler* anglicises Hedda into a sort of wayward Mitford girl … At bottom it's a form of cultural imperialism' (2005: 406). Hamilton resents the use of the medium of translation to 'interpret' a work in a foreign language, although he apparently considers himself qualified to identify Ibsen's 'intentions'. As the other translations in my sample show, interpretation takes place whether or not the translator is familiar with the original language. Indeed, when can interpretation ever be absent?

This *Hedda Gabler* shares several features with the preceding translations I have discussed. All are imbued with the ethos of the National Theatre, even if, in Eyre's case, it is to some extent a reaction against those theatrical exigencies. All have been indirectly translated, and in two cases directed, by high-profile writer/directors who are steeped in the conventional English

theatre tradition. All were developed from literal translations created by English-speaking theatre professionals with a good knowledge of the original language (but who received a lesser degree of acknowledgement). All three productions presented themselves with a purposefully English face, which was remarked upon by the reviewers. All were based on originals which had a history of translation. I turn now to a production with a very different genesis from the above three, but which also emanated from the Almeida and can be usefully contrasted to provide a further insight into the practice of theatre translation.

Festen: collaborative enterprise

Festen enters this selection of productions under discussion as a result of its commercial production at the Lyric Theatre, Shaftesbury Avenue, in London's West End from 15 September 2004 to 16 April 2005, but it was first shown at the Almeida Theatre in 2004. The published text states on the cover that it is 'by David Eldridge. Based on the Dogme film and play by Thomas Vinterberg, Mogens Rukov and Bo hr. Hansen' (Vinterberg, Rukov and Hansen 2004: np). The programme also attributes the Dogme film and play to Vinterberg, Rukov and Hansen, but labels Eldridge's work 'a dramatisation'. Information released by Premier Public Relations on behalf of the Almeida stressed the originality of this production with the appellation 'World Première' and an emphasis on 'this new adaptation' (Premier Public Relations 2004). There is no mention of a literal translator in any of these documents. From the print evidence, at least, the method of creation of this piece, and its transfer from Danish film to English-language play is unclear, although the number of names connected with the English playtext suggests a wide circle of collaborators.

Only when Jenny Worton suggested that I speak to Marla Rubin did the genesis of this project become apparent. Rubin is a freelance producer with experience in documentaries and film production, but, as I learned in a personal interview with her, the production of *Festen* the play was both a personal and a professional commitment with career-changing intentions and consequences.[15] To understand Rubin's involvement, it is necessary to consider the antecedents of the play.

Festen (The Celebration) was released as a film in 1998 by the Danish Dogme 1995 collective, a group of filmmakers formed with the intention of differentiating their approach artistically and organizationally from

[15] Marla Rubin, interview with Geraldine Brodie (London, 15 July 2010).

Hollywood-style procedures. *Festen* was the collective's first film. Made in Danish, and released outside Denmark with subtitles, it was nominated for, and won, a number of awards, including at the Cannes Film Festival, mainly in the 'Foreign Film' category. The success of this and subsequent films brought Dogme international attention and, to some extent, notoriety, largely as a result of the combination of subject matter (*Festen* deals with the revelation of incest at a family patriarch's birthday party weekend) and its matter-of-fact exposition. The collective's narrative approach is codified in a manifesto and ten film-making rules, labelled the 'Vow of Chastity'. These include: 'Shooting must be done on location; the sound must never be produced apart from the images or vice versa; the camera must be hand-held' and seven further requirements for simplicity and transparency in filmic techniques (MacKenzie 2003: 53). The rules, while largely adhered to in *Festen*, have often gone on to be broken by the collective itself in later films.

Marla Rubin saw the film in 1999 and spent the next four-and-a-half years bringing an adaptation to the stage. She negotiated the rights with Dogme, identified David Eldridge and Rufus Norris respectively as the writer and director for the project, and presented a completed package, including theatre script, to various London theatres. In the resulting bidding war, she chose to work with the Almeida because, in her words, Michael Attenborough, the artistic director, was 'very good at knowing how to nurture things'. In her interview, Rubin took personal possession of this project at all stages. She views herself as an 'ideas producer', claiming, 'I create an idea and try to make it happen from inception'. She saw her role in the production of the playtext as editor, particularly in evolving a structure for the play prior to detailed writing. She stresses the importance of producing a new work for the stage and declared herself 'horrified' to have been presented with an English playscript by the Dogme collective, as she had been clear 'from the get-go' that the film would need to be remade in a substantial adaptation if it were to be suitable for stage production.[16]

The translation of *Festen* can therefore be differentiated from the other translations in my sample because it overtly displays the features of Roman Jakobson's categories of intralingual, interlingual and intersemiotic translation (1959: 233), since it constitutes transfers from English script to English playtext (intralingual), Danish script to English script (interlingual), and Danish film to English play (intersemiotic – although in a wider sense than Jakobson's definition, which stipulates 'the interpretation of verbal signs by means of signs of nonverbal sign systems'). It became clear in discussion with Marla Rubin that several agents participated in this process: the Dogme

[16] Marla Ruben, interview with Geraldine Brodie (London, 15 July 2010).

collective, within which she conducted negotiations with at least two indi-
viduals, Thomas Vinterberg and Mogens Rukov; David Eldridge, English
writer; Rufus Norris, British director; the Almeida staff, headed by Michael
Attenborough; and, not least, Rubin. And yet within this collaborative pro-
cess, Rubin distinguishes herself as the driving force behind the project. She
could not have accomplished it alone, but she was present at all stages of the
process, and indeed still participates, as the owner of the stage rights for this
translation, in the production of *Festen* on stage around the world and trans-
lated on into further languages. Rubin sees the English playtext as a work
distinct from the film, emphasizing that 'you can't compare the two; each is
a gem in its own way'.[17] Commercially, this is corroborated by the fact that
the playscript produced by the Dogme collective has been sold separately
from the rights to convert the film to the play obtained by Rubin, and has an
afterlife distinct from Eldridge's version. Rubin's *Festen* and Dogme's *Festen*,
even when appearing on stage, are structured and presented differently. This
development provides an excellent example of the blurriness of authorship
and authenticity in the concept of 'original' and the jostling of subsequent
translations for the position of 'authorized version'.

The playwright David Eldridge insists that he is an adaptor and not a
translator, with no knowledge of Danish and little formal training in any lan-
guage other than English.[18] Nevertheless, he takes moral ownership of the
text uttered by the actors and heard by the audience, and consequently he
accepts at least partial responsibility for the transmission of meaning. His
ownership is indicated by several means. First, the published text, while
asserting the rights of Vinterberg, Rukov and Hansen 'under the Copyright,
Designs and Patents Act, 1988, to be identified as authors of this work', states
that 'David Eldridge has adapted this work for performance in the English
language. This edition of Festen, first reprinted in 2005, incorporates revi-
sions made to the text in rehearsal and should be regarded as the definitive
version' (2004: np). His name is thus clearly associated with the text, even
more so as the only authorial name on the spine of the published book.

Second, having seen the film, he produced a draft document setting out
the narrative structure for the play in order to conduct negotiations with the
Dogme group.[19] This short document demonstrated revisions to the film nar-
rative which reflected Eldridge's own playwriting technique of enclosing a
small number of characters within a limited space and focusing on certain
key properties. His play *Under the Blue Sky*, for example, restricts the action

[17] Marla Ruben, interview with Geraldine Brodie (London, 15 July 2010).
[18] David Eldridge, interview with Geraldine Brodie (London, 26 January 2011).
[19] David Eldridge, interview with Geraldine Brodie (London, 26 January 2011).

to three consecutive pairs of characters loosely connected with each other, in a domestic setting. The first act is largely dominated by a kitchen knife, the second by a bed (Eldridge 2000). His *Festen* is similarly dominated, in turns, by a dining table and a bed and reduces the number of characters from the screenplay to a smaller number of protagonists more evenly weighted within the ensemble, all connected to the family within which the main plot device of incest takes place. Eldridge thus establishes an intertextuality between his reworking of *Festen*'s structure and his own earlier play. The lengthy, and at times tense, negotiations which took place in relation to this new version of *Festen* suggest that an implicit ownership contest was understood by all participants.

The third indication of Eldridge's authorial presence in the text, and a demonstration of how his understanding of meaning is transmitted to the audience, is his approach to writing the adaptation. He explained to me that, when producing his first drafts for translated plays, he prefers to refer only to the English translation from which he is working so that his version is more likely to reflect his personal response to the original piece. He will then do any research he finds necessary, which could include information about the author, the subject matter, the context or the translation itself, and make further drafts as appropriate. This is his adaptation process, applied here to *Festen*, but also developed in the several Ibsen adaptations he has created (working with the same literal translator each time, Charlotte Barslund). He only differentiated between Ibsen and *Festen* to the extent that the original authors were still living and therefore might wish to approve the adaptation. Nevertheless, he told me that he was prepared to take a stand to defend his work and creative decisions, whether adaptation or original, while it was in the writing stage and in early rehearsal. However, he made the point that later in the production process he was more likely to accept changes and step back to being part of the team where an adaptation was involved. This indicates two important features of the theatre translation process: first, that the final translator consciously creates their own reading of the original work, which is overtly presented as such to the audience by means of naming that translator; second, that this reading is mediated and refracted by other theatre practitioners during the process of staging the performance, which, although less overtly stated, is nevertheless implicit in the extensive list of cast and creative participants in the programme, and selected individuals from this list in promotional material.

A fourth sign of Eldridge's possession of the text lies in the production information released prior to the press night (an early performance to which theatre critics are formally invited, and on which they base their opinions which will form the published reviews likely to influence the sale

of tickets). The need to balance sales-generating information with accurate creative credits resulted in the lines: 'Rufus Norris directs the World Première of David Eldridge's English Language stage adaptation of Festen (The Celebration). This new adaptation of the original Dogme film and play, opens ...' (Premier Public Relations 2004). The production is flagged as new, carefully applying the term to Eldridge's adaptation. This is necessary because Dogme's English-language playtext, closely based on the film script, was given to Rubin during the negotiation process. This play had already been performed in London by the time Eldridge's version opened, but in Polish with English surtitles, in an 'avant-garde production' directed by Grzegorz Jarzyna, at Sadler's Wells Theatre (Bassett 2002). Thus Eldridge's association with the Almeida's production was crucial, distinguishing it from the alternative adaptation and enabling his text to be identified as new. While the relationship between the film and Eldridge's play is stressed, and was mentioned in most of the reviews, very little reference is made by the critics to the other play.

I avoid the label of 'original play' because, even after interviewing Eldridge, Norris and Rubin, I am not clear to what extent Eldridge's version is dependent on the Hansen script. Rubin suggested to me that the script was written for her when she first approached Vinterberg and Rukov about bringing an adaptation of the film to the stage. However, in her book on *Festen* the film, Claire Thomson cites Rukov attributing the creation of the play to 'somebody in Germany' (2013: 127). Thomson observes, based on Danish and French versions of the text, that the 'dramatisation is indeed very close, in terms of language and narrative shape, to the original film; many lines can be recognised more or less verbatim' (2013: 127). Comparing Eldridge's published play with the English subtitles of the film (*Festen* 1998) suggests that Eldridge may have been working from an English text based on the film, as his dialogue frequently resembles the film's English subtitles. However, his adaptation does not confine itself to reducing the expansive surroundings of the film's mansion-setting to the theatrical stage. It reorders parts of the narrative, revealing the patriarch's molestation of his children at different points in the evening from the film's account. Act One, Scene Three of Eldridge's play also reworks a film sequence which cuts between three conversations in different rooms, bringing all six characters onto the stage around one bed and requiring the actors to perform their dialogues as if still in three separate rooms, with the conversation moving between each pair every few lines. This use of a simple item of furniture to centre the dramatic action prefigures the crucial dining-table scenes later in the play (shown in Figure 3.5) and demonstrates Eldridge's ability to use theatrical limitations to dramatic advantage.

Eldridge's adaptation thus displays his familiarity with dramatic stage technique and his confidence in the actors' ability to portray a theatrical device convincingly, allowing him to move away from a purely filmic representational narrative. Rubin implied that the agreement of the revised structure of the play was the most significant and testing area of negotiations with the Dogme group. Eldridge's comments in the *Festen* Projects Pack support this:

> I wanted to shift the order of things that happened in the story, in order that it would work better in a theatrical context. This led to some big debates because their story had been grown so organically and so carefully. They made a rule that I could cut things but that I couldn't change the narrative order of scenes: I had to fight for them to trust me and to understand that any re-ordering was for good reason. (Manson Jones and Dickenson 2006: 10)

Eldridge's words demonstrate his struggle to claim some kind of ownership of the English play.

The conflict was not apparent to the critics. Reviewing Eldridge's version in the *Independent*, Kate Bassett failed to mention that she had seen

Figure 3.5 *Festen*, adapted by Davis Eldridge; Jonny Lee Miller as Christian; Jane Asher as Else. Directed by Rufus Norris; Almeida Theatre, 2004. Photograph copyright: Geraint Lewis

(and reviewed) a play of the film in a different production just over a year before, writing, 'You may wonder why anyone would rework Thomas Vinterberg's celebrated Dogme film *Festen* for the stage' (2004a: 396). Susannah Clapp in the *Observer* pointed out that 'some 40 versions are now being staged around the world' (2004: 398), apparently referring to Hansen's play, but not making that distinction. Only Michael Billington in the *Guardian* compared the two productions, noting, 'Thomas Vinterberg's original 1998 Dogma film had the feel of docu-drama. A recent Polish stage version turned the story into doom-laden Shakespearean tragedy. Now David Eldridge's adaptation heightens the work's element of black comedy' (2004: 397). Billington's ability to differentiate between original and adaptation demonstrates his understanding of theatrical processes: each production reflects the personalities of its immediate creators but also subscribes to an intertextuality with its predecessors and the wider literary field in which it is situated. Thus Eldridge's *Festen*, in my opinion, is an excellent example of the 'architextuality', developed by Theo Hermans from Gérard Genette (Hermans 2007: 32), which characterizes translation generally but is more clearly marked in theatre translation. This play owes its existence to a film of the same name, shares many characteristics with another play of the same name, and bears the marks of the original film's developers, the Dogme collective, along with the distinctive style of its adaptor, Eldridge. Yet it can also stand alone.

I have referred to this production as 'David Eldridge's *Festen*'. However, as I described at the beginning of this section, this play overtly displays an unusually highly populated circle of collaborators. The producer Marla Rubin played a key conceptual role in bringing together the collaborators and smoothing the path for them to progress their work. Compared with the three foregoing translations in this chapter, *Festen* has a varied background of genesis. The main differentiating factor for *Festen* is the identity of the personality publicly associated with the translation. In the three previous cases, the indirect translators – Hare, Farr and Eyre – were the principal names connected to the translated texts. The *Festen* reviews frequently acknowledge Vinterberg, Dogme and Eldridge collectively in establishing the play's credentials, displaying a difficulty in awarding possession of the translation, but nevertheless using a writer as referent. They do not, however, mention Marla Rubin. Thus in a highly collaborative enterprise, the identity of the participants may not be recognized in proportion to their activity. My next discussion explores this phenomenon further, investigating another commercially successful play where the vision and control extends beyond the indirect translator.

Don Carlos: vision and visibility[20]

Friedrich Schiller's *Don Carlos* was commissioned by the Sheffield Crucible Theatre, where it was performed from 2 September to 6 November 2004, thereafter transferring to the Gielgud Theatre in London from 28 January to 30 April 2005. At the time of the production, the director, Michael Grandage, was filling three positions which have a bearing on this translation: associate director of the Sheffield Theatres, artistic director of the Donmar Theatre in London and director of this production of *Don Carlos*. Grandage's multiple roles and his status in the London theatrical field are important elements in the consideration of both the creation and reception of this translated play.

Grandage's achievements in theatre are related on his company's website (Michael Grandage Company 2017), where it can be seen from his lists of awards and transferred productions that he has been spectacularly successful since his career in artistic directing began at the Sheffield Theatres, and particularly in relation to the Donmar Theatre. His Donmar predecessor, Sam Mendes, had departed in order to develop a burgeoning career in Hollywood and there was doubt as to whether Grandage would be able to continue the artistic and financial trajectory which Mendes had initiated. Maddy Costa provides an illustration of this sentiment in her article for the *Guardian*: 'Mendes put the Donmar on the map, bringing in the likes of Nicole Kidman and Gwyneth Paltrow to work there and presenting one impeccable, sold-out production after another. How could anyone follow someone so dynamic? Grandage, however, refused to be intimidated, and put his stamp on the place from day one' (Costa 2005).

Grandage consolidated his own and the Donmar's reputations as creators of innovative and well-crafted theatre productions and furthermore instituted outreach both into affordable West End productions (a season at the Wyndham Theatre in 2008–2009) and more experimental productions showcasing young directors at the Trafalgar Studios in 2010–2013. Furthermore, his grasp of administrative matters provides a solid financial foundation for creative practice. That he chose to include the following extract on his website reveals the importance he places on organizational stability alongside artistic activity:

[20] This section is based substantially on 'Schiller's *Don Carlos* in a Version by Mike Poulton, Directed by Michael Grandage: The Multiple Names and Voices of Translation' in Hanne Jansen and Anna Wegener (eds) *Authorial and Editorial Voices in Translation 1 – Collaborative Relationships between Authors, Translators, and Performers*, 119–40, Montréal: Éditions Québécoises de l'Oeuvre, collection Vita Traductiva (2013), and is being reproduced with the permission of the publisher.

In 2008, Michael announced that the Donmar organisation had secured the purchase of the Donmar Theatre site on Earlham Street. In 2011, he announced the Donmar had also secured the purchase of their own offices, rehearsal studio and Education space in Dryden Street, Covent Garden. (Grandage 2011)

Fundamentally, Grandage's approach to theatre and his reputation indicate both a deep personal involvement on his part with all aspects of production and a predisposition among the participants and receivers to look beneficially on any project in which he collaborates. These effects are displayed in analysis of the translation process of *Don Carlos*.

Prior to Grandage's production, *Don Carlos* had rarely been seen on the London stage, with only limited appearances elsewhere in English. The RSC transferred their 1999 production from the Other Place (the third Stratford-upon-Avon theatre, used for studio productions) to the Barbican Pit theatre (another studio theatre used for small productions and audiences) in 2000. A review for this production declared that 'it ought to be a matter of some shame that this is the first production of Schiller's play that the RSC has put on but it probably won't be. It's a shame that it's so rarely performed and, consequently, better known in this country for the Verdi opera' (Cooter 2000). This was apparently the only production appearing in the main London theatres for at least 100 years; Robert Tanitch's *London Stage in the 20th Century*, which covers 'all the London premieres of world playwrights, all the major classics and modern revivals, and all the major visitors from five continents' (2007: 1), does not list *Don Carlos*, and notes only two productions of Schiller's *Mary Stuart*, in 1922 and 1958, the latter in a translation by Stephen Spender (2007: 67, 172). Bettina Göbels lists six *Don Carlos* productions after 1945 prior to the Sheffield Crucible production, two of which emanated from London theatres: Bridge Lane Theatre, Battersea (1986) and the Lyric Theatre Hammersmith (translated by Peter Oswald in 1992). Both of these theatres were situated in west London suburbs and therefore considered as fringe or local venues – the Lyric Theatre Hammersmith is indeed an affiliate member of SOLT, supporting this view. The remaining productions originated in Cheltenham (1975), Manchester (directed by Nicholas Hytner in 1987), Glasgow (1995) and Stratford-upon-Avon (1999), with only the latter touring to London's Barbican Pit, as mentioned above (Göbels 2008: 233–37). Yet since the Sheffield 2004 production, Schiller has been further represented in London at the Donmar by *Mary Stuart* (in a version by Peter Oswald and directed by Phyllida Lloyd, 2005) and *Luise Miller* (in a version by Mike Poulton and directed by Grandage, 2011), and a further production of *Mary Stuart*, in a new version by David Icke, at the Almeida

Theatre in 2016. Outside London, Mike Poulton's versions of *Mary Stuart* and *Wallenstein* were produced by Clwyd Theatr Cymru and Chichester Festival Theatre respectively, and his *Don Carlos* revived in a student production at the Oxford Playhouse, all in 2009. Göbels's analysis demonstrates that Schiller has been performed more often than is apparent from studying Tanitch, but nevertheless the Sheffield production was greeted as a fresh approach updating an unfamiliar playwright.

Matthew Byam Shaw, who brought the production to London as producer, takes the view that this *Don Carlos* revitalized Schiller for an English-speaking audience.[21] Göbels comes to a similar conclusion:

> Grandage's status in the theatre world is one explanation [for the positive reaction from the press], but the reason for the overwhelming, unprecedented attention to and success of a Schiller play in England was the fact that this was the first production to combine three crucial factors: star theatre; a domesticating translation that avoided Schiller's Shakespearean borrowings without descending into a prosaic or inappropriately restrained style; and a high degree of political topicality that gave spectators a heightened sense of relevance and urgency of the themes. (2008: 215–16)

The label 'domesticating' for this, or indeed any theatrical translation requires further nuance, as Emma Cole and I discuss in our introduction to *Adapting Translation for the Stage* (Brodie and Cole 2017: 1–18). However, I agree that the direction, cast, translation and contemporary approach combined to promote this production. It generated interest in a neglected dramatist, filled the Donmar, and has supplied Poulton and Grandage with a stream of work among their other theatrical activities over the years since their version of *Don Carlos* first appeared.

The SOLT advertisement for *Don Carlos* at the Gielgud in 2005 used the label 'adaptation'. However, this production, of all in my sample, has had the largest variety of descriptions, and was the most opaque when it came to identifying its means of translation. The cover of the published text proclaims itself to be 'a new version by Mike Poulton' (Schiller 2005: np), whereas the London programme terms it a 'new adaptation' on the title page (which was also used for the publicity posters), but a 'new translation' in the cast list, while identifying Poulton as the 'translator' in the biographical pages. The Sheffield programme adopts the terms 'new translation' and 'translator'. Nowhere in the literature can be found any indication of whether there was a literal translation. Poulton writes in his published note on the adaptation:

[21] Matthew Byam Shaw, interview with Geraldine Brodie (London, 5 April 2011).

> Where I am competent in the language I am to work in, I make my own literal translation before beginning the serious, and lengthy, business of adaptation. In languages where I am not competent – most of them – I commission a literal translation. (Schiller 2005: xiii)

Intriguingly, he does not disclose which applies in this case, but goes on to say that he studied the play at university, so a first assumption might be that he has a working knowledge of German, which would be corroborated by the use of the term 'translation'. This turns out not to be the case.

That adaptation, version and translation can all be applied to this one text might perhaps reflect Poulton's admission in relation to another of his translations that he 'cut the play brutally, re-ordered scenes, combined characters or invented new ones, and underpropped the whole thing with new and more plausible action' (Jackson 2006: np). Furthermore, Poulton admits in his note on the adaptation of *Don Carlos* that he was 'faced with the task of bringing it in at under three [hours]' (Schiller 2005: xiii). In the event, he accomplished this task comfortably, the London performances running for 2 hours 50 minutes, including a 15-minute interval, according to the Gielgud Theatre programme (2005: np). Poulton's efficiency in condensing and cutting probably had more than artistic appeal for Grandage; overtime payments become payable after three hours, so an ability to keep within this limit may be crucial to the production budget. A comparison between Poulton's version and Schiller's German text immediately demonstrates how Poulton approaches his work; the very first scene of the play shortens the lines of both speakers significantly, and completely omits Carlos's last soliloquy (Schiller 1912: 9, lines 122–27), replacing it with the opening stage direction, 'Carlos looks as if he's falling apart mentally and physically' (Schiller 2005: 5). The translated text continues in this vein.

A glance at Poulton's other translations and adaptations (for example, his *Morte d'Arthur* for the RSC, 2010, or his stage adaptation of Hilary Mantel's *Wolf Hall* trilogy about Henry VIII's advisor Thomas Cromwell, also for the RSC in 2014), reveals his particular ability to create well-received stage productions from large bodies of work, suggesting that this use of virtual scissors is a trademark, and might well be one of the reasons he was commissioned by Grandage to produce the translation of *Don Carlos*. Grandage is known for his spare productions of Shakespeare; Michael Billington's review of his 2011 *King Lear* for the Donmar represents the general reception, pointing out that 'the miracle of Michael Grandage's production is that it is fast (under three hours), vivid, clear and, thanks to a performance that reminds us why Derek Jacobi is a great classical actor, overwhelmingly moving' (Billington 2010).

This review could apply equally well to *Don Carlos*, even down to the critique of Derek Jacobi's performance (he played Philip II, the main role in *Don Carlos*). It overtly sets out some basic features of Grandage's modus operandi. But it is also clear that Grandage imposes his vision on the production in ways which affect the entire mise en scène (Figure 3.6). He tends to work with a regular group of collaborators, who accept his multifaceted directorial supervision. Interviews with the creative team for the Sheffield Theatres Creative Resource website display a recurring theme of responding to Grandage's detailed ideas. Paule Constable, the lighting director, for example, who later won an Olivier award for this production, reveals that 'Michael was also acutely aware of the pace that the play requires and he uses both music and light to make links and keep a rhythm of change' (Sheffield Theatres 2004b).

The music and sound score composer, Adam Cork, paints a similar picture of their collaboration, recalling that 'what [Grandage] generally does when we work together is firstly to go away and sit down with the play by himself and read and make notes. I picture him imagining very strongly how the production will be as Michael is a very intensely imaginative director. So he starts off with ideas and then he emails me a document' (Sheffield Theatres 2004a). This insight portrays Grandage engaging with an existing script as he consolidates his plans for the production – in this case, presumably a script created by Poulton. However, his interventions continue into rehearsals; an unattributed diary on the same website records a series of interactions:

> Michael . . . briefly clarifies a stage direction with Mike Poulton. (Sheffield Theatres 2004d)
> Michael adds that they may create a 'silent' scene prior to Scene 10 . . . as he feels the audience need to know how the King has these items in his possession in the following scene. (Sheffield Theatres 2004d)
> Michael amends tiny details to ensure that the audience is clear and that the scene plays truthfully. (Sheffield Theatres 2004c)

Grandage is indeed behaving as one would expect a director to behave: orchestrating the creative output of the whole team in order to present his overriding interpretation of Schiller's play. The information available on the creation of this play in translation is unusual. As Eva Espasa has observed, when asking for permission as a research student to attend rehearsals, 'a theatre director rejected my petition, on the grounds that rehearsals were like a love affair between him and the performers, and he did not want voyeurs' (2000: 61). However, the Sheffield information is notable in that it was made publicly available (Grandage pointed me to it himself), and that it demonstrates the teamwork involved in staging a translated play. Teamwork in which the lead

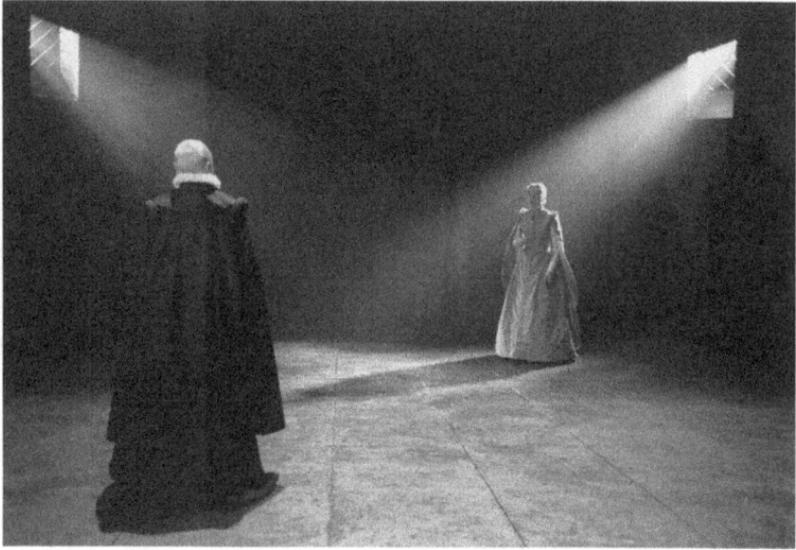

Figure 3.6 *Don Carlos* by Friedrich Schiller in a version by Mike Poulton;
Derek Jacobi as King Philip II of Spain; Claire Price as Queen Elizabeth.
Lighting by Paule Constable. Designed by Christopher Oram. Directed by
Michael Grandage; Crucible Theatre, Sheffield, UK, 2004; Photograph copyright:
Ivan Kyncl/ArenaPAL; www.arenapal.com

figure is not necessarily the translator; however, that translator may well be
present and consulted for any revisions.

There was further teamwork related to this translation, although very
much less public. Only in a personal interview did Poulton reveal to me that
he did in fact commission a literal translation from a trusted collaborator
for his indirect translation. Although this was the least visible literal trans-
lation in my sample, it was the most active site of interactive engagement;
Poulton told me that he worked with his translator on a regular basis, and
even cancelled a meeting with me because he needed to discuss translation
issues with her.[22] Among this selection of translated productions, this was the
only instance of a literal and an indirect translator meeting. When I asked
Poulton why there was no credit for the literal translation, he seemed sur-
prised, explaining that in his experience literal translators preferred not to be
mentioned, often because they held some other more formal employment.
I have since seen what I assume to be indirect translations by Poulton from

[22] Mike Poulton, interview with Geraldine Brodie (Stratford-upon-Avon, 26 May 2010).

Swedish (Strindberg's *The Father*, Chichester Festival Theatre, 2006) and Norwegian (Ibsen's *Rosmersholm*, Almeida, 2008) and not found a literal translator credit. On the other hand, the Chichester Festival Theatre production of Eduardo de Filippo's *The Syndicate* (2011) is also described as 'a new version' by Mike Poulton. In this case, as I discovered by asking Poulton himself, he prepared his own literal translation from Italian. The programme is silent on the matter, and therefore the manner of the creation of the playtext remains a mystery to the public, for this as for so many other translated plays. When I queried the apparently random use of the labels translation/version/adaptation for *Don Carlos* with its producer Byam Shaw, he implied that selecting these terms for their different contexts had been a matter of quite delicate negotiation. It would seem then that the use of translation/version/adaptation terminology serves more as a reminder that translation is a site of contention than providing an indication of the detailed processes involved in creation.

Göbels also reflects on the manner of translation, taking the view that 'the power of the habitus makes it necessary for a foreign play to be anglicised, not only in terms of fluency ... but also in terms of taste' (2008: 33). The incidence of literal translations she sees rather as a mark of the 'lower, more ancillary status of translating' in British rather than German theatre (2008: 63). Göbels does stipulate a link between the two-step literal-indirect translation process and domestication, but acknowledges the controversial nature of this theme, concluding that although 'often criticised by translation theorists as part of the parochialism and cultural xenophobia of the British theatre world, [this process] has paved the way for the German classics' (2008: 231). For Göbels therefore, in contrast to many translation critics, domestication is not necessarily a negative attribute and has brought about the assimilation of neglected German classics into the English repertoire. She nevertheless remains hopeful 'that after Schiller has been established in the dramatic canon in Britain, audiences will be ready for a return to more faithful versions' (2007: 439). I cannot agree that this Sheffield *Don Carlos* is in some way a domesticated second-best, leading to future perfection. Arguably, all translations are adaptations; in theatre this is a result of the style of the performed translation rather than the fact that it might be reworked from a literal translation. For me, the features that made the production stand out, the decisions of the director, cast and translator and the topicality of the treatment of the subject matter can only be assessed in the context of the time and place of their creation. The team combines to highlight the translation.

When compared to the foregoing translations in this chapter, *Don Carlos* displays a variety of features. Once again, the named translator worked on a largely unacknowledged pre-existing translation. Like the first three

translations, *Don Carlos* is a revision of an established classic and, like all four, it is presented with an English outlook – Göbels cites the use of the phrase 'the authority of Parliament' (Schiller 2005: 118) as an example of 'domestication' (2008: 216–17). An argument can be made that the original invited interpretation: the Marquis of Posa character in *Don Carlos* is an inserted fictional character within a historical framework, an intentional anachronism that allows Schiller to 'use a sixteenth-century setting to challenge the political absolutism of the eighteenth' (Sharpe 2005: vii). Like *The UN Inspector* and *Hedda Gabler, Don Carlos* in translation echoes its source in its critique of diachronic and synchronic cultural and political circumstance. And like *Festen*, the translation is the result of an orchestrated collaboration; in this instance, the vision of a very visible individual outside the formal translation process: Michael Grandage. The remaining plays to consider in this chapter were translated directly. I examine to what extent the variance in translation process affects the circulating influences of the agents in the production.

Hecuba: cultures of change[23]

Tony Harrison describes himself in his 2008 play *Fram* as 'a grubby Yorkshire poet with a bad degree in Greek' (2008: 10). His translation of *Hecuba* for the RSC, however, was described as a 'version' in the publicity. The published text calls itself 'a new translation from the Greek by Tony Harrison' (Euripides 2005: np); this text is included by J. Michael Walton in his 'comprehensive list of all Greek plays in English translation' (2006: 243), the requirement for inclusion being 'fairly rigid adherence to the original' (2006: 7). Nevertheless, the use of the term 'version' in this case hints at a degree of freedom from the original, reflecting Harrison's relationship with classical texts and themes in his other plays and poetry, including work by Aeschylus, Aristophanes and Sophocles. There is no indication in the published text or programmes that Harrison used a literal translation to create his version. Vanessa Redgrave took the title role and Laurence Boswell initially directed this production, which takes part in my selection by virtue of its appearance at the Albery Theatre in the West End (since renamed the Noël Coward Theatre).

The ownership history of the theatre building itself provides a potentially comparable background to the peregrinations of this translation, as it appears to have been through a succession of investors in freehold, long

[23] This section is based substantially on my article 'Translation in Performance: Theatrical Shift and the Transmission of Meaning in Tony Harrison's Translation of Euripides' Hecuba', *Contemporary Theatre Review*, 2014, 24 (1): 53–65 http://dx.doi.org/10.1080/10486801.2013.858324

and short leases, including the Ambassador Theatre Group, Associated Capital Theatres and Delfont Mackintosh Theatres, all prominent names in commercial theatre, as I discussed in Chapter 2. At the time of the *Hecuba* production in 2005, the Albery was managed by the Ambassador Theatre Group, but moved into the management stable of Delfont Mackintosh Theatres shortly afterward on 19 September 2005. Delfont Mackintosh had already acquired a leasehold interest in the Albery in 1999 from the owners of the freehold, the Salisbury Family Trust's Gascoyne Holdings (Delfont Mackintosh Theatres 2011). The theatre premises were therefore under differing levels of control, even between competing producers, at the time of the *Hecuba* production. This cloudy history and subsequent name change suggests that the Albery was in a state of flux when it hosted *Hecuba* in spring 2005. While this should have no direct bearing on the translation, the stability of the physical site of performance is crucial to the effective function of the production team. This production was not well-received in London, prompting the question as to whether management and administrative uncertainties can carry over from the immediate creative team to external perceptions.

As the RSC had no regular residency in London at the time, the Albery provided a temporary base for the 2005 London season. The following year, Michael Boyd (RSC artistic director 2003–2012) opted to transfer productions from the home base at Stratford-upon-Avon to London's Novello Theatre. The theatrical site of the RSC London season was in itself controversial after an earlier artistic director of the RSC, Terry Hands, had suspended the RSC contract with the Barbican Theatre in 1990–1991, a decision confirmed by his successor, Adrian Noble (1991–2003). Given that the Barbican Theatre had been designed specifically to RSC specifications as a permanent London base, the cancellation of this contract (justified as a money-saving measure) caused consternation at the time and marked the beginning of a lengthy itinerant chapter for the RSC in presenting its work to London audiences. It was 2010 before a more permanent agreement for a regular base in London was agreed, and then this took the form of only a five-year contract with the Roundhouse venue in north London – not the most obvious choice for one of the nation's most well-established theatre companies. From 2016, the RSC returned to a permanent seasonal residency at the Barbican, another marker of its peripatetic activity in the intervening period. While this contextual background may appear loosely connected with the *Hecuba* translation, it reveals a period of changing management strategies and temporary solutions within the RSC at the time of this production's commission and performance. A shifting organizational culture

can filter down to affect creative projects. My case study suggests that this might be a possibility in this *Hecuba* production, which experienced a variety of unusually visible alterations as it progressed from inception to performance.

In addition to an unsettled element with regard to venue, this production also experienced scheduling challenges. Its genesis within the RSC commissioning procedures was unusually fast. This may have been related to the involvement of the leading actor, Vanessa Redgrave, and the topicality of the approach taken to Euripides's play. Unusually, all performances in the Stratford home venue were cancelled due to Redgrave's illness, and the theatre remained closed for the nights when the play should have been performed. Even where a performer has the status of Redgrave, it is rare for a production to be closed rather than shown with an understudy. Notably, the RSC had recently announced a new policy with regard to understudies, with Boyd declaring that they were 'the hidden talents of the theatre' and introducing 'understudying performances' for which the audience would be charged 90 per cent less than the normal ticket prices (Alberge 2004). Furthermore, where a principal role is occupied by a box-office draw, the RSC has some history of using an understudy; the replacement of the *Doctor Who* star David Tennant by his understudy, Edward Bennett, for large stretches of the London run of *Hamlet* in 2008 is an example commented on in the press (Billington 2008). Nevertheless, for Redgrave and *Hecuba*, the theatre was closed by her indisposition, and the entire Stratford season cancelled, with the production premièring in London on 7 April 2005. However, the RSC's Annual Report for 2004/05 attributed lost income of £500,000, with a net cost of £900,000, to the cancellation of *Hecuba* (2005a: 27–28). This was only partially compensated by an insurance payment of £200,000 in the following year, according to the financial accounts for the year ended 31 March 2006 (2006: 8). It might be expected that the inevitability of financial losses would render cancellation an undesired outcome; the decision to cancel indicates the centrality of Redgrave to the production. The replacement of Boswell as director by Harrison himself for the post-London tour signifies further shift. An analysis of the movement in the text and production provides a demonstration of how such shifts and challenges are echoed in a retranslation that overtly manipulates textual and non-textual elements to introduce contemporary references, and the extent of collaborative input in the recreation of a canonical work.

In her review of the London production of *Hecuba* for the *Sunday Times*, Victoria Segal is dismissive of its political overtones. She refers in particular to Redgrave's line 'democracy demands a human sacrifice', at which point, according to Segal, 'you can almost feel the whole cast turning to give the

audience a big, right-on thumbs-up' (Segal 2005: 447). Segal must have been listening very closely to the speech, or Redgrave must have been delivering it very clearly, to have absorbed this line. She could not have obtained it from Harrison's published text, which reads: 'Does something force them into human sacrifice?' (Euripides 2005: 11). The line spoken by Redgrave is a pencil amendment in the prompt book for the London production.[24] It is not unusual for a prompt book, the backstage production guide ensuring the consistency of what must be seen and heard on stage, to differ from a published playtext. In order to be available for sale from the opening of a production, the text might be submitted to the publisher a month in advance, when many of the changes which result from the collaborative process of rehearsal have yet to be made. Pencil alterations in the prompt book, however, demonstrate a further collaborative shift at a late stage in preparation.

It is almost certainly the use of the word *democracy* that prompted Segal to pick out that line in her critique: it represents the general tone of Harrison's version, the tone that was commented on in most of the reviews and which differentiated this production from a *Hecuba* produced in London a few months before at the Donmar Theatre, in a version by Frank McGuinness, with which the RSC's production was generally unfavourably compared.[25] McGuinness's reading of that line is, 'Did they put it down to fate?/They must have a human,' (Euripides 2004: 14). A typical response to the McGuinness treatment is given by Kate Bassett in the *Independent on Sunday*, 'A strength of this production is that it doesn't pile on heavy-handed allusions to contemporary conflicts' (2004b: 1170). The reviewers of the McGuinness version praised it for its portrayal of the horrors of war whereas Harrison's translation was seen as a condemnation of Western policy in Iraq. That this was an accurate reading of the translator's intention seems likely, given his introduction to the published text, which states explicitly, 'We may still be weeping for Hecuba, but we allow our politicians to flood the streets of Iraq with more and more Hecubas in the name of freedom and democracy' (Euripides 2005: x). 'Democracy demands a human sacrifice' spoken by Harrison's Hecuba is more than a critique of the Greeks of both Odysseus and Euripides; it is an updated reproach to modern society. But how was this line created?

Some shifts which apparently result from collaboration are well-documented in archival evidence. Others are less obvious, although it

[24] Manuscript consulted at the RSC Archive, Shakespeare Birthplace Trust, Stratford-upon-Avon, 30 October 2008.

[25] In a comparison of reviews collected in *Theatre Record*, all eighteen reviews for the RSC's *Hecuba* tended towards a negative reaction (Shuttleworth 2005a: 442–47) whereas sixteen of the seventeen reviews for the Donmar Warehouse's *Hecuba* were positive (Shuttleworth 2004: 1170–74).

is possible to conjecture from the available information, or lack of it, which processes may have taken place. The pencil changes in the London prompt book were enshrined in a master script which accompanied the play on its planned tour to Washington, New York and Delphi, with Tony Harrison as director. Analysis of the prompt book reveals that many of the pencil changes occurred in Vanessa Redgrave's lines as Hecuba. Regarded as one of the English-speaking theatre's most accomplished, charismatic and politically motivated actors, Redgrave is in a position to exercise influence over her own lines. She is a powerful figure in the theatrical field, her impact extending beyond stage appearances. Theatre hierarchy, overtly displayed in a practitioner's biography and positioning in the programme, is widespread in theatre practices, a feature recognized by many of my interviewees in Chapter 4. One backstage example cited by Aoife Monks is that 'the dressing room can also establish the star persona of the actor' (2010: 18) depending on its proximity to the stage and the degree of comfort in its fitting-out. In this vein, the *Hecuba* production archives include a list of Redgrave's requirements for her ease on stage, including knee-pads (because she spent a considerable time on her knees) and throat-soothing sweets to be kept in the wings. Her influence in and over the production is tacitly expressed by these means. Redgrave's intervention in the script would therefore be one more signifier of her theatrical authority.

If Redgrave were the initiator of the line change, its anti-war tenor would be in keeping with her public persona. While she was in New York for *Hecuba*, Redgrave appeared on television in an interview with Bob Costas on CNN's *Larry King Live*. She claimed that any connection between the production and Iraq was 'kind of an accident' but went on to say that she thought the main issue of the play was justice and that the basis of democracy was, in her view, access to law. Later in the interview she said, 'How can there be democracy if the leadership of the United States and Britain don't uphold the values which my father's generation fought the Nazis [sic]?' and discussed the rule of law in more detail (CNN 2005). Her words suggest that she was making some form of connection between the content of *Hecuba* and the status of democracy, and it is likely that this informed her portrayal of the role and any input to the script. It adds weight to my theory that the amendment, 'Democracy demands a human sacrifice', came from Redgrave herself. It may also be relevant to the time-scheme and genesis of the commission that on 27 November 2004 Redgrave and her brother, Corin, had announced their launch of the Peace and Progress Party, which would campaign for 'the withdrawal of

British troops from Iraq' and in favour of human rights (Branigan 2004). The situation in Iraq was evidently an important motivator for Redgrave in her approach to the Hecuba role, and the timing suggests that she may have been active in proposing that the play adopt its political line. Her return to the RSC after forty-three years to play the role of Hecuba indicates that this play was a significant element in her decision, and possibly of her own selection.

In addition to the London prompt book amendments, legitimized by incorporation into the subsequent master script, there were significant nontextual changes for the overseas tour, underlining the importance of the whole creative team in collaborating on a central theme; the changes seemed orchestrated to strengthen the production's contemporary political allusions. The visually most obvious alteration was the stage set itself. For the London production, the set was described by its designer, Es Devlin, as 'a formal space composed of layers of recycled cardboard, areas decomposed with water during the tragedy' (Devlin 2011). This design echoed images from the filmic work of the Iranian visual artist Shirin Neshat, whose production stills were included in the London theatre programme: seven black-and-white illustrations of women in dark robes and headscarves grouped together in otherwise deserted monumental landscapes. Devlin's set was similarly monolithic, a circular space seemingly at the base of an inverted columnar wall, as shown in Figure 3.7.

Furthermore, the costumes, also designed by Devlin, perpetuated the associations with Neshat's images, including head-coverings and flowing robes for the women, although in shades of faded indigo rather than black, with a deeper indigo for Hecuba and jade green for her sacrificed daughter, Polyxena. These layers of images on stage, combined with the inclusion in the programme of photographs and a detailed map showing the site of the Trojan wars, appear to be attempting to link the play to current events in the Arabian Gulf. This is reinforced by bold-text statements in the programme:

> The first great war between the East and the West is over. Troy has fallen and the victorious Greek coalition forces are on their way home.
>
> 'We've got no choice, no choice at all. We're slaves.' That's true for the Chorus at the play's end. But for us, and now? Euripides's challenge is as relevant as ever. (Royal Shakespeare Company 2005b)

While the first assertion points towards subsequent wars between East and West, and pointedly adopts the term 'coalition' (used by Harrison in his translation, but also generally associated with the Western forces in Iraq), the

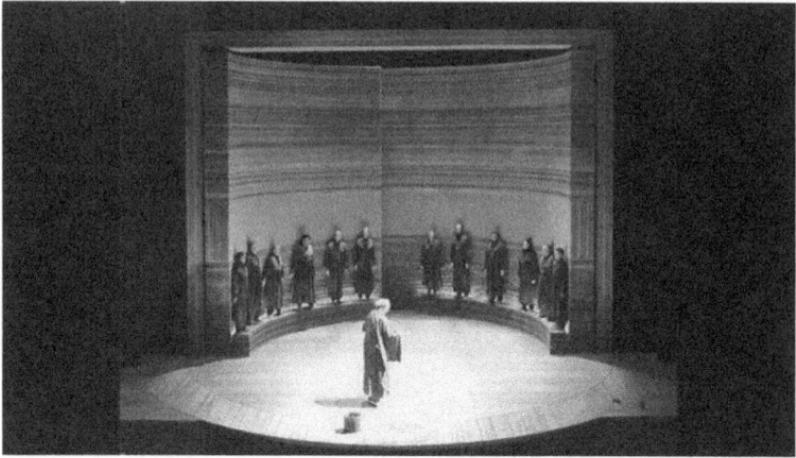

Figure 3.7 *Hecuba* by Euripides, translated by Tony Harrison for the Royal Shakespeare Company. Set and costumes designed by Es Devlin; Albery Theatre, London, 2005. Photograph copyright: Es Devlin

second statement issues a challenge to the audience, explicitly personalizing the play's subject matter. There could be little doubt from these paratextual indications that the play was intended to reference recent Western activity in Iraq.

Nevertheless, the design was substantially altered for the tour to Washington and New York from the formal space of the monolithic columnar set to what Devlin describes on her website as 'an amphitheatre of Desert Storm tents returned from the Gulf War' (Devlin 2011). Figures 3.7 and 3.8 reveal the striking change in emphasis. In the London set, the stark figures of the actors are outlined against the surrounding wasteland, echoing the Neshat production stills reproduced in the programme. In New York, the characters are almost lost in their faded blue and green robes, surrounded by a busy backdrop of ragged, khaki tents, rising in layers above the centre stage, unmistakeably giving visual reference to Harrison's source of inspiration. This radical redesign of the set would have entailed significant time, both in design and organization, and therefore not have been undertaken lightly. One sign of the inconvenience and expense caused by the new set was the cancellation of the first performance in New York. Correspondence in the Brooklyn Academy of Music (BAM) archives[26] indicates that the initial intention had been to rebuild

[26] Correspondence consulted at the BAM Archive, Brooklyn, 19 May 2011.

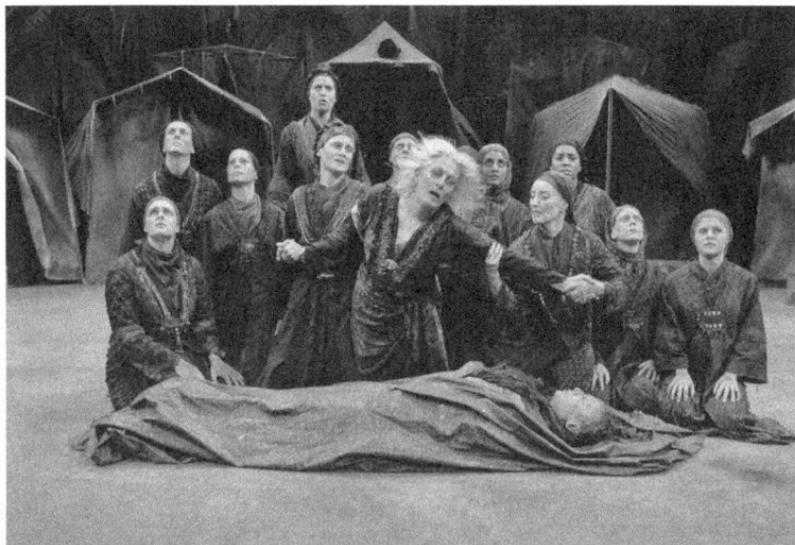

Figure 3.8 Vanessa Redgrave as Hecuba for the Royal Shakespeare Company; Brooklyn Academy of Music Opera House, New York, 2005. Photograph copyright: Richard Termine

the original design using new materials in the United States, as there would be insufficient time to sea-freight the existing set. In the event, the Desert Storm tents used were not only US-sourced, but also US-specific. The scenery was assembled by the Kennedy Center in Washington, and returned there 'for dispersal' after the final performance at BAM. This set change was the most visible sign of the production's overhaul, and the most pointed reference to the underlying linking of Euripides's play with criticism of US involvement in Iraq.

The shifts in the directorship, production and text reflect the reactions of the practitioners engaged in this production to external influences, to their source material and to each other. In *Hecuba*, as in my previous plays, the culture of the organization commissioning and hosting a translation is transmitted to the production and the text. Further similarities are the retranslation of a classic, well-known work by an established writer of English; overt manipulation of the text and performance to reference current events; and the evidence of collaborative input in the text and production. My final two plays were directly translated from the original language. Unlike *Hecuba*, they were both recently written plays translated into English for the first time; the next two productions therefore provide a contrast to the foregoing retranslations in this selection.

Way to Heaven: shifts and flexibility[27]

David Johnston was commissioned by the Royal Court to translate *Way to Heaven* (original title: *Himmelweg*) for the first full professional staging of a play in London by one of Spain's leading modern dramatists. Juan Mayorga's work had been staged in Spain, Croatia, Portugal, Venezuela, Argentina and the United States (Theatre Catalyst, Philadelphia, a fringe theatre) by that time, both in the original Spanish and in translation. Even so, Johnston was effectively introducing a play and an author which were both relatively new to English audiences. Mayorga is also a *new writer* in the sense that he was born in 1965 (in Madrid) and his first professionally performed play was staged in 1992. He fits the Royal Court profile as an author who takes on challenging themes, as demonstrated by *Way to Heaven* and his other work which, in addition to his plays, includes his philosophical study, *Revolución Conservadora y Conservación Revolucionaria. Política y Memoria en Walter Benjamin (Conservative Revolution and Revolutionary Conservation. Politics and Memory in Walter Benjamin)* (2003). Mayorga had also been awarded several prizes for his theatrical work by 2005, including the Premio Enrique Llovet for *Himmelweg* in 2003. In short, Mayorga had recognition and a substantial track record in Spain and elsewhere; already the author of a defined body of work, he was unknown only in the sense that his work had received very limited exposure in London and to other English-speaking audiences. The translation therefore had to reflect the fact that this was the work of a confident, established and well-regarded playwright while acknowledging its unfamiliarity but simultaneous suitability for the Royal Court audience. These requirements were echoed in the publicity material:

> The heart of Europe. 1942. Children playing, lovers' tiffs, a deserted train station and a ramp rising towards a hangar. This is what you can see, but what should the Red Cross representative report say?
>
> Juan Mayorga was a participant on the Royal Court's International Residency 1997. *Way to Heaven* has previously been produced at the Teatro María Guerrero, Madrid by the Centro Dramático Nacional. His other work has been produced in Spain and around Europe as well as in Argentina, Venezuela and USA. (Royal Court Theatre 2005b)

The biography emphasizes Mayorga's links to the Royal Court, his status within the Spanish theatrical field and his international standing. The play is

positioned in Europe – vaguely, considering the text itself specifically places the action 'thirty kilometres north of Berlin' in the first spoken lines of the play (Mayorga 2005: 19). The circumstances of the setting are made personal to the audience ('This is what you can see …') and the wartime context is referred to only obliquely by including the date 1942. The image accompanying the advertising material, of a clock-face with shadowy figures superimposed, is equally mysterious. The invitation extended to the prospective audience is open in its scope. Does the translation reflect the elasticity of this invitation?

Way to Heaven has been described by its translator as a work of 'extended monologues and hypertheatricality … where the monstrosity of the Holocaust is reflected through the story of the camp at Theresienstadt' (Mayorga 2009: 13). The play reflects upon the report of an unnamed Red Cross representative who, on visiting a concentration camp, fails to notice that the apparently well-treated Jewish prisoners are following a script devised and stage-managed by the camp commandant. The camp station clock permanently stands at six and a ramp leading from the station to a closed-up hangar is called 'the way to heaven'. The visit is discussed and displayed from the differing perspectives of the Red Cross representative, the commandant and Gershom Gottfried, a prisoner. Johnston's direct translation is from Spanish, but once in its English translation, the genesis of the play is obscured as only its original language gave any clue to its source culture.

Mayorga has changed some of the historical details of the notorious Red Cross visit to the concentration camp in what is now the Czech Republic, creating a fictional camp and characters whose motives and allegiances are of more relevance than their nationalities. The site of the play's action is explicitly set thirty kilometres north of Berlin in 1942. There are no allusions to Spain, other than the Commandant's inclusion of Calderón alongside Corneille and Shakespeare in his library (Mayorga 2005: 41–42), and the fact that the clock's balances originated from an earlier clock built in Toledo (Mayorga 2004: 20). The international nature and themes of the play for its Spanish audience would have been underlined by the title, a German word: *Himmelweg*. The first lines spoken explain that this means 'camino del cielo' in the Spanish version (Mayorga 2004: 13), translated as 'way to heaven' in English. The German-language title has been retained in translations of the play into other languages such as French, Italian and Norwegian, but the Royal Court production used the English translation of the title; foreign-language titles, particularly in German, are perceived to be less favourable for ticket sales in London. Looking back to the Royal Court's concern, expressed in the financial accounts, that its work 'presents a challenge to the Press, Marketing and Development departments', it is possible to discern

here an example of external influences imposed on the translator: commer-
cial imperatives, in this case built on cultural assumptions, may interfere with
the transmission of the author's intention and the translator's scope.
These cultural assumptions are not necessarily shared. The official website
of the off-Broadway production of David Johnston's translation at the Teatro
Círculo in New York between May and August 2009 shows *Himmelweg* prom-
inently in brackets below the English title of the play (Way to Heaven the
Play 2009). The published French translation translates 'Himmelweg' on the
inside cover as 'Chemin du ciel', in brackets, but not on the outside front cover
(Mayorga 2006). The Spanish published text does not translate the German
into Spanish other than in the course of the playtext itself (Mayorga 2004).
The English published text operates the same non-translation approach but
reversed in that 'Himmelweg' only appears in the playtext and is not used to
subtitle the play (Mayorga 2005). Similarly, it was not used in the advertising
material. The absence of this German title serves to blur the site-specificity of
the Royal Court production and translation, at least prior to arriving at the
theatre or opening the text. It offers the play as a subject for open interpreta-
tion. A review of Mayorga's drama suggests that in this, the translation was
echoing a persistent theme of his composition.

Mayorga broadly adopts a pan-European approach in his work. His plays
make international references to place, such as *Hamelin* (2005) and *Love
Letters to Stalin* (1999), and even, perhaps in an allegory for his work as a
whole, a train crossing western Europe in the case of *Blumemberg's Translator*
(2000). His work also 'draws upon, and enriches itself from, the radical philo-
sophical tradition of Montaigne, Kant, Benjamin and Agamben', according
to Johnston (Mayorga 2009: 14), thus covering a wide range of European
philosophy. On the one hand, this pan-European approach is reflected in
the geographical vagueness of the Royal Court's advertising material. On the
other hand, the translation of the play's title into English, especially when
compared with the strategies I discussed above, to some extent negates the
otherness of the play and the fact that it deals with issues outside London
boundaries. It presents theatre practitioners, including the translator, with
the challenge of signalling the cultural conflict inherent in the original title to
an English-speaking audience unfamiliar with Mayorga's work. In the event,
this was attempted once the audience had been drawn inside the theatre, in
various ways, not least in the period costumes of an otherwise sparse studio
set, shown in Figure 3.9.

Johnston, as translator, retains the back-translation of 'Himmelweg' in the
first utterances of the play, and this was very clearly articulated and repeated
by the actor playing the Red Cross representative. Even before that, the props
list and rehearsal notes show that each member of the audience was to be

presented with a book supposedly from the commandant's library on enter-
ing the theatre, these books being ' "classic European paperbacks" from sev-
eral different European countries in their own language'. These props would
serve as a reminder to the spectators of the interlingual nature of the play, but
also draw them into the creative process in a gesture of inclusion.

Does this inclusion process, already noted in the advertising material
('This is what you can see …'), sharpen or blur the cultural conflict inher-
ent in the play? It might be expected that the international nature of this
play's characters and subject matter lessen the pressure on the translator to
negotiate cultural difference. The play already presents a neutral canvas: the
Red Cross representative is not connected with any national allegiance. The
cultural dilemma for the translator is whether to pursue the indeterminate
portrayal of the character, permitting the viewer to impose their own back
story, or to intervene in the script to clarify that the Red Cross representa-
tive must be from a neutral country (Switzerland, in the historical event).
In other words, should the translator go beyond the original text to make
explicit to the English audience that this is not an English play? Johnston's
translation maintains the neutrality of the original with no furtherance

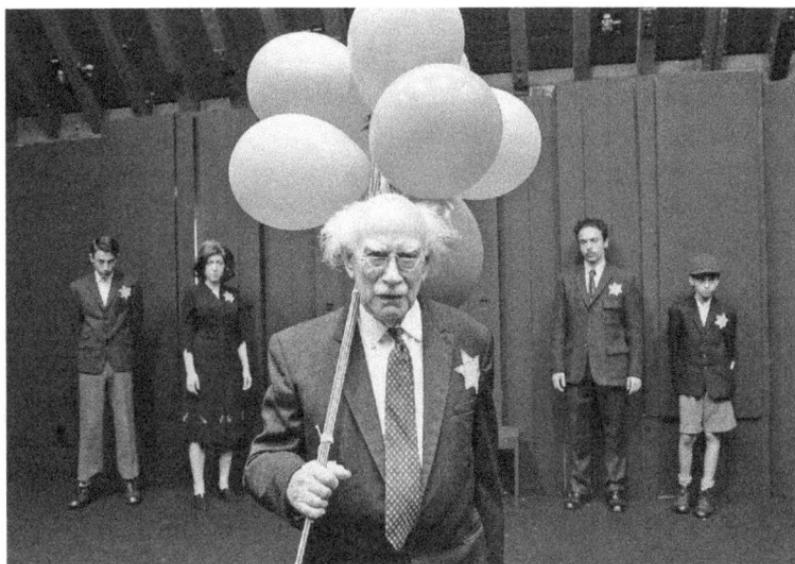

Figure 3.9 John Barrard in *Way to Heaven* by Juan Mayorga, translated by
David Johnston; Jerwood Theatre Upstairs, Royal Court, 2005. Photograph
copyright: Tristram Kenton

of the anglicized title. The effect of this can be seen from the newspaper reviews. Two out of thirteen reviews collected in the journal *Theatre Record* (Shuttleworth 2005c), Nicholas de Jongh (*Evening Standard*) and Paul Taylor (*Independent*), specifically identify the Red Cross representative as British or English. This demonstrates the extent to which the audience identifies with the character, domesticating his nationality. On the other hand, ten reviews include a reference to Spain, suggesting that the writers are clear about the provenance of the play, but not concerned with the implications of its translational status: only three reviews include the word 'translation' and only *The Times* reviewer critiqued the translation, with the word 'lucid' (Shuttleworth 2005c: 850). The name of the translator is shown prominently close to that of the author in the publicity material and the playtext (which doubles as a programme), along with a reference to the International Playwrights series. The importance of the paratext in identifying and locating the translation is thus evident, but even so the receivers choose to focus on other aspects of the play from their own national perspective.

Possibly, this reception of *Way to Heaven* demonstrates Mayorga's intended affect. Interviewed in *El Pais* (Vallejo 2008), he explained: 'That character … resembles myself and many people around me, who want to help, but end up complicit in cruel or unjust actions' (my translation). Perhaps a portrayal of everyman is appropriate here. Johnston has the advantage of access to Mayorga, and indeed has written in respect of his translation of *Nocturnal* that Mayorga works with the translator and is prepared to rewrite if necessary (Mayorga 2009: 14). The subject matter of Mayorga's plays and his detailed study of Benjamin also indicate on his part an interest in the theory and practice of translation. *Way to Heaven* itself reflects upon translation and the relationship between author and translator. Specifically, the commandant appoints Gottfried as his psychological translator to pass on his directions to the other prisoners: 'You will find the right words' (Mayorga 2005: 47). His words comment on the importance of the translator's role and the significance for translation of collaboration in the dual sense of the 'traduttore, traditore' (translator, traitor) trope.

Reflecting on this direct translation, its approaches to the cultural negotiations necessary for all translation do not strike me as significantly different from those undertaken in indirect translation. Where it differs is the attribution of agency among the practitioners undertaking those negotiations. David Johnston, who translated Juan Mayorga's *Way to Heaven* in my sample for production at the Royal Court, notes Mayorga's 'willingness to work collaboratively with new directors, actors and translators, to re-assess as new sensibilities engage with his plays' (Mayorga 2009: 14). His narratives and characters are open to transformative interpretation, and Mayorga

says himself that none of his work is ever finished or in a definitive version. Mayorga likes to work with Johnston because of his active approach as a translator: another indication of author–translator teamwork. Mayorga played a double role in the *Way to Heaven* translation team: dramaturg for the translated play and writer of the original. Furthermore, Mayorga takes on the task of indirect translator himself on occasion, such as his 2011 version of Büchner's *Woyzeck* for the Centro Dramático Nacional at the Teatro María Guerrero in Madrid. He sees the strengths he brings to indirect translation as those of the dramaturg and prefers to leave linguistic translation to an expert.[28] In other words, Mayorga is happy to be a team player in the production of translated work, be it his own or that of another playwright. For him, a specialist in the work of Walter Benjamin, there is no stable text and no perfection, and other contributors enrich the creative process.

Way to Heaven, then, bears some similarities with the foregoing productions under discussion, despite being a direct translation from a new play. It accommodated its English audience, in title and cultural specificity, which was made possible by the flexibility of the author and a shifting Spanish text – thus bearing the hallmarks of collaboration. The name of the translator was displayed prominently on the theatre's website and in the text, although not in the SOLT advertisement, a fate shared with the other translators of contemporary plays within this selection, David Eldridge and David Tushingham. David Johnston's name may not constitute the box office draw of David Hare or Tony Harrison, but he combines a high academic profile with a reputation for creating performable theatre translations, including versions and adaptations, such as his 2008 'adaptation' of *The House of Bernarda Alba* and his 2010 'version' of Molière's *The Miser*, both for the Belgrade Theatre Coventry. Perhaps a focus on the identity of the translator is of less significance for a new play, which does not have to distinguish itself from foregoing translations, but it may also be related to the Royal Court emphasis on the writer. I consider this further in the next and final play of my sample.

The Woman Before: inviting translation

Roland Schimmelpfennig is a contemporary German playwright, whose extensive body of work has been produced in over forty countries (Goethe Institut 2011). A description of Schimmelpfennig's plays as 'surreal text montages which appear to be inspired by García Márquez or Antonioni' (Kultiversum 2011 – my translation), provides some insight into the

[28] Juan Mayorga, interview with Geraldine Brodie (Madrid, 2 November 2010).

cross-border intertextual references which may be found in his plays and the extent to which his creations lend themselves to, and even invite, translation.

The Woman Before (2005) was a direct translation by David Tushingham, a regular German translator for the Royal Court, who has also translated other Schimmelpfennig plays for performance in London: *Arabian Night*, premièred in 2002 by the Actors Touring Company (ATC), and, more recently for the same company, *The Golden Dragon* (2011) and *Winter Solstice* (2017), in addition to *Idomeneus* at the Gate Theatre Notting Hill (2014). Peter Eötvös's opera *The Golden Dragon* (2014), based on Schimmelpfennig's play, was performed in Gregory Vajda's English translation at the Buxton festival in 2016. The frequency and variety of these productions demonstrates the growing awareness of Schimmelpfennig's work among English-speaking audiences, in which Tushingham and the ATC have been significantly instrumental. Tushingham worked as a literary assistant at the National Theatre, and then extensively in Germany as a dramaturg, and has tended to specialize in translating modern plays in German. He has also authored a book of interviews with theatre practitioners, *Not What I Am: The Experience of Performing*, which explores 'that strange collision between the worlds on and off stage, between the performers and the audience' (1995: np). His credentials as a theatre translator from German into English are therefore impeccable, meeting both linguistic and performability requirements. Better known to literary departments and commissioners of translations than the theatregoing public at the time, Tushingham's name might not have been considered to boost ticket sales.

The same could be said of Schimmelpfennig himself in 2005 within the boundaries of the United Kingdom. Modern German plays are not widely known or produced in London, in spite of the best efforts of the Goethe Institut. Dramatic performance works in German were more likely at the time of my sample in 2005 to be associated with opera than theatre: the Online Review London, for example, included two operas by Richard Strauss (*Salomé* and *Ariadne auf Naxos*), three by Richard Wagner (*Twilight of the Gods*, *Siegfried* and *The Rhinegold*), Alban Berg's *Lulu* and Engelbert Humperdinck's *Hansel and Gretel*. That is seven out of a total of thirty-five reviews, or 20 per cent, for six venues (English National Opera, Royal Opera House Covent Garden, Glyndebourne, Richmond Theatre, Sadler's Wells, Bridewell Theatre) in the 2004/5 season (Online Review London 2005). Such popularity does not translate through to theatre. Göbels points out the rarity of classic German plays in Britain since 1945 (2008: 80). Certain twentieth-century playwrights, especially Bertolt Brecht, receive regular productions. However, the presence of two German plays in my sample of

eight (the only other language represented twice is Spanish) surprised me. The trend towards an increase in German translations, generated by the success of *Don Carlos*, would not have been apparent at the time of commissioning this translation. Even though it is a direct translation, this Royal Court production resembles *Don Carlos* – and indeed the translations from other languages in this selection – in the signs of its absorption into the mainstream English repertoire.

The Royal Court's two theatres – the Jerwood Theatre Downstairs (seating 400) and the Jerwood Theatre Upstairs (seating 90) – offer plays that are expected to attract different audiences, as is shown by the full SOLT membership of the downstairs theatre while the upstairs theatre has the affiliate membership signifying a smaller theatre producing more challenging work. *Way to Heaven*, discussed above, was shown in the smaller venue, as is usually the case with translated modern plays. Classic translated plays are more likely to be presented in the larger theatre downstairs, for example, Eugène Ionesco's *Rhinoceros*, translated by Martin Crimp; Max Frisch's *The Arsonists*, translated by Alistair Beaton; and Chekhov's *The Seagull*, in a version by Christopher Hampton, all in 2007. Although the latter was the only one to depart from the Royal Court's policy of commissioning direct translations from source-language speakers, all were attached to prominent names in the playwright/translation field. It is unusual for a modern translated play to be produced downstairs. A recent exception is Marius von Mayenburg's *The Stone*, translated by Maja Zade, in 2009. Neither of the names in this translation project was widely known in the United Kingdom at the time, but an earlier Mayenburg play, *The Ugly One*, had been revived downstairs in 2008 after achieving a sell-out upstairs in 2007 (Royal Court Theatre 2007). This revival, along with two other plays, was titled the 'Upstairs Downstairs season' by the Royal Court in a wry nod to a long-running television series portraying the lives of an upper-class Edwardian household and their staff. It might also be possible to read into this title a reference to the second-class status of translated plays.

The Woman Before joined the select group of translated plays in the Downstairs category. During the course of my interviews with a number of Royal Court practitioners, no firm answer came to light as to why this might be the case. Neither Schimmelpfennig nor Tushingham had previously provided a best-seller for the Royal Court box office, though both were respected writers, and Schimmelpfennig, like Mayorga, had been through the international writers programme, which frequently is the source of playwrights new to the Royal Court and other English-speaking audiences. Aston and O'Thomas point out that *Push Up* (which had been translated by Maja Zade) was 'not … profiling an emergent playwright, but introducing an internationally

acclaimed German playwright to London audiences' (2015: 131). It was nevertheless shown Upstairs as part of the 2002 International Playwrights scheme. The decision to present *The Woman Before* in the Downstairs Theatre may reflect Schimmelpfennig's growing international renown; it may also be connected to the identity of the director Richard Wilson, who had won a Best Director Award in 2000 for his work on another German play at the Royal Court, *Mr Kolpert* by David Gieselmann, also with David Tushingham as the translator.

The play was not incorporated into the repertoire as part of an international series, but rather included in a Downstairs season made up of new plays from up-and-coming British writers, including debbie tucker green (*Stoning Mary*), Richard Bean (*Harvest*) and Jez Butterworth (*The Winterling*). At six weeks, it had one of the longest runs of the season (Royal Court Theatre 2006: 8). The production was endowed with a creative team which should justify its inclusion in the larger auditorium. Both female roles were played by actors seen regularly on television, in particular Helen Baxendale, who had played an important supporting role in 1998 as the love-interest of one of the main protagonists of *Friends*. This Warner Brothers television series garnered immense international popularity, running from 1994 to 2004, still available in boxed sets and satellite channel repeats as I write. And Wilson, an associate director at the Royal Court, was also widely known to the general public at the time for his portrayal of the character Victor Meldrew in the BBC television series *One Foot in the Grave*, and the recurrent catch-phrase, 'I don't believe it'. These popular cultural associations were more appropriate to a mainstream play, and the Downstairs venue.

In an interview (with an unnamed interlocutor) on 5 June 2005, Richard Wilson stressed the importance of new plays and new writers at the Royal Court, adding that 'the thing about Roland Schimmelpfennig's play was that there aren't many people writing that sort of stuff in Britain at the moment and it was just a page turner inasmuch as you never knew what he was going to do next' (Richard Wilson Archive 2011). This suggests that its provenance from outside the United Kingdom was a factor in the selection of this play, which was underlined by the then literary manager, Graham Whybrow, in a post-show discussion on 24 May 2005 with Wilson and four of the actors:

> We can't speak for the writer, but there is a kind of visitor's logic here in Britain, which is predominantly Anglo-American in its theatre culture. When you see a new German play, you tend to make slightly false connections with other German plays, because we don't quite get into the detail of where this writer is sitting. It represents a challenge to us as a theatre to try and break out of that and connect again with continental

European theatre, Eastern European theatre, because we find it quite challenging to the directors, to the actors, to the designers. The plays in a sense take you to a place that you wouldn't otherwise go, which is appealing. (Royal Court Theatre 2005a)

Whybrow thus presents this play as 'not-English', but also as 'not-German', stripping away any tendency to stereotype or appropriate. Perhaps he identified this play as particularly suitable for such treatment, and Wilson agreed to direct accordingly, emphasizing the international aspects of the play.

The subject matter of the play lends itself to a non–culturally specific treatment as it makes strong connections with Greek myths, most obviously Medea's revenge of the poisoned robe (in this case, a gifted bag from former lover to wife, causing spontaneous combustion), and the extended chorus-type monologues of a minor character. In fact, the reviews refer more to links with Greek tragedy than to the play's German provenance (Shuttleworth 2005d). This may indicate that Whybrow's intended effect was achieved. In production, there was no question of removing *The Woman Before* from Germany; all the character names were retained, including that of Romy Vogtländer (a potentially challenging enunciation for an English-speaking actor), and the character's name Claudia was pronounced in the German way. Almost subliminal hints were used to reference things German: the props list cites a marker pen that is 'German made', and the rehearsal notes call for 'a set of Mercedes car keys'. The set portrayed the generous apartment described in Schimmelpfennig's stage directions, as shown in Figure 3.10.

Nevertheless, the effect of this play, recounted by the audience contributing to the post-show discussion, was one of formality and distance. Both the play and its reception can perhaps be summed up by the actor playing Claudia, Saskia Reeves:

> We were struggling in the last week [of rehearsals], and I remember thinking, if this is Beckett we wouldn't argue so much, and then I remembered Brecht and cheese. Richard [Wilson] also said, this is a European play, this is a German play. These aren't English people. (Royal Court Theatre 2005a)

I assume that in her reference to Brecht and cheese, Reeves is thinking of the cheese ceremony in the Prologue of *The Caucasian Chalk Circle*. Meg Mumford recounts an anecdote concerning Brecht's direction of that scene, and his insistence in rehearsal on using a real piece of cheese as a prop to 'help build the episode into a historical moment' (2009: 104). One of the characters in this scene also speaks the line: 'You see, our goats didn't like the new grass. Different grass, different cheese, see?' (Brecht 2009: 4). Reeves displays her

Figure 3.10 *The Woman Before* by Roland Schimmelpfennig, translated by David Tushingham; Tom Riley as Andi; Saskia Reeves as Claudia; Helen Baxendale as Romy; Nigel Lindsay as Frank; Royal Court Theatre, 2005. Photograph copyright: Alastair Muir

awareness of Brecht's concepts of epic theatre and *Verfremdungseffekt*, thus associating Schimmelpfennig's work with alienation, otherness and, for good measure, Beckettian absurdity. It would appear therefore that the audience's reception of 'distance' reflected the Royal Court's approach to the play.

The play was thus presented as 'Other' rather than 'German' and, not unlike *Way to Heaven*, approached its English audience by way of non-cultural specificity, offering classical references and what the post-show audience considered as the universal theme of love. Schimmelpfennig's writing lends itself easily to this treatment, as can be seen from the intercultural composition of his other plays – *Arabian Night*, for example, concerns a diverse group of immigrants (2002), *The Golden Dragon* is set in a 'Thai/Chinese/Vietnamese fast food Restaurant' serving an assortment of generically described characters such as 'The Grandfather' and 'First Stewardess' (2011: 19, 21). Furthermore, my comparisons of Tushingham's submitted draft, the published text, the prompt book and the performance recording reveal that there were barely any amendments to Tushingham's translation. Aston and O'Thomas note that 'in London, it was the style, rather than the content, that drew the critics' attention: the temporal shifts, cool

playfulness and classical formality of the drama' (2015: 131). In my opinion, Tushingham brilliantly captures these elements of the German language in which Schimmelpfennig writes, a language that invites translation and creates a path for Schimmelpfennig's work to cross boundaries.

How, then, does *The Woman Before* compare to the previous translations in my sample? Of the eight plays, its translated text appears to display the least intervention from London theatre practitioners, and even the translation itself seems to me to be the closest follower of its source text, much of which is due to the outward-facing linguistic skills of both the writer and the translator. It is apparently a long way from the overt adaptations of the *UN Inspector* or *Hecuba*. Nevertheless, there are signs of its approach to its English audience. Like *Hedda Gabler* and *Way to Heaven*, the source-language play expects to be translated, and sits easily on the English stage, received at face value by the reviewers. Like most of the plays, *Way to Heaven* being the possible exception, there was an element of celebrity casting, both on- and off-stage, bringing the play into the domestic arena. So *The Woman Before* slipped into the English repertoire, recognized more for its allusions to Greek tragedy than for its German origins, and joining the cohort of translated plays on the London stage.

The paradox of visibility

The brief summaries of this collection of productions of translated plays give an indication of the variety of processes that arise when a playtext is translated into English for the mainstream London stage. The translator or writer may be composing for personal use as director, or at the request of a director; may be using a literal translation prepared by a theatre specialist or translating from the original in consultation with its author; may work regularly with a specific playwright or a particular genre. The practice cannot easily be divided into distinct types and the practitioners themselves move between different procedures, as will become clearer in the next chapter. Furthermore, the use of the word 'celebrity' to refer only to indirect translators does not seem appropriate when studying the details of these translations. All the direct, indirect and literal translators of the sample are known in their field, many are also more widely recognized by the theatre-going public. All are selected as theatre specialists by the commissioners of the translations. And in most cases, a lesser-known translator is supplemented by a celebrity elsewhere in the production. The exception to this practice is possibly *Way to Heaven*, where the contributors were seasoned professionals rather than household names, but as this production was shown in a studio theatre it is

likely to have been operating on a smaller budget and also had fewer tickets to sell. This practice does, however, indicate the importance of a 'package' when putting together a translation team: a degree of visibility is deemed to be required in at least one element of the production.

One of the most remarkable trends in my sample is the recurrence of the name David: this is the case for five of the eight translators. Extending this analysis, it is striking that all the direct and indirect translators, directors and playwrights in this sample are male, with the least visible contributors – four of the literal translators and a producer – being female. As Lori Chamberlain asserts, 'feminist and poststructuralist theory has encouraged us to read between or outside the lines of the dominant discourse for information about cultural formation and authority; translation can provide a wealth of such information about practices of domination and subversion' (2012: 267). Women seem to be more visible in the theatre as I write in 2017 than was the case in 2005, with female artistic directors at two of the theatres I examine, Vicky Featherstone at the Royal Court and Josie Rourke at the Donmar. The head of the new work department at the National Theatre is Emily McLaughlin and Clare Slater has taken up a newly created literary manager role at the Donmar. But my impression is that the directors of translated productions are still more likely to be male, with Katie Mitchell a notable exception, as are the writers and visible translators of texts for staged translations. It would certainly appear from this sample that viewing theatre practices through a translation prism provides information pertaining to theatrical hierarchies and visibility, which I consider further in the next chapter, especially in relation to the least visible practitioner: the literal translator. However, the above analyses also demonstrate the fundamental role played by the literal translator in the production of the translation. In particular, just as for indirect and direct translators, the stagecraft skills of literal translators are a priority alongside their linguistic ability. This is evident in the use of literal translators who are well-grounded in theatre, trained in literary departments or as practising actors. In every case, these translators pursue a career connected with performance in addition to their translation work. This is significant to their part in the collaborative process.

Five translators were named in the *Sunday Times* advertisements from which this sample was drawn, as shown in Figure 1.1, a mixture of direct and indirect translators. If a celebrity sells tickets, this suggests that celebrity names are used for direct as well as indirect translations: the advertisers are not distinguishing between translation processes when including the name of the translator. I would argue, however, that they are muddying the translation waters by using other terms. None of the plays with named translators are labelled as translations in the advertisements: they are offered as versions

or adaptations, although they may be described as translations somewhere in the accompanying literature. In naming the translator while denying the translation, these advertisements suggest that it is not translation skills that are being sold but something else: the translator's voice and its expression of the original play. In my sample, it is the recognized plays from the theatrical canon that are tied by advertisement to a celebrity name. New plays are apparently not considered to be in need of being linked to a new voice. In my view, this suggests that the identity of the translators is relevant for what they add to the performable text – the value of innovation. The advertisers seek to give their prospective audience a reason to buy a ticket for a play they have seen before, hence the name of the translator and, invariably, the appearance of the word *new* in the advertisement. This blurs the association of 'celebrity' with indirect translation alone and suggests that it has further uses.

My proposition is that the use of a celebrity translator highlights the act of translation and the existence of translations themselves. The fact that the audience is not seeing the original text is pointed out to them by the prominence of the translator's name, a reminder that a production is a new reading of a pre-existing text. Marvin Carlson considers the 'excitement and promise' of a concept of supplementation for theatrical performance (1985: 11) and, as Sirkku Aaltonen points out, 'the study of translations (like the study of performances) can reveal what indeterminacies different types of translations have revealed, and how these have been supplemented at different times by differing agencies, and why' (2010: 104). Theatre translators, particularly indirect translators, are expected to produce a text with which the audience will feel comfortable: a 'domesticated' text whose 'transparency' will contribute to Venuti's invisibility of the translator and the translation. Paradoxically, in my view, the celebrity translator chosen for the position they adopt towards the text, that evaluative attitude of translation which Hermans points out 'is inscribed in and comments on the actual translation' (2007: 85), is more visible precisely because of their overt intervention in the text. Their role is not to mediate, but, as Mona Baker describes, to 'participate in very decisive ways in promoting and circulating narratives and discourses of various types' (2005: 12). I am arguing here that the celebrity translator adds more than a name to a translation: their presence gives visibility to the act of translation, demonstrates the importance of the translator's voice, queries the mediation role popularly expected of an unseen translator, highlights the collaborative processes of theatre translation and foregrounds the existence of the genre of 'plays in translation'. However, beneath the visible surface of the named translator, the contributions of other collaborators may go unseen. In the next chapter, I delve further into these contributions, and how the collaborators themselves view their involvement.

Agents of Translation

Practitioners and process

One of Nicholas Hytner's many duties as the artistic director of the National Theatre (2003–2015) was to report on the state of the organization's affairs in the annual financial statements. In the accounts for the fifty-two weeks ended 2 April 2006, Hytner wrote:

> The atmosphere and the audience are a consequence of the show, and it is always to the show, on what it has to say and how it says it, that we return; and the quality and integrity of the imaginations of those who create it are paramount. To sustain those imaginations we rely ... on both the ticket-buying public and on the patronage of the state. We will continue to do everything we can to attract both of them. (Royal National Theatre 2006: 5)

Hytner's emphasis on the significance of creativity for critical and financial reception is the impetus for the discussions and analyses in this chapter. Who are the individuals that contribute to translated plays in production? What motivates and inspires them, and is it possible to quantify their role within the creative collaboration that ends in production? I follow Hytner's lead and investigate how these 'imaginations' are marshalled by theatrical management, of which Hytner is a leading example, into a team responsible for the theatrical performance of a translated playtext. Is the teamwork itself, the collaboration, manifest to the audience in the 'atmosphere' around the play or in the translated text? And how is that visibility managed, artistically and commercially? This chapter summarizes my conversations around the topic of theatre translation with a selection of theatre practitioners connected with the eight plays in my sample. I interviewed agents involved at many stages of production, from commissioning to presentation on stage, discussing the practical processes of translation for performance in relation to the specific plays in my sample along with the general approach and experience of these agents to theatre translation.

Manuela Perteghella has concluded from her own descriptive study of collaboration in theatre translation that 'inequality in power relations is ...

unavoidable in collaboration' (2004b: 195), and I would echo that each power relation is unequal in its own way. These conversations reveal different levels of collaboration both within and beyond the translation process, much of which is unknown to the audience, ignored by the reviewers and discounted by theatre practitioners themselves. I have grouped my interview subjects under broad headings which provide the closest descriptions of their role, but it became obvious during interview that many practitioners have experience of more than one position within the spectrum and are sometimes fulfilling several roles simultaneously. Michael Grandage, for example, was both the artistic director of the Sheffield Theatres and the director of the play *Don Carlos*; these intersecting roles are reflected in the fact that he is therefore included in two sections of my analysis. Similarly, among the translators, Mike Poulton, interviewed for this project with reference to his work as the indirect translator for *Don Carlos*, translates directly from Italian and therefore his general views are informed by that practice. Simon Scardifield, interviewed as a literal translator, translates directly for performance and has acted in translated plays. Several practitioners have worked in a literary department at some stage in their career, and most of my interview subjects had some connection to the National Theatre through their theatrical experience. Such instances are the norm rather than the exception, and for this reason I have not attempted to stratify translation practices according to the descriptive–anthropological model advocated by Perteghella (2004a: 11–19), since it would require the attachment of several labels to each practitioner, creating a graphic web rather than a tabular illustration.

Aiming to obtain a body of comparable data, I devised a system of semi-open interviews. However, I tailored these questions for each subject according to the creative role and production under discussion. The natural length of an interview seemed to be about one hour, whether there were several roles and productions under discussion or only one. This may have been dictated by the time available in a full schedule, but is more likely a feature of a participant's engagement level with a now finished project, and the amount of introspection to which any interviewee was prepared to submit. What is striking, particularly now that I look back on the interview process, is that so many busy people, many of whom are self-employed and therefore foregoing paid time, agreed to respond to and indulge a researcher's questions on past endeavours. This fact alone suggests to me the commitment of my interview subjects to their process and product, their pride in their work, and their awareness of their contribution to the wider theatre-making translation field.

Each interview necessarily differed in its conduct and subject matter and while my analyses seek to draw out consistencies of approach among different agents, the results must ultimately be seen as subjective and applicable

only to each individual concerned. This subjectivity extends from my own involvement as the formulator of the questions and the conductor of the interviews to the implied acquiescence of the interviewee in agreeing to participate. I sometimes felt that I was told what the speaker thought I wanted to hear or what they hoped I would repeat to their advantage. Nevertheless, the eighteen interviews that I conducted combine to supply a record of translation activity in mainstream theatre around 2004–2005, and raise questions that are pertinent to current practices and the future of stage translation.

Perteghella sees literal translation as 'a first draft of a collaborative project' and insists that literal translators 'play a prominent role in the dissemination of contemporary foreign theatre in Britain' (Meth, Mendelsohn and Svendsen 2011: 209). In my sample, two of the three modern plays were directly translated and the third, *Festen*, was an amalgam of intralingual, interlingual and intersemiotic translation, in which an English-language playscript, never intended as a literal translation, was one of several elements. Thus the dissemination of contemporary foreign literature was not the impulsion for literal translation in my sample. The four literal translations all related to new versions of classic texts, and were specifically commissioned for performance, even though a range of extant English translations were available. The eighth play, *Hecuba*, was translated from ancient Greek by a specialist linguist, Tony Harrison. Nevertheless, Harrison is also a specialist poet and adaptor who was knowingly adding to the acknowledged pluralism of translations of ancient texts; his version was an overtly personal statement. What functions are the literal, direct and indirect translators therefore performing in the dissemination of translated theatre? And must the translation of contemporary theatre be differentiated in approach, practically and theoretically? If, like Perteghella, I consider literal translations to form an important part of the collaborative project of staging translated plays, I have to establish the purpose of an invisible and laborious body of work which apparently retraces steps that have already been taken. In order to do this, I look behind the first tap on the translator's keyboard to the practitioners who commission not only the translations but also the inclusion of the translated plays themselves in the repertoire. Who sets the process in place and who can be identified as a collaborator? The following sections chart the organizational networks, perceived or otherwise, within the substantially collaborative practice of theatre translation. I begin by considering the roles where projects are generated, and end with the thoughts of an author, Juan Mayorga, whose source text is the subject of translation. However, as the theatrical translation process contains a degree of circularity within its linear progression, the following order relies more upon pragmatic narrative intuition than exclusive classifications and strict hierarchies.

Artistic directors

An informative description of the role of the artistic director is provided by the American Association of Community Theatre: 'Responsible for conceiving, developing, and implementing the artistic vision and focus of the organization, and for major decisions about the ongoing development of the aesthetic values and activities' (American Association of Community Theatre 2011). This, then, is a key position in a theatre's management structure, setting the tone of the in-house culture and the parameters for the annual programme of productions. The artistic director is highly influential in the progression of a translated play, from commission to performance. All the subsidized theatres discussed in Chapter 2 employ an individual who performs the functions of an artistic director, and this will be the case in most commissioning theatres. Generally, additional directors are engaged on a contractual basis to conduct specific productions. The majority of directors are therefore self-employed, with only a small number of artistic directors in permanent employment. Unemployment is an occupational regularity for theatre practitioners, as explained by the US Department of Labor:

> Work assignments typically are short term – ranging from 1 day to a few months – which means that workers frequently experience long periods of unemployment between jobs. The uncertain nature of the work results in unpredictable earnings and intense competition for jobs. Often, actors, producers, and directors must hold other jobs in order to sustain a living. (Bureau of Labor Statistics 2011)

Consequently, the position of artistic director is highly prized among theatre practitioners; once in possession of this demanding role, its holder will feel under pressure to maintain a critically and commercially successful output, conducting business accordingly. Not only is the position of the artistic director relatively rare, it is also high-profile. Even in a smaller theatre, the artistic director personifies the culture of that organization. The artistic head of a large company such as the National Theatre is publicly held to account for all the activities of that organization, and freely criticized. In an interview with the BBC's Arts editor Will Gompertz, broadcast on the BBC Radio 4 Today Programme on 13 July 2016 to mark the end of his first year as the artistic director of the National Theatre, Rufus Norris, who succeeded Nicholas Hytner in 2015, noted the necessity to 'grow leather skin – quick' because 'the criticism from outside, and sometimes from inside, is going to be constant' (BBC 2016, my transcript). An artistic director's management decisions are inevitably affected by this public face.

Commercial theatre groups operate on a different basis, whereby independent producers, often in consortium, will put together financial and artistic proposals for productions which are then accepted into West End theatres. The next section discusses production and producers. The three commercial organizations in my sample, Delfont Mackintosh (ultimately owned by the producer Cameron Mackintosh), Nimax and Ambassador Theatre Group, do not have artistic directors. Their chief executive will generally be ultimately responsible for the programming of productions in their owned and managed theatres, assisted by additional members of staff in production and programming. The Ambassador Theatre Group includes several production companies, among them Sonia Friedman Productions which employs a number of production specialists and draws on the expertise of the former head of the National Theatre literary department, Jack Bradley, as a member of the team.

Michael Grandage had been the artistic director of the Sheffield Theatres responsible for commissioning Mike Poulton's new version of Schiller's *Don Carlos*. Unlike the three other artistic directors I tried to contact, Grandage responded promptly to my request for interview, and broke away from rehearsals at the Donmar Theatre to meet me in one of the theatre bars. My interview with Grandage covered his activities as the artistic director of the Sheffield and Donmar Theatres and the director of a specific theatre production; in this section I focus on his role in planning and programming a translated play. It became clear during our discussion that Grandage has an overview of the shape any translation will take and assembles the creative team accordingly. The play itself is the first item to be chosen, which may be a work he already knows, as was the case for *Don Carlos*. In such instances, Grandage has an impression of the play which he characterizes as being 'more about a narrative than the text'[1] and he may not feel the need to conduct further textual research before continuing the process. Where Grandage is less familiar with a play, he will read 'quite a few' translations as they 'can vary so widely'. He will then commission a literal translation in advance of appointing a writer to work on the project. His assumption is that a literal will be needed, as very few writers are sufficiently comfortable in another language to work from the original, although he identified Christopher Hampton, a well-established writer and adaptor known most recently for his commercially successful translations of new French plays by Yazmina Reza and Florian Zeller, as an example of a writer who would not want or need to work from a literal translation of a French-language play.

[1] Michael Grandage, interview with Geraldine Brodie (London, 28 May 2010).

It is notable that Grandage characterizes the creator of the performed translation as a professional *writer*. He makes the point that this practitioner need not be a playwright, and could be a poet or other writer, but must be someone whose 'job is language'. For him, therefore, there is not an initial question, or official policy, of operating a two-step translation process. The essential task for him as artistic director is to identify a writer who complements the original: 'I always try and customise the skills of an individual voice to the temperament of the play'. This may take the form of identifying a writer who deals in subject matter similar to that of the play but may result from more 'lateral thinking'. David Eldridge, for example, writes about domestic drama in a voice that Grandage felt would bring a fresh approach to Ibsen's *The Wild Duck*, because the themes of Eldridge's own work made a good fit with Ibsen's content, even though the writing styles might be very different.[2] Grandage therefore prioritizes voice over linguistic ability, commissioning a literal translation at the beginning of the process merely to save time and not because he believes the two-step process to be superior. He may not yet have identified the writer selected for the translation; the source-language proficiency of the putative adaptor is therefore unknown, but a literal translation is likely to be required.

Accordingly, Grandage will commission a new literal translation for each project, in the same way that he prefers to commission a new translation, even when an existing translation remains 'fresh and contemporary'. For him, it is crucial that his theatre's production has 'new life and a new breath'. This discernment extends to the appointment of the literal translator. Grandage will make enquiries to establish who is likely to produce a workable literal translation, using the literary department at the National Theatre as a resource for this information. However, if he is aware of a 'serious expert' in the relevant language, he will approach that person by preference. He commended Helen Rappaport, translating from Russian, 'because she comes up with fantastic notes'. This demonstrates his emphasis on the precision required from a literal translation, offering a context for the decisions to be made and providing dramaturgical advice.

Grandage's investigative approach to commissioning a play as artistic director applies equally to the appointment of the writer and director, and he assumes responsibility for the progression of a translation until the creative team is in place. For *Don Carlos*, the distinctions were blurred as he fulfilled both directorial roles. However, his summary of commissioning procedures

[2] In the event, this production, premièred in December 2005, was the subject of both critical acclaim and box office success, leading to a further collaboration between Eldridge and Grandage on Ibsen's *John Gabriel Borkman* (2007).

in general made it clear that all productions under his governance as artistic director would fall in with his overall vision of how the theatre's offering should be presented. As Grandage appoints translators and directors, he sets the tone for a production, although he acknowledges that this is 'tricky' because he cannot know how the as yet unappointed director will 'interpret the play'. At this stage, he differentiates his position as artistic director, explaining that he is 'speaking for the play rather than the production'. He also referred to a case where the translation, when it arrived, was not what he had requested, stipulating that he was responsible for any lack of communication and that he had learned from that incident to be very clear in his commissioning requests. This clarity in management expressed itself throughout the interview: Grandage replied to my questions in a focused and ordered way, illustrating his points with examples. As a result, although this was one of my shortest interviews, he addressed all the issues I had prepared. I could imagine how he would succeed in imposing his vision on creative and administrative personnel, as he is well-organized and clear in his approach to management.

For *Don Carlos*, Grandage selected Mike Poulton as translator on the basis of research and informal professional references. They had not worked together previously, but the actor Derek Jacobi, who had agreed at an early stage to play Philip II, had appeared in a Poulton translation[3] to his satisfaction. Grandage specified that he had read and seen several of Poulton's translations and was attracted to his work by

> an unusual ability to create something that felt very contemporary but classic in style. I haven't come across that in a lot of translators or adapters. I absolutely wanted *Don Carlos* to breathe for a modern audience, so that they didn't think they were watching some kind of fusty museum piece.

That this desire was achieved can be seen from the reception to the play, discussed in Chapter 3. It also demonstrates Grandage's ability to conceive of a directorial strategy and then successfully communicate it to his creative team. As artistic director, Grandage's approach to plays in translation can probably be summarized as privileging what he sees as holistic production values (the totality of the mise en scène) over textual matters, including translation issues. He views the writer/translator as part of a dynamic and synchronized team under his control. Grandage devotes great attention to the assembly of the production team, which is frequently made up of trusted

[3] Anton Chekhov's *Uncle Vanya*, directed by Bill Bryden at Chichester Festival Theatre, 1996.

individuals known to him from previous assignments. Translation is just one of the elements to be considered, with the translator a member of a collaborative team. As he says, 'I assemble an overview, a vision of a production … That's the visual starting point. You then want to draw on people who will help you create that'.

Grandage's view is instructive for translation purposes, both for its emphasis on collaboration and for its subordination of translatorial issues to his personal vision. It makes clear that any translation appearing in a theatre over which Grandage has control must subscribe to the culture, themes and values of that organization. This is to be expected, and my observations of the other theatres in my sample, and other artistic directors with whom I have worked closely since this interview process, such as Christopher Haydon of the Gate Theatre Notting Hill (2012–2017), is that the personality and management style of the artistic director strongly influences the approach to all productions, including translations.

One of the most successful productions during Nicholas Hytner's artistic directorship of the National Theatre was his direction of Richard Bean's *One Man, Two Guvnors*, a comedy based on *The Servant of Two Masters* by Carlo Goldoni. In an article published in the *Financial Times* at the time of the production, Hytner claimed that this translation 'reconciles a degree of literary critical analysis with a shameless determination to entertain, and that it, therefore, has something in common with [National Theatre productions of] Ibsen and … Chekhov' (2011: 2). This gives an indication of Hytner's approach to the translation of canonical texts that can also be seen in the reworking of *The UN Inspector* in this sample: an irreverent updating that nevertheless closely acknowledges its source. Hytner went on to reinforce this view in his article:

> I often find myself juggling a profound belief in the transformative power of theatre with a fear of pretension. I think the strength of the British theatre often lies in the reconciliation of the desire to elevate and the desire to entertain. (2011: 2)

This combination of entertainment and instruction is not a new concept, neither in the arts (for example, the founding mission of the British Broadcasting Company to 'inform, educate and entertain') nor in Britain. Lope de Vega's *Arte nuevo de hacer comedias en este tiempo* (1609) extolled 'engañar con la verdad' ('tricking with the truth' – my translation) (line 319) to entertain and instruct, a precept taken up by Lorca in his direction and adaptation of Lope's works for the Barraca touring company (1932–1935). Beliefs and conventions are passed down through generations of theatre-makers; the second of the two plays under Hytner's control in this sample was authored

by Lorca. The dual themes of entertainment and instruction feature equally in this production.

If, as I believe, the priority to entertain can be understood to include offering productions likely to attract an audience, Hytner appears remarkably similar to Grandage. They both describe the tension between creative imagination and audience accessibility which they have constantly to address in their roles, and which must also be applied to translation for the theatre. For the successful artistic director, a translation, like any other production, must have audience appeal. And the artistic director has the power to ensure that this focus is achieved.

Producers

Four plays in my sample transferred to West End theatres from the subsidized sector. Of these, two began in production at the Almeida Theatre: *Festen* and *Hedda Gabler*. *Don Carlos* originated at Sheffield Theatres, and *Hecuba* was commissioned by the RSC. Richard Eyre, the director and indirect translator of *Hedda Gabler*, sets out the genesis of his project in his introduction to the published text (Ibsen 2005: 8). Eyre's description of his presentation of a prearranged package for production to the then artistic director of the Almeida Theatre, Michael Attenborough, and the commercial producer, Robert Fox, is similar to the approach outlined to me by Marla Rubin, the producer of *Festen*.[4] Rubin differentiates her role from that of a 'moneybags producer', insisting that raising money is only a small part of her role; she is more interested in managing the creative aspects of a project. Rubin has detailed recall of her search for creative collaborators who would coincide with her vision of the *Festen* project, not only in the writer/director pairing of Eldridge and Norris, but even going so far as the production designer Ian MacNeil, whose work she had admired on Broadway in the touring production of J. B. Priestley's *An Inspector Calls*. This latter production, originally directed for the National Theatre by Stephen Daldry in 1992 and still on stage in 2017,[5] adopts a non-naturalistic production approach to murder in a dysfunctional middle-class family, thus containing several parallels with *Festen*. This detail demonstrates the extent of planning and research in forging a production plan.

[4] Marla Rubin, interview with Geraldine Brodie (London, 15 July 2010).
[5] *An Inspector Calls*, directed by Stephen Daldry, was in production at the Playhouse Theatre London for a 'limited season from 4 November 2016 to 4 February 2017', according to its dedicated website http://aninspectorcalls.com/ (accessed 12 August 2016).

At the time of the transfer of the *Festen* production from the Almeida Theatre to the Lyric Theatre in London's West End theatre district, Rubin entered into a new partnership agreement with Bill Kenwright, a well-established commercial theatre producer with a long track record of staging successful productions in the West End and on Broadway.[6] Rubin explained that Kenwright 'brought infrastructure and capital' to the project, although she had already raised (undisclosed) funds herself, and took her own investors onwards into the transfer. While this demonstrates the importance of funding for West End productions, it does not preclude artistic endeavour from the business of production. In 2012, Bill Kenwright Ltd listed two theatre consultants on its website and thirteen employees whose titles referred to production or programming, alongside nineteen management, financial and administrative functions, which gives an indication of the specialist nature of the production business (Bill Kenwright Ltd 2012). Rubin expressed delight in recollection of her agreement with Kenwright that she should take precedence in the production credits, 'for the first time in his career'. Rubin saw this as recognition of the balance of ideas and money in the production process.

In spite of Rubin's claim to be unusual in focusing on the creative side of production, Matthew Byam Shaw's insistence on the interaction of creativity and finance in his role as producer also points to the interdependence of these elements in the production process.[7] Byam Shaw, who produced the transfer of *Don Carlos* from the Sheffield Theatres to the Lyric Theatre in London's West End theatre district, claimed that in this instance he was in a more subordinate role than would usually be the case for a producer. He felt this was so because he was also employed at the time as the literary associate for Sheffield Theatres, and had been 'hired by Michael Grandage'. As a producer, he would usually expect to be consulted in advance decisions concerning the creative team, including translation issues. In this case, however, the ideas came mostly from Grandage, who Byam Shaw described as 'a strong artistic leader'. Even so, Byam Shaw suggested that this production was not untypical in its genesis and subsequent arrival in the West End: 'Most fresh producing in the West End comes from forged relationships between the subsidized and commercial sectors'. It is certainly the case that the four West End productions in my sample all started life in subsidized theatres. Byam Shaw suggested, however, that, in contrast to the *Don Carlos* trajectory, the

6 Kenwright's production *Blood Brothers*, for example, ran at the Phoenix Theatre, London, from 1991 to 2012 and was still touring the United Kingdom in 2016–2017, according to the website for Bill Kenwright Ltd, http://www.kenwright.com/?id=576 (accessed 12 August 2016). The production was also staged at the Music Box Theater on Broadway in New York, from 1993–1995, and toured internationally.
7 Matthew Byam Shaw, interview with Geraldine Brodie (London, 5 April 2011).

possibilities of a West End transfer are often factored into planning at an early stage in the development of a production.

While still in preparation, *Don Carlos* emerged as a likely candidate for transfer, and Byam Shaw was 'marking out a possible theatre and marketing strategy, in readiness'. This practice, he explained, is a feature of his production planning, even though transfer may not ultimately take place. He considered *Don Carlos* a 'huge gamble' in the West End, as it did not fit the general 'rule of thumb': 'Title, stars, reviews'. With regard to the title, Schiller's plays had made only infrequent appearances in London up to 2004. As far as star quality was concerned, Derek Jacobi, the lead actor in the production, although a well-known actor, was at the time not a guaranteed box office draw, having recently appeared in a new play by Hugh Whitemore, *God Only Knows* (2001), which had disappointed the critics, subsequently running at the Vaudeville Theatre for only twelve weeks. And although the local Sheffield reviews for *Don Carlos* had been excellent, they had not necessarily permeated as far as London. However, Byam Shaw asserts that the 'rule of thumb' is not always correct, and, in this instance, he was encouraged to push for transfer based on his personal artistic involvement with the production in Sheffield. This exemplifies what Byam Shaw enjoys about the production process: 'The tension between the art and the commerce'.

Byam Shaw takes the view that 'an unlikely hit will always get out' because it will be noticed in some way. In the case of *Don Carlos*, he recounted a telephone call from the box office early on a Saturday morning ('very rare to take money on a Saturday') asking for permission to put on an extra member of staff to deal with bookings. The night before, the production had received uncharacteristically glowing reports on the BBC *Review Show*. He attributed the success of *Don Carlos* to its narrative structure and tautness: 'It works as a thriller'. He also praised Grandage for making sure that the audience does not have to sit for too long. This recognition of the collaboration between Grandage and Poulton in cutting and structuring the play echoes the recollections of both of these agents. The unlikely success of this production owes much to the reformulation of the play through translation.

Byam Shaw looks to include translated plays among his corpus of potential West End productions, but inclines to the view that 'a named translator can help a British audience towards a title they might otherwise be shy of', in addition to bringing 'their undoubted dramaturgical skills'. The most important factor for Byam Shaw in a successful production is the nature of the creative team: 'Everything is about the collision of the collaboration'. As producer, he is generally closely associated with building that team. The producer, therefore, is influential in the translation process and financial

considerations play their part among the many elements which make up a production.

A further area where the producer has influence over translation and its perception is in the billing of a production. Byam Shaw pointed out that advertisements become cluttered with too many names, and therefore many key participants are omitted, himself included. The producer thus joins the list of invisible agents, which might also include the translator, direct, indirect or literal, depending on their perceived recognition in selling tickets. However, in his view, everyone should appear in the programme. He was not able to comment on why no literal translator appeared in the *Don Carlos* programme. He remembered the negotiations as to whether the production should be labelled a translation, version or adaptation being 'delicate' and was not willing to discuss this matter any further. In fact, it bears all three labels in varying formats, which I analyse in further detail in my contribution to a volume on authorial and editorial voices in translation (Brodie 2013: 119–40). Speaking more generally, however, Byam Shaw felt that there might be times when a writer would push for the term 'adaptation' while the director preferred 'translation', which to some extent reflected the degree of creativity which each contributed to the project. Negotiations are likely to continue.

My interviews with Rubin and Byam Shaw reveal the inextricable place of funding within the translation project. While neither discussed their financial transactions in any detail, they acknowledged that their role was to combine finance and creativity, and demonstrated their inclusion in the team-building process which ultimately sustains any production. Additionally, in their descriptions of the negotiations taking place throughout the commissioning and rehearsal process, they reveal a glimpse of the tensions and power struggles around the site of production. Translation, with its multiplicity of agents and voices, further contributes to that tension.

Literary departments

Defining the activity of a literary department is a challenge, not least because it is an area of theatre studies which remains largely untheorized. The work of the literary department tends to be conflated with dramaturgical activity. Adam Versényi describes the typical function of a literary department in his 'dramaturgy' entry for the *Oxford Companion to Theatre and Performance*:

> The literary management necessary to select a theatre's season, collaboration with a director to create a new approach to a Shakespeare play, aid to a contemporary playwright in the gestation of a new work, writing

programme notes or leading a post-show discussion, preparing a new translation of a play, or providing the visual, textual, or aural tools to stimulate a company's rehearsal process. (2010: 176)

This may well be the situation in the United States, where Versényi is based. Cathy Turner and Synne K. Behrndt's study of UK dramaturgy, however, claims that the job title of 'dramaturg' is 'distinct from "literary manager", "artistic associate" and so on' (2008: 13). The term 'dramaturg' has been a rarity in the United Kingdom, although it is now gaining ground. At the time of my sample, the National Theatre, the RSC and the Royal Court had literary departments; the Almeida Theatre had an artistic associate; the Sheffield Theatres had a literary associate. More recent developments in dramaturgy, such as the reorganization of the National Theatre literary department to become the new work department, reflect a shift identified by Duška Radosavljević in which 'notions of "new writing", "theatricality", "writing for performance" and "dramaturgy" meet in contemporary British theatre' such that 'dramaturgy is not restricted only to the domain of writing for the stage' (2013: 91, 103). Literary departments and their remodelled equivalents contribute to – and coordinate – theatre and performance practices that are ultimately consolidated in a performed production.

Theatre literary resources are well-known to theatre practitioners: many of my other interview subjects referred to a literary department in discussion, and at least three, Karin Bamborough, Matthew Byam Shaw and David Tushingham, had been members of such a department during their careers. Nevertheless, this activity, which, as Versényi points out, is always being carried out, 'whether or not someone carrying the title of dramaturg is involved' (2010: 176), is overlooked when considering the influences on productions and, for my purposes, translations. Even Manuela Perteghella, who sees the work of a literal translator as akin to that of a dramaturg (2004b: 206), writes of commissioning in the passive tense and characterizes literary departments as sites of 'reading' (91). The source of the instruction to commission a translation, and the function of carrying out that instruction, is rarely investigated, although there has been a recent surge of interest in dramaturgical processes, notably Katalin Trencsényi's study *Dramaturgy in the Making*, which includes a chapter on dramaturgy and translation among a wide-ranging view of the dramaturgical field (2015). My interviews, however, combined to provide a general impression of the processes in a literary department applicable to commissioning a translation, and it became clear that, if a translation is to be commissioned, literary personnel are likely to be involved.

Paul Sirett, associate artist at the Soho Theatre, who ran the literary department of the RSC from 2001 to 2005 where he held the title of dramaturg,

described a literary manager as a 'matchmaker with a bulging address book'.[8] Their job is to 'look for a particular writer to match the sensibilities of the artistic director', each of whom has 'a particular aesthetic'. It may be that the artistic director has already conceived of a pairing between a play and a writer, in which case it is the literary department's task to make practical arrangements and monitor the progress of the project, along with administrative procedures such as agreeing a contract. On the other hand, the literary manager may be required to suggest names or find substitutes, in which case they need to be aware of current practitioners in the field. This requires substantial networking ability, and regular attendances at performances in other theatres.

Sirett also made the point that 'only a fraction of commissioned work gets put on'. There are many reasons why a project may not come to fruition: 'Through the subjective tastes of the people running the building, and the pragmatic choices because of how much money there is around, which actors are available, how it fits with other stuff going on'. This insight demonstrates the pressures of finding an effective pairing of a translator with a play, and explains the attraction of using at least one component that has a track record of progression through the obstacles paving the way to production. One area of particular difficulty, in his experience, was the marketing of new plays from new writers, 'especially in a theatre which has a broad range of programming'. A specialist theatre has a prepared audience; the Royal Court Theatre, for example, highlights its position as an institution that champions new writing, and its regular audiences know what to expect. Otherwise a marketing department needs to find some element about an unknown play and writer that can be used to attract audiences. Plays that are not only new but also translated are correspondingly more difficult to market, because they contain more of the unknown.

Although my interviewees were aware of marketing constraints, our conversations emphasized the priority devoted to the literary aspects of their work, as might be expected from literary specialists. All of them took a literary approach to the translation of plays, were aware of the ethical issues of ownership between writer and translator(s), and were attuned to issues of public perceptions of translation. Several had engaged with the theoretical debate around the visibility of translation and translators; Jack Bradley, Christopher Campbell and Paul Sirett contribute to academic theatre translation conferences, for example. I found a great understanding of the tensions inherent in the two-step indirect/literal translation process and some sympathy for the literal translator. Bradley identified the potential predicament

[8] Paul Sirett, interview with Geraldine Brodie (London, 17 January 2011).

for the literal translator in his summary of the different working practices, pointing out that 'some playwrights and/or directors simply utilize the literal translation that is made for them. Others consult the literal translators as part of the ongoing process of version making, and others again will see the literal translator even as a source for research'.[9] The translation processes in my sample display all of these circumstances. The degree of involvement of the literal translator in the creation of the performance text depends to some extent on the nature and timing of the commission; a translation created at the specific request of a playwright is likely to be more targeted than a literal translation composed for an earlier production. These nuances will be lost in the attribution of the process. In Bradley's view, the consequence is that the extent of the literal translator's contribution could be under-appreciated, particularly as 'the wider public may not grasp quite what they contributed because of how they were credited'.

The hierarchical structure of London theatre featured regularly in my interview discussions, but was particularly apparent in conversations with literary personnel. It was clear that the artistic director's tastes informed each theatre's cultural practices in general terms and also governed specific decisions. Even Christopher Campbell at the Royal Court Theatre, where the writer is foregrounded, made it clear that 'with all things in theatre, the artistic director has to say "yes" '.[10] Within those parameters, the extent to which the literary department is involved in commissioning a translation varies between productions. Jack Bradley did not recall working on *The House of Bernarda Alba* during his time managing the National Theatre literary department, which he thought was likely to be because David Hare and Howard Davies were regular contributors to the National Theatre, familiar to Nicholas Hytner, and accustomed to working together; this team would therefore not request dramaturgical assistance. He was however asked to commission the literal translation, and turned to Simon Scardifield, knowing him to be a linguist and actor who would want to take the opportunity of working with Hare. For the same reasons, it is likely that Tony Harrison or another of the principal agents, perhaps the actor in the title role, Vanessa Redgrave, would have approached Michael Boyd, the artistic director of the RSC at the time, with suggestions for *Hecuba*, thus bypassing the literary department. High-profile theatre practitioners have the power to express their creativity across a large field, with a corresponding imbalance of creative input and recognition for other participants. Even so, it does not

9 Jack Bradley, interview with Geraldine Brodie (London, 28 April 2010).
10 Christopher Campbell, interview with Geraldine Brodie (London, 10 January 2011).

necessarily follow that high-profile translations are less well-matched than other translation pairings. The process may be cut short if effective teams are already well-established.

The Royal Court Theatre is frequently differentiated in theatre translation circles as explicitly favouring direct translation. As its literary manager, Christopher Campbell, underlined,[11] the theatre's international department is 'unique' in its outreach to international playwrights through its mentoring and residency programmes.[12] Such projects present the Royal Court Theatre with the opportunity to mix translated international plays with new English-language plays – the acknowledged priority – in their programming. For Elyse Dodgson, the director heading the Royal Court international department, 'translation is the purest way' of showcasing these new international plays and writers: 'If you are presenting a writer for the first time, you want to stay close to the original'.[13] While this may seem to be a departure from the approach adopted by other theatres and literary departments, for whom a new version is generally preferable (lending itself to the indirect/literal route), on close analysis, Dodgson and the Royal Court Theatre have a similar goal to other commissioners, but their material requires a slightly altered set of parameters. Dodgson defines the *version* as 'making [the text] theatrical', and expects it to be written by someone who does not speak the original language. She admits that her preference is to use translators who have English as mother tongue and experience of writing for the stage. In this, she is no different from the other commissioners of translations in my sample. The variation in her approach stems from the resources available to her. She heads a department which can seek out translators from languages infrequently encountered on the English-speaking stage, such as Korean or Turkish. Having experienced some difficulty in sourcing translators with the desired capabilities, she has set up an informal training system of group meetings between novice theatre translators and experienced English mother-tongue stage translators. Dodgson has the time and space to create these initiatives because the work of the international department is supported by designated funding from the British Council and private foundations[14] and thus differentiated from the theatre's general operating budget and output. Even supported by these additional resources, translations of plays generated by the international department do not generally go on to

[11] Christopher Campbell, interview with Geraldine Brodie (London, 10 January 2011).
[12] The uniqueness of the Royal Court's international department is examined in Elaine Ashton and Mark O'Thomas's full-length study *Royal Court: International* (2015).
[13] Elyse Dodgson, interview with Geraldine Brodie (London, 4 August 2010).
[14] Designated donations for the Royal Court international programmes amounted to £226,784 in the year ended 31 March 2006 (English Stage Company 2006: 24).

full production, but are given rehearsed readings or workshops, reflecting their initial motivation. The international programmes inform the Royal Court Theatre's approach to translation, but in many ways represent translational work-in-progress. Fully performed translations, while generally created using the direct method, are commissioned according to Campbell's most important attribute for a translator: 'A dramatic writer who can speak the other language'.

Questioned on the importance of matching direct translators to texts, Campbell's reply resembled Michael Grandage's approach to commissioning translations: there must be 'a sense of affinity, or an interesting lack of affinity, some kind of relationship with the original material'. However, Campbell stressed that the choice of translator was no more important than any other member of the team; the same would be true of the lighting designer. They are all collaborators in the production. Conversations with literary personnel reverted to this theme every time; stagecraft takes precedence over language ability, and the commissioner's interpretation of the original play dictates subsequent choices. Jenny Worton, artistic associate of the Almeida Theatre, took a similar view, but went on to explain that decisions may be further complicated by copyright requirements.[15] Where a playwright is still living, or their estate is managing their legacy, agreement has to be obtained to create a new translation. This may extend to agreeing the identity of the translator(s), and the resulting text will also be subject to scrutiny before approval. Worton suggested that in translating living playwrights there might be less freedom for the translator and production; she noted that the translation of new writing was a specialist area, in which Campbell was an expert. The Almeida Theatre does not therefore generally produce new plays in translation, although the directing team will consider new adaptations from another medium, such as *Festen* and Worten's 2010 project based on the Ingmar Bergman film *Through a Glass Darkly*. When commissioning a translation, Worton seeks to 'think of a writer who suits the material', and identifies key attributes that might suit a particular individual, such as comic timing or the ability to move a large number of actors around the stage. This reinforces the notion that a play's textual features are only one of the factors taken into account when planning its translated manifestation on stage.

Nevertheless, all literary agents who commissioned literal translations stressed the importance of the function of the literal translation in the wider translation process for the stage. Worton explained that she would always commission a new literal translation unless the playwright had sufficient command of the source language. A published translation would not be adequate because it is prepared 'for understanding, not for performance'.

15 Jenny Worton, interview with Geraldine Brodie (London, 22 June 2010).

The literal translator must have knowledge of the theatre industry, and be aware of 'the specific meaning [of the play] as it is related to performance'. The resulting literal translation should be 'uninfluenced' and should include many footnotes. Furthermore, the literal translator should be available for consultation by the indirect translator, and provide a valuable resource for the source text beyond verbal translation, including advice on what the 'original playwright wanted to achieve'. Worton was inclined to believe that a literal translator would be consulted more if the playwright wanted to make significant changes, such as conflating several characters, in an effort to remain 'faithful' to the original. If Worton is correct in this supposition, advisory activities of this nature draw the literal translator into staging and production decisions (conflating characters, for example, reduces the number of roles to be filled on stage). It is clear that literary departments have a high opinion of the ability of the literal translator to represent the text and its original creator. Such expectations may be unattainable: how can any translator possess an absolute understanding of authorial intention, especially when the original writer is distanced by geography or time? Nevertheless, the perception of the extent to which literal translations contribute to the staging process demonstrates a key theoretical concept of translation: its cultural ramifications beyond linguistic code-switching.

My conversations with literary department personnel reinforce Perteghella's view that a literal translator provides dramaturgical support and collaborates in the translation process. However, they also offer many examples of the complexities in commissioning a translation. The nature of the source text is crucial, and it seems that there is an overwhelming view that a first-time translation should be carried out by a direct translator, but that stagecraft is prioritized over language ability when a translation is reworked. First-time translations also tend to be shown in smaller spaces, with cheaper productions, and by organizations with a higher risk threshold. Commissioning a translation takes place at an early stage in the production process; it is key to the successful outcome of the project, and many careers may potentially be affected by the result. Considerations of copyright, availability of key performing or creative cast, rehearsal time, cohesion of the team, physical stage constraints, all came up in my discussions with literary personnel. Marketing, when mentioned, tended to be referred to the relevant department and was not cited as a major factor in decision-making. My conclusion, based on these conversations, is that the appointment of a translator – direct, indirect or literal – owes more to the incorporation of a tried-and-tested team member within the project than financial and marketing prerequisites. I did however discover the significance of another scarcely visible activity within the theatre translation process: the personnel in the literary department.

Directors

Visibility remains pertinent when considering my next group of practitioners. As Paul Allain and Jen Harvie observe, 'The public perception of theatre directors' work is that it is often invisible' (2006: 148); poor visibility in theatre is not restricted to the translator. Visibility and power do not necessarily equate, however. Just as a literary manager has a significant influence on commissioning and developing a translation, a director makes a substantial impression on its trajectory and ultimate appearance. At a superficial level, directors have minimal visual presence: they do not appear on stage, their names in the programme are generally unaccompanied by their photograph, and they are rarely promoted in the advertising literature unless they have sufficient 'star quality' to sell a production. In contrast to the artistic director and often also the literary personnel, they are usually freelance contractors, with no job security and only short-term prospects. How much influence can a director exercise? Maria Delgado and Dan Rebellato summarize their edited volume of essays profiling the role of contemporary European theatre directors as follows: 'Directing is shown to be both a function and a profession, a brand and a process, an encounter and a market force' (2010: 21). In spite of the apparent disadvantages of the directorial mode of operation, it is a position occupied by individuals with the confidence and ability to impose their own tastes on others, with far-reaching effects. Three directors from my sample discussed their approach to translated plays with me, from which their traces in the translations can be assessed.

Rufus Norris, the director for *Festen*, has worked extensively on staging adaptations; sources include novels, such as DBC Pierre's Booker Prize–winning *Vernon God Little*, which Norris directed at the Young Vic Theatre in 2007, adapted by his regular collaborator, the writer Tanya Ronder. He also draws on less predictable resources, one example being *London Road*, directed by Norris at the National Theatre in 2011, and created by Alecky Blythe and Adam Cork. This musical production was based on recorded interviews with the inhabitants of a district in Ipswich, a county town to the east of London, on the topic of the serial murder of local prostitutes. Norris's ability to deploy this unconventional source is demonstrated by its further adaptation into a film, also directed by Norris, which was released in 2015. Together with Ronder, he has taught workshops on 'Adapting for the Stage' as professional development for such organizations as Living Pictures Productions and the Royal Court Theatre, another indication of his interest in this particular form of theatre. I interviewed Norris before his appointment to the position of artistic director at the National Theatre, at a time

when he had not yet gained the experience of running a major national organization full-time. Norris therefore solely discussed his directorial practice in respect of his work on adaptations when we met (although, serendipitously, the interview took place backstage in the National Theatre Green Room).

Norris considered his role as a director to be primarily concerned with the theatricality of a production, leaving the writing to the expert.[16] In the case of *Festen*, that expert was David Eldridge. Norris considered *Festen* to be a 'classic example of something made for adaptation' in that it takes place over the course of one night, in one location. He had been instrumental in bringing the film to Eldridge's attention, and admitted to lobbying Marla Rubin, the producer, for the job of director once he knew that Eldridge would be working on the text. Norris pressed for a black-and-white set, providing a neutral background distinct from the film – which travels through the well-appointed rooms and grounds of a large country house – so that all attention would be focused on the characters. He remembered that two-thirds of the rehearsal time was spent working on Act One, Scene Three, in which three pairs of characters conduct separate conversations, oblivious of each other pair, around one bed. This is the most theatrically envisaged scene of the play. Norris explained that although the spoken words did not change very much through the process, the order was moved around (this can be seen very clearly when comparing the published text to the film) and many different variations were attempted. An assortment of practitioners influenced the eventual outcome, including the sound designer, who was unable to support certain combinations which were then discarded. Norris spoke of these collaborations as inclusive, but was clear that when there was a range of opinions he was the ultimate decision-maker. Norris stressed that his general aim in directing is audience-focused, with the intention of creating 'accessible' theatre, especially for a younger audience, whose requirements are 'more theatrical than literary, more musical in tone, more visual'. This is not dissimilar from the approaches taken by Michael Grandage and Nicholas Hytner, emphasizing the holistic qualities of visual narrative and entertainment, of which text is only one element.

Ramin Gray, directing at the Royal Court, displayed similar leanings, constructing and retaining a visual conception of his production, *Way to Heaven*.[17] When I explained that I had been unable to see the play and relied on an audio recording in the British Sound Archives for my impressions of the production, Gray recounted a detailed description of the mise en scène, even noting the audience's viewing positions (standing, then sitting on the

[16] Rufus Norris, interview with Geraldine Brodie (London, 7 March 2011).
[17] Ramin Gray, interview with Geraldine Brodie (London, 6 May 2010).

floor). However, Gray differentiates his attitude as a director in that he feels a particular affinity for language, identifying himself as 'half-Iranian': 'I love language. I learned about directing from a playwright (Gregory Motton): the sanctity of the text. I take an exegetic approach to text.' Gray also describes himself as a specialist in international theatre, working on many of the Royal Court's international plays. This international focus was to lead to Gray's appointment in 2010 as the artistic director of Actors Touring Company, a theatre company which 'challenges and inspires a wide-range of audiences by touring ambitious contemporary theatre with a strong international focus' (ATC 2011). In some degree, Gray's specialist international and linguist focus is apparent in his directorial style and material.

Gray and Norris both worked on plays that were being presented in English on the London stage for the first time. Gray, however, was enabled to communicate directly with both the original author, Juan Mayorga, and the direct translator, David Johnston, because 'the Royal Court pays for writers to come over, even in the small theatre'. They therefore attended early rehearsals, and he was able to conduct textual negotiations in situ and in collaboration. Gray spoke warmly of both men, but described his encounters with Johnston as, at times, 'combative', complaining that he sometimes 'took decisions on behalf of Juan'. Gray explained that his attachment to an original text might lead him to question even the loss of a full stop in a comparison between an original and a translation. He admired the technique of David Tushingham in translating *The Woman Before*, which he envisaged as loading the file onto his computer and overwriting, so that the shape of the play would remain. Gray is very clear that he prioritizes the original text above other considerations: 'I'm not the artistic director, running the building. My job is to deal with the writer; it's very pure'. Gray and Richard Wilson were the two directors in my sample of eight who engaged with plays unknown to the British audience. The remaining plays were reworked from originals which had already been shown in London, either in translation or, in the case of *Festen*, with subtitles (as a film and a play, albeit structured differently). Wilson, in his post-show discussion recorded for the British Sound Archives on 24 May 2005, commented that 'the language of [*The Woman Before*] had a formality about it; it had a rhythm about it. We said in rehearsal that it's not really a very actor-friendly play' (Royal Court Theatre 2005b). The prompt book, however, showed very few alterations to Tushingham's translation. It is striking that Wilson and Gray appear to prioritize and conserve textual detail, effectively requiring the actors and audience to engage in the challenges of interpretation. This may be part of the ethos of the 'writers' theatre' that is the Royal Court, but there is also an implication that the translation of a new text demands a different approach from a retranslation.

This approach extends to the location of stagecraft, a quality frequently cited as essential in theatre translation. Gray took the view that the original writer possessed stagecraft, and that was the reason why the translator should follow the source-language text as closely as possible, and not 'come between the director and the writer': 'The translation shouldn't draw attention to itself'. Other directors privileged the English-language writer. Norris asserted that a 'singular voice [in the translation or adaptation] is crucial', adding: 'What's most important for me is that a writer has written the language'. These sentiments are reminiscent of Grandage's insistence on the 'skills of an individual voice'. If translation is a process, it seems to me that the directors of new plays focus on input while the practitioners working on new translations concentrate on output. 'New' seems to be the conditioning element in decision-making. Directors share a horror of the museum. What I heard in interviews with Grandage and Norris has been publicly voiced by other directors in my sample. Laurence Boswell, the director of *Hecuba*, commented on his earlier Spanish Golden Age season, 'It has to work on stage, it has to be fun, it has to be alive. This isn't museum theatre' (Johnston 2007: 153). Richard Eyre, director and indirect translator of *Hedda Gabler*, defined the choices made by 'even literal translations' as 'according to taste, to the times we live in and how we view the world' (Ibsen 2005: 9). Eyre summarizes the tension inherent in translating as 'being close to what Ibsen intended while seeming spontaneous to an audience of today' (Ibsen 2005: 9). The spontaneity of the new raises additional problems for directors presenting well-known classics. Questioned on the binary opposition of domestication and foreignization, Norris's response was to define domestication as British 'stereotyped ideas', for example of Lorca or Ibsen. For him, foreignization would be to present a well-known playwright in an unexpected way, dispensing with romanticism and sentimentality which, in his view, 'deny a very theatrical writer his theatricality'. Thus 'new' can equate with 'foreignized' for the directors of retranslations. The director of a new play translated for the first time is not forced to grapple with the issue of how to present a familiar source text in an unfamiliar way; paradoxically, relocating a well-known play from the hackneyed symbols relied upon to represent origin – Ibsen's wood-burning stove, Chekhov's samovar – can introduce an element of strangeness. But when that relocation erases the origin, how much of the 'other' remains? The directors I have consulted indicate their awareness of this debate, and their exploration of a variety of approaches in search of solution.

Ultimately, however, production decisions must be firmly and irrevocably made. A former artistic director of the Gate Theatre Notting Hill (1998– 2000), Mick Gordon, sees himself as the author of a production, talking

to and inspiring every other collaborator, but making the final decisions.[18] This encapsulates the approach of all the directors I interviewed, and others recorded elsewhere. It reveals the presence of the director in the translation, undermining any superficial invisibility. Even so, directors, like other theatre practitioners, are aware of a hierarchy imposed on their practice. It is instructive to examine their perception of this hierarchy in relation to translation. Like Gordon, most directors speak of collaboration in terms which indicate an uneven power-weighting. Gray and Grandage both exuded an expectation of realizing their own vision – at the expense of other practitioners, if necessary. Gray related a vignette in which he had sacked an actor over the interpretation of a translated metaphor. On the other hand, he was at pains to demonstrate his focus on the privileged position of the original writer, which suggests that a writer might take priority in any conflict between director and writer. Grandage was more diplomatic: 'If a disagreement arose, we'd have to move on', he said euphemistically, from which I understood that the indirect translator would be doing the moving (away). He described working 'very closely' with Mike Poulton during rehearsals for *Don Carlos* when they made many further cuts, 'changed the interval position, refined speeches, tightened up certain characters'. Poulton was 'very collaborative', said Grandage, but I had the impression that it was Grandage who took control. Norris, on the other hand, claimed that the (re)writer was the senior in the 'pecking-order'. Eldridge possessed a veto in any clash of opinions over *Festen*, and Marla Rubin would have to be included in decisions, because she had initiated the project. Norris, however, saw the writer–director team as the 'core relationship'. Eldridge, in interview, described Norris, a good friend, as 'quite an interventionist' director in rehearsal. It seems from these hints that the director expects and obtains a significant amount of influence over the text. It is also the case that the writer/translator is usually in rehearsal for the first week and then towards the end of preparations, but the director is present every day. That is in itself an assumption of power.

Where does this leave the translator? In the case of the literal translator, there is likely to be little or no contact with the director, and their contribution, while seen as important, is left to be managed by the indirect translator or literary department. From Gray's account, it would seem that the direct translator's principal role is to serve as a conduit for the original writer. The indirect translator, however, takes on the role of the original writer in consultation with the director, and this is the arena where a power struggle is most likely to take place.

[18] Gordon made these comments at the *Staging Translated Plays* conference, University of East Anglia, June 2007.

Indirect translators

In the miasma of near-invisibility which seems to apply to the theatre practitioners discussed in the above and following sections, the indirect translators take on a sharper focus. Their names are those which attach to the production, in the programme, the publicity and the published text. This is also the profession often criticized in academic translation circles. Joseph Farrell, for example, adopts the term 'surrogate translator' to describe the writer of the performed translation, and takes the dismissive view that such a figure 'has no more knowledge of the culture he is handling than has a dilettante with a metal detector of the Roman treasure trove his machine has uncovered' (1996: 54). There is a feeling among professional translators and language academics that indirect translators are taking on work more appropriate to an expert linguist, whose ability to interpret the original text would result in a more 'faithful' reproduction. There is also a degree of disgruntlement that these 'celebrities' receive higher fees, sometimes a share of the box office revenues, and the copyright of the translation, while the literal translator is paid a set fee – around £500 to £1,000 – and retains limited rights to their translation. I have heard several theatre translators say that they would not be prepared to produce a literal translation because they are not satisfied with the ethical procedure.

Some writers for theatre are also linguists. The playwrights Christopher Hampton (translating from French and German) and Michael Frayn (from Russian) were mentioned to me on many occasions in illustration, and I am aware of others; for example, I attended performances of direct translations by Caryl Churchill and Martin Crimp from French and Alistair Beaton and Rory Bremner from German in 2007 and 2008. Practising translators may also be specialists in intercultural exchange; I have argued with regard to Martin Crimp in particular that he engages with translation theories and applies these concepts to his writing for theatre, even when he may not be translating directly from the source-language text (Brodie 2016: 83–96). Within my sample, Mike Poulton produces his own Italian literal translations, Richard Eyre studied Russian at school[19] and David Eldridge admits to 'a bit of tourist French and Spanish'. Exposure to another language in some form does not seem unlikely for playwrights, who tend to have been educated to tertiary level. Furthermore, an ability to perform 'intralingual translation or *rewording*', as defined by Jakobson (1959: 233), is probably essential for a professional writer who spends their time transposing thoughts, emotions

[19] Richard Eyre mentioned his 'O' level in Russian during his presentation at *Chekhov's Major Plays*, Hampstead Theatre, 20 January 2010.

and observations onto a page, and between drafts. I am reluctant, therefore, to categorize indirect translators as monolingual. A better question, perhaps, might be – are they producing a translation?

Eldridge was very clear on his occupation, starting our conversation with, 'I don't consider myself to be a translator'.[20] He was invited to become part of the project to stage *Festen* after the producer, Marla Rubin, saw his own play, *Under the Blue Sky*, which was first performed at the Royal Court Theatre in 2000. Rubin felt that Eldridge's writing style would complement the *Festen* theme, and Grandage commissioned him to write a version of Ibsen's *The Wild Duck* for the same reason. It was Eldridge's voice as a writer that was demanded, and he sees himself as the writer in situ when working on an indirect translation. 'In the rehearsal room, I act as if it's a new play authored by me. I have that demeanour,' he insisted. 'If people bring in other translations, I'm not having any of that. We're doing my version.' In claiming an ownership of his writing, Eldridge is not refusing to consider amendments or revisions, but he is taking responsibility for the playtext, based on a combination of an English-language playscript prepared by the film-makers and the subtitled film itself. 'I made a play from this source material', declared Eldridge, differentiating his new play from what had gone before. This differentiation is required, given that the playtext written by Vinterberg and Rukov continues to receive productions, and was most recently seen in London at the Barbican Theatre in 2011, performed in Romanian by the Nottara Theatre company of Bucharest.

Mike Poulton was less adamant about his job description, which is perhaps reflected by the fact that *Don Carlos* has been described as translation, version and adaptation at various points in the programmes and published text. Poulton described discussions with his agent, who takes the view that ' "translator" covers everything', but admitted to thinking that 'adaptation is a more suitable term', except for those instances when he prepares his own literal.[21] Nevertheless, subsequent to our conversation, Poulton's direct translation of *The Syndicate*, by Eduardo de Filippo, was presented at Chichester Festival Theatre in 2011 as 'in a new version by Mike Poulton'. Unusually, its Italian title, *Il Sindaco del Rione Sanità*, was displayed on the front cover of the programme, perhaps in recognition of the play's linguistic origins in compensation for the omission of the term 'translation'. I interpret this reluctance to be labelled as a translator as a differentiation on the part of the indirect translators between the text they produce and the source text – the literal translation – from which they work. Their adaptation is not a polished

[20] David Eldridge, interview with Geraldine Brodie (London, 26 January 2011).
[21] Mike Poulton, interview with Geraldine Brodie (Stratford-upon-Avon, 26 May 2010).

version of the literal translation, but a new piece of work in itself. Even so, it is a new piece of work which is circumscribed by its source text. Both writers acknowledged the difficulty of creating an adaptation and determining an appropriate terminology to describe their efforts. Poulton outlined the technical problems:

> But adaptation is not a good term. It implies that you've changed the foundations of the work, but it's not like that. There's not much choice in adaptation. The author demands that you stick to certain rules and follow certain lines. You can adapt within what he has given you, but you cannot provide your own solutions to the problems he has created.

Eldridge reflects on the creative implications of producing an adaptation:

> Robert Holman [the playwright] says playwriting is energy distilled on paper. When you are creating a blueprint for living, breathing human beings, and can go at the speed of an actor's thought, you need something that can live on the moment. When you write an original play, that's much easier. If it already exists in a literal form, I do my best to recreate the conditions of being on the moment.

Thus both writers apply their own voice to the translation, but they are voicing a pre-determined outcome. They can only partially take possession of their creation, leading to a frustration apparent in my interviews.

This complex relationship with the text results from and provokes a collaborative procedure in its development. Both writers acknowledged the literal translation as a vital starting point in the creative process. For Poulton, it is a compositional tool, the key to his understanding of the original work. 'I want to know everything that's going on under the line. Translation is not so much about translating the words, it's about translating the humour, the tone, getting the author right.' He compares the literal translation to the original text – with the help of a dictionary, the literal translator and source-language-speaking friends – and carries out extensive research. Eldridge adopts an opposing technique. 'I like to have a pure experience for a first draft, and not do academic research. I try to have a pure response to the literal'. This is Eldridge's approach for creating a text that is 'on the moment'. He insists, however, that he will go on to produce many more drafts, rigorously revised, the result being 'very, very faithful' to both the original playwright and to the literal translator. Both writers stressed the importance of the quality of the literal translation for their own work. They liked to use trusted literal translators, expressly commissioned. Eldridge remembered that, for *The Wild Duck*, he had seen an old literal translation and asked for advice from Jack Bradley on who would produce 'the best' new literal. Charlotte Barslund's translation

'had a clarity, and really good footnotes and references', he said, 'I'm there to write the acting text. Her job is to give me a translation that I can work from, not to put a spin on it.'

Barslund is an expert in the translation of Scandinavian literature, evidenced not only by her catalogue of translations, several of which have been nominated for awards, but also her contribution of a chapter on the translation of literary prose to *The Oxford Handbook of Translation Studies* (2011: 139–52). She is credited for her literal translation in the programme and the published text of *The Wild Duck*. 'It is important to credit her, the theatres by and large don't need to be told', explained Eldridge. Poulton, on the other hand, was surprised when I asked why his literal translator was not credited, 'I always ask, but they tend not to want to be credited'. He felt that this was because they had other jobs with which they preferred to be associated. Poulton's suspicion recalls Bassnett's discussion of 'the tradition of translator academics being advised to keep quiet about their translations and not record them on their CV because this might hinder promotion prospects' (2006: 2). Bassnett refers to translations prepared by academics, not theatre translations in particular, and my own discussions with theatre translators suggest, in contrast, that they would prefer more rather than less acknowledgement; perhaps, by virtue of the fact that they were prepared to discuss their activities with me, my interviewees were predisposed to take that view.

While collaboration with the literal translator tends to be at arm's length, judging from the above accounts, input from other theatre practitioners during rehearsal was shown as a significant influence in developing the performed text. Both Eldridge and Poulton reported that they produced a succession of drafts for themselves, the latter adding that he tested even his early drafts through informal workshops among actor friends. However, in both cases, once in rehearsal the draft text is closely interrogated by all the participants, especially the director and actors. It is at this stage that the development of a performance text becomes more widely collaborative. The translator and scholar Kate Eaton describes the rehearsal room as her laboratory, in which 'performance versions of the texts emerged as the outcome of a collaborative rehearsal process involving director, actors, and translator' (2012: 172). Eaton is recording her impression of the direct translation process. Poulton, who works both directly and indirectly, is similarly aware of a shared progression, explaining that there 'comes a point where the draft has a life of its own, when you work with the company, the actors, and feel that you have the freedom to make the changes that performance will require'.

Eldridge remembered Norris requesting simplification of the bedroom scene, and a rewrite of later parts of the script because 'they just didn't work'. However, he also remembered a confrontation with an actor who referred

back to the film when querying his lines. The upshot was that Norris banned the film from the rehearsal room. 'Any copies passed around had to be done out of our sight', laughed Eldridge. This was half-joking, but demonstrates the extent of negotiation required, and also the ultimate site of power in the rehearsal room. Even so, Eldridge differentiated his involvement in rehearsal for an adaptation from that of an original play: 'What's different is the relationship to the actors after the read-through. Even though you have taken on the function of the writer in the room, you didn't create these characters ... As the creator of an original play, your opinion has huge value. But in a version, what I have to say doesn't carry the same weight.'

These writers recognize that their contribution to the translation project is more collective, and that the creation is shared among a group of collaborators. As discussed in Chapter 3, Eldridge does not own the copyright to the text, although his is the only name printed on the spine of the published book. His recollection of these negotiations demonstrates his pragmatic approach; 'At the time, I was unknown. The pie was carved up between us. I knew this would be a good thing for me, so I accepted it at the time, and I accept it now. Now, my agent would say I shouldn't accept it. But everyone knows what I've done.' Several years after this conversation, evidence supports Eldridge's conclusion. The Seattle-based New Century Theatre Company mounted a new production in 2015 which was publicized as 'Festen by David Eldridge', further detailed on the company website as 'adapted by David Eldridge from the Dogme 95 Film, "The Celebration" by Thomas Vinterberg, Mogens Rukov & Bo hr. Hansen' (New Century Theatre Company 2015). In a Hungarian translation staged in 2014, Eldridge was billed as the author (szerző) with a subsequent page adding that the play was based on the Vinterberg, Rukov and Hansen Dogme film (Vígszínház 2016a, 2016b). Eldridge's name thus continues to be associated with the authorship of this performance text.

So how have these indirect translators contributed to this translation that bears their name? A review of the interviews makes it quite easy to identify the skills which Poulton and Eldridge contribute to the project, less from their own insistence than because these features arise almost constantly throughout the conversation. Poulton was very aware of the spectators, and of how a modern audience might react to language, to plot development and even to staging. He describes the style of his dialogue as 'heightened language', reflecting the emotion and speech patterns of the German, but easily comprehensible to the audience and speakable by the actors. He uses an acting class at the Royal Academy of Dramatic Arts as a trial ground for his language. Poulton revised one of the last scenes in the play which requires Don Carlos to disguise himself as his grandfather's ghost in order

to effect a meeting with the Queen. This would appear absurd to the modern audience, who would laugh inappropriately at the tragic climax of the play. With regard to staging, Poulton remembered making small changes on transfer from the thrust stage at Sheffield to the proscenium arch in London. The audience was no longer seated on three sides of the stage, with a more three-dimensional view of the action, and therefore entrances and lines had to be changed to allow focus on Philip II's face in a tableau setting during the final interview with the Grand Inquisitor. 'We want the audience sitting on the edge of their seat for three hours', explained Poulton. When asked how he gauged what would be effective for an audience, Poulton replied, 'I have studied the audience for forty-five years! The audience is key. It is like an orchestra, an elaborate musical instrument which the actors are playing.' This demonstrates his emphasis on performance and reception, and his professional experience.

Eldridge placed a similar prominence on theatricality in his approach. He frequently repeated the phrases 'on the moment' and 'the speed of an actor's thought', reflecting the spontaneity and speakability of his approach to writing. He also emphasized the differences between theatre and film, relevant to *Festen*. He compensated for the inability to create camera close-ups in private moments by shifting the focus of the whole play to the abused son, Christian. In recognition of this, he composed a form for his play which he imagined as 'something theatrically loose, which gets tighter and tighter, and ends in knots, like Christian's stomach'. He referred to Sarah Kane's *Blasted* as his inspiration for this approach, another example of the exclusive theatricality of his intention. Like Poulton, he was alert to the presence of the audience in devising his adaptation, seeing the play as a 'subversion of a middle-class evening in the theatre', so that the audience response is very much part of the atmosphere generated by the play – another theatrical effect. For Eldridge, the 'liveness and shared space [of theatre] bring an intimacy that more than compensates' for the inability to film close-up.

My interviews with indirect translators suggest that, while they do not claim to translate, these practitioners generate the textual and playable elements which are ultimately seen by the audience in a translated performance. Their commitment and professionalism towards the project was striking in interview. To suggest that they had been selected to sell tickets seems over-cynical. They were unquestionably focused towards communication with the audience. That, however, is an important ingredient in theatre and performance. While some performance theory focuses on process itself, the relevance of the audience to theatricality cannot be discounted when considering theatre translation, as translators and theatre practitioners at all stages of the process highlight prominently.

Direct translators

Only three plays in my sample were directly translated without recourse to an intermediate translation prepared by another agent. Two of these plays were translated for their first productions in English from recently written source texts, copyright 2004. The third, *Hecuba*, was initially performed in its source language in about 425 BCE (Walton 1991: xiii) and first translated into English in 1726, with at least twenty further translations between that date and 2005, when Tony Harrison's translation was staged (Walton 2006: 242). These three plays therefore present aspects of translation which are poles apart in time and audience-familiarity. Furthermore, the new plays, *Way to Heaven* and *The Woman Before*, were both staged at the Royal Court Theatre, which, as I have already discussed, has an idiosyncratically distinct approach to theatre and translation, foregrounding new writing. *Hecuba* was produced for the RSC, and therefore emanated from a theatre specializing in the re-presentation of canonical texts. Not unconnected with this dichotomy, the Royal Court productions were presented as translations, while *Hecuba* was advertised in the SOLT listings as an 'adaptation', described as a 'new translation' in the RSC programme, a 'new version' in the Brooklyn Academy of Music *BAMbill* when it appeared in New York and a 'new translation from the Greek' in the published text. This inconsistency of terminology is not unusual, as I have discussed, and resembles in particular another production in the sample, *Don Carlos*, an indirect translation.

Johnston and Tushingham perhaps had more in common with David Eldridge than Harrison, in as much as they all operated in the knowledge that the original creators of the texts to be translated were alive, scrutinizing their writing process and likely to intervene in the result. Unlike Eldridge, Johnston and Tushingham were already acquainted with the original playwrights before beginning their translation projects. They are also regarded in theatre circles as translation specialists, alongside their complementary careers, whereas Eldridge's principal profession is that of playwright. Johnston and Tushingham are language experts in Spanish and German respectively, and were able to work from the source-language text. Nevertheless, similar themes regarding collaboration, ownership and visibility arose, with some variation relating to the direct translation process and the presence of a living author.

Most, if not all, translators and writers spend the majority of their time alone with a text, creating drafts, writing and revising. Tushingham, however, was the most expansive on the solitary nature of his working method:

> With new plays performed in the English language for the first time, there is more of an investigative process ... for everybody, including the

translator. Translators sometimes work under very difficult conditions … They aren't able to see the plays in performance; they often just get sent a playscript. They have to deal with dialect, sub-text and other issues which are hidden in the text for other people to find slowly. They have to work to a timetable.[22]

The image of isolation conjured up by this description might presuppose a text requiring substantial revision. However, of the comparisons I made between the published playtexts and the prompt books or recorded productions among my sample, Tushingham's translation displayed the least number of changes. I was therefore surprised to hear that he had spent very little time in rehearsal, as he was concurrently working on a theatre festival in Germany. His translation was apparently found performable with few revisions by the director and actors, and equally acceptable to Roland Schimmelpfennig, the author, who has a wide command of English and was himself the translator of *Hamlet* for Schauspiel Frankfurt in 2011. Asked whether, in view of his limited availability, he had supplied detailed notes with his translation, as for a literal, Tushingham located that kind of intervention in the rehearsal process, but explained that he and Schimmelpfennig had met at the director Richard Wilson's house and discussed 'what might come up, read through everything, made the odd change'. Tushingham had worked with Schimmelpfennig and Wilson separately on previous occasions; he translated Schimmelpfennig's play *Arabian Night* (Soho Theatre) for performance in 2002 and *Mr Kolpert*, directed by Wilson in 2000 (Royal Court). Tushingham could reasonably have confidence that his work on *The Woman Before* would meet their requirements. The limited changes in rehearsal suggest that this assurance was well-founded, although Wilson's observation in the post-show discussion that 'it's not really a very actor-friendly play' (Royal Court Theatre 2005b) also intimates that the rehearsal process sought to deal with any speakability issues by other means than textual alterations.

David Johnston's account of his working relationship with Juan Mayorga on *Way to Heaven* suggested a much more integrated association. Johnston had initially translated the play with support from L'Atelier Européen de la Traduction. He was subsequently asked by the Royal Court Theatre to translate the play *Nocturnal*, developed by Mayorga from a shorter piece commissioned by the Royal Court Theatre, and both plays had then been considered for production through a series of workshops and readings. *Way to Heaven* was ultimately selected, while *Nocturnal* went on to be produced at the Gate Theatre Notting Hill, London, in 2009. Johnston's translation had therefore neither been commissioned by the Royal Court Theatre nor had he created

[22] David Tushingham, interview with Geraldine Brodie (London, 21 July 2010).

the English playtext with that space in mind. Johnston, however, was famil-
iar with Mayorga and his body of work before they came together to attend
the first week of rehearsals. Mayorga himself spoke of an open approach to
the revision of his plays during our conversation. As his translator, Johnston
observed that 'Juan infuriatingly, but understandably, rewrites and rewrites',
necessitating coordinated modifications to the translation.[23] Johnston felt
that if the play had been produced on the larger stage of the Royal Court
Downstairs Theatre, it would have required further alteration in order to
conduct its inherent debate with a wider audience. As it was for the smaller
space upstairs, however, 'the translation and the original were sparking off
each other' during the rehearsal. Mayorga, in interview, also acknowledged
the contribution of the translator to the progress of his plays. This cooper-
ation extended to the director Ramin Gray, who, as Johnston remembered,
'didn't impose many textual changes. Changes were done through prompting
and questioning, in a genuine collaborative sense.'

Although the collaborative experience was recounted differently by these
two direct translators, their view of the translator's locus in the rehearsal room
was remarkably similar. For both, the presence of the original writer affected
their ownership of the English text. Tushingham saw himself as a mediator,
required to act as a dramaturg, 'occasionally a referee', when director, writer
and translator were together. For his own part in the creative process, how-
ever, he took a more active view: 'Creative misreadings can be liberating, so
I'm not too worried about speaking for the writer'. He pointed out that 'know-
ing a language doesn't mean you know everything about a play', saying later
that 'I'm not infallible'. He seemed to accept that he might have a divergent
response from that of the writer or director, which could validly be added to
the mix of opinions. Ultimately, however, he insisted that 'theatre-making is
happening in the present, and for an audience'. Communication with the audi-
ence informed his approach as a translator, and his closing words expressed
his perception of the responsibilities of his role: 'Translation is part of practi-
cal theatre-making, not a literary exercise.' Tushingham's words could have
been spoken by any of the directors, indirect or literal translators interviewed;
the creative process addresses the target audience first and foremost.

Johnston was similarly focused on the practicality of his endeavours. His
enthusiasm for and commitment to the text and argument of *Way to Heaven*
was self-evident, but he was clear on the extent of his role:

> The translator is in a relationship with the author, and the only represen-
> tative of the process of writing if the author isn't there. But the translator

has to say to the director, 'it's your show' ... Translators are not there as representatives of an author to say, 'no changes'; they are there to negotiate a text.

Johnston's ownership of the translated text extends to the copyright, but not to the unassailability of the text itself. In this he mirrors Mayorga as creator of *Way to Heaven*, but he applies the same logic to his other translations, including those where the original writer is unable to insist on a continuing interest. Johnston retranslated Molière's *The Miser* for the Belgrade Theatre Coventry in 2010. The programme presented the play as 'in a new version', but Johnston was credited inside as 'translator and adaptor'. The play moved to Belfast later that same year, and Johnston explained to me how it had been 'rewritten to suit a Belfast audience'. He had clearly enjoyed the experience of writing for his home crowd, and the opportunity to build in features which he had not been able to employ in Coventry, such as a purposely created song in French. For Johnston, a translation is constantly evolving to suit its current requirements, a challenge he is pleased to take up: 'A published text doesn't capture the whole organic process. I find that quite appealing: the contingency, provisionality and dynamism of theatre and translation.'

His work as an adaptor, not to mention his position as professor of Hispanic studies at Queen's University Belfast, gives David Johnston a measure of visibility beyond his activities as a translator. For *Way to Heaven*, however, he was credited as the 'translator', as was David Tushingham for *The Woman Before*. Johnston prefers to include the term 'translator' among his credits, although he admits that 'every act of translation involves some measure of linguistic adaptation'. He also accepts that the designation applied to his role rests ultimately with the professional marketing department, which has the 'specialist skill' of 'getting an audience into the theatre'. Tushingham was content to rely on the Royal Court Theatre's standard translator contract for his own credits, but conscious of the general visibility issues for translation in the theatre. He felt that larger theatres adopted the route of using a well-known playwright for translating existing classic plays because their 'name was there to reassure audiences, and only significant in marketing terms'. But he could conceive of occasions when a recognized name could be inappropriate to the circumstances:

A new play is a more invisible translation process because you are interested in a contemporary foreign writer, people who have no UK reputation. If coupled with an existing British writer, even of their own generation, their name would be very much eclipsed by the British writer.

Tushingham was concerned that the effect of such a coupling might be to blunt the different perspective that a newly translated playwright might have to offer. However, he was aware that even in the circumstances of a new play, a well-known British name might usefully be attached to the production. He cited the example of the 2005 production at the Traverse Theatre, Edinburgh of Luis Enrique Gutiérrez Ortiz Monasterio's *The Girls of the 3 1/2 Floppies* in Spanish, with subtitles written by Mark Ravenhill: 'Sometimes a well-known name can be a great help to a production that otherwise wouldn't get very much attention.'

The overriding impression that I received from my conversations with Johnston and Tushingham was that of a devoted pragmatism towards translation. Johnston described himself as 'a thinking practitioner, or a practising thinker', and this portrayal seems appropriate not only to him and Tushingham, but to all of the agents I have interviewed in the course of my investigations. There was an acknowledgement that audiences must be attracted to see the production that has so painstakingly been put together, but the emphasis remained on constructing the highest-quality work possible, while attempting to reconcile the conflicts placed on a translation by the original author, the director, the actors and one's own creative response to the material.

Literal translators

Four of the translated plays in my sample were created by professional stage writers or directors working on a translation prepared for this purpose by a literal translator. The fifth indirect translation, *Festen*, was translated into English by the Danish writer Bo Hansen, who had adapted a playscript from the film script. I met and interviewed Karin Bamborough, Charlotte Pyke and Simon Scardifield, the translators for *Hedda Gabler*, *The UN Inspector* and *The House of Bernarda Alba*, respectively. All these literal translations had been commissioned by the literary department of the National, for use in its own productions. Bamborough's literal translation had subsequently been reused by Richard Eyre when writing his version of *Hedda Gabler* for the Almeida Theatre. I was able to identify these three translators from either the programmes or web pages of the producing theatres, and obtained the literal translations for *The UN Inspector* and *The House of Bernarda Alba* from the National Theatre archives. Therefore, although literal translation is in many ways one of the more invisible translation practices in theatre, its activities are evidenced by an archival trail whose ease of following depends largely on the systems development of the relevant organization. On the whole, I did not detect an intention to disguise or hide the existence of a literal translation,

more an expectation that it was an internal theatrical practice of little interest to the public.

The three translators interviewed shared the combined qualifications of a background of study in the source language and performance experience. Pyke and Scardifield are actors who translate, in Scardifield's description, to 'supplement' their acting career. Bamborough previously worked in the National Theatre literary department, subsequently turning to a career in producing, including teaching this discipline at the National Film and Television School, Beaconsfield. This mix of qualifications is typical of literal translators, who are often selected for specialities which are additional to their language skills. The author of a number of literal translations outside this sample, Helen Rappaport, was described by several of the theatre practitioners I interviewed as a particularly effective literal translator from Russian. A more visible literal translator than most, publishing and speaking about her theatre translation work, she also trained as an actor, and now describes herself on her website as 'writer, historian, Russianist' (Rappaport 2017). These are professional translators with targeted experience in theatre and performance, who are employed to carry out a specific task.

The activity of a literal translator, to the extent that it is thought of at all, is frequently characterized as boring, derivative and undervalued. The dramatist Richard Bean, for example, whose 2011 adaptation of Carlo Goldoni's eighteenth-century comedy *A Servant of Two Masters*, retitled *One Man, Two Guv'nors*, was one of the most commercially successful productions in the history of the National Theatre, described his working process thus:

> I worked from a literal translation because if you do this, you've got to get to the bare bones of it. If you've ever read a literal, though, you'll know that you read it for five minutes then fall asleep. It's impossibly dull. It's like a blank piece of paper – you've got your structure but you've got nothing else. (Cavendish 2011)

Bean's ungenerous depiction is all the more surprising in coming from a writer who has been listed in the small credits on previous occasions – he was credited in the programme for Dion Boucicault's *London Assurance* at the National Theatre in 2010 as responsible for 'Textual Revisions'. His remarks nevertheless demonstrate how literal translation can be perceived; another reason why this activity is undervalued by both the users and creators of translations.

The term 'literal' reinforces what Catherine Boyle sees as 'the deadly and deadening space' of the 'clichéd "page and stage" divide' (2007: 64); it does not convey the potentiality of performance that is written into these specialist theatrical translations, nor the invitation of the multiple translation

avenues opened through the use of annotations and paratextual commentary. Boyle composed a literal translation of Sor Juana Inés de la Cruz's *House of Desires* for the RSC Spanish Golden Age season in 2004, subsequently engaging in a 'syntactical unwinding' of her own text to produce lines that would work for actors on stage (2005: 22). Boyle reflects on the involvement of academics (herself included) from the beginning in developing translations for performance and notes that practitioners 'of theatre and knowledge' combined 'creatively and theoretically' to interrogate the plays 'from the space of the potential text in performance'. Boyle thus promotes the liveliness and creativity of literal translation. And there is a further element mentioned independently by two of my interview subjects: *fun*. Bamborough, who produced literal translations jointly with her Norwegian mother Ann, recalled that she first began because it was 'fun', and then continued because it was an enjoyable joint activity for mother and daughter.[24] Scardifield also explained that he enjoys providing notes and background information. 'The fun of it lies in the slightly nerdy, pernickety thoroughness', he analysed, adding, 'I solve problems, and that's satisfying'.[25] In spite of the invisibility of the literal translator's activity, its operatives obtain an intellectual reward along with the monetary payment, the possible credit in the programme and the two tickets to press night. In interview, the intellectual and emotional investment of my subjects in their translations was rapidly perceptible.

Nevertheless, these literal translators were well aware, from the inception of their involvement in the project, of what was required of them and why. Bamborough, as a former member of a literary department, could be expected to have a clear idea of her role. Her approach to the translation was always on the basis that it would be used by a non-Norwegian-speaker, and therefore she would attempt to strike a balance between the cadences of the Norwegian language and the accuracy of the word. This might result in a 'clumsy, clunkier' translation, but 'you expect the person doing the final version to tidy that up'. Bamborough stressed, however, that such avoidance of polish was by design rather than the result of a rushed job: 'A great deal of work goes into it [but] you are paid the equivalent of one week's wage'. The Bamborough team would go through several drafts in preparation, reviewing each other's work, with Karin producing the final version, 'tidy[ing] up' her mother's English. 'I was aware of the need to make sure that quality was maintained in the translation' asserted Bamborough, seeing her translation as 'another way into the play' for the writer, assisting in their 'new interpretation'. Bamborough identified the desire for a new interpretation as the

[24] Karin Bamborough, interview with Geraldine Brodie (London, 8 February 2011).
[25] Simon Scardifield, interview with Geraldine Brodie (London, 30 June 2010).

motive for commissioning a literal when extant translations were available. Her *Hedda Gabler* translation had originally been prepared for the writer and translator (from French and German) Christopher Hampton's version at the National Theatre in 1989, and she had been surprised to discover that Richard Eyre used it as the source for his own version in 2004. Her translation remains in use and was credited in Patrick Marber's published version for the National's production in 2016 – although not mentioned in the theatre programme (Ibsen 2016: np). The Almeida Theatre had contacted her agent, at a late stage in production, as she held the residual copyright to her translation, and she had been invited to press night. Bamborough described how she would usually have a 'conversation' with the writer to explain Ibsen's use of 'certain words of the Norwegian language', but had not done so on this occasion. She was therefore unable to cast light on how Eyre might 'capture cadences that [he] could at least infer from the Norwegian original', as he claims (Ibsen 2005: 9), although she enjoyed the production, and noted with approval Eyre's use of the word 'mardy' to describe Hedda (Ibsen 2005: 12).

Pyke and Scardifield similarly experienced severely limited contact with the users of their translations within my sample, although they recounted discussions and meetings with practitioners in relation to other literal translations. For Pyke, *The Government Inspector* was the first literal translation she had prepared, and she 'had a good chat with Chris Campbell', who commissioned the translation, before beginning.[26] Scardifield did not remember being asked to provide notes with his translation, but explained, 'I felt I had to. Any decisions I made were obscuring a truth or covering up part of the story, which I would need if I were writing a version'. Scardifield's own translation experience manifests itself in his mindfulness of the subsequent writer. Pyke is similarly aware of the user's requirements and her own response: 'they don't want bias or your own cultural interpretation, so I use extensive notes'. Both used the adjective *fresh* to justify the commission of a new literal translation when other translations were readily available. Pyke pointed out that an additional layer of adaptation would be required if working from an 'old scholarly' translation when modern English usage would be applied, although she herself consulted academic texts when preparing her translations. Scardifield suspected a 'built-in mistrust of the translation process', a fear that an older translation might be 'tainted with some awful fifties fustiness'. Writers 'want a literal that's still warm', he suggested, so that they can 'feel on virgin territory'. These three translators reveal through their comments their clarity on the use to which their translations will be put, and how they address those needs as they translate. This recalls

[26] Charlotte Pyke, interview with Geraldine Brodie (London, 14 July 2010).

Hans J. Vermeer's theory of *skopos* in translation, whereby 'source and target texts may diverge from each other quite considerably, not only in the formulation and distribution of the content but also as regards the goals which are set for each, and in terms of which the arrangement of the content is in fact determined' (2012: 193). The aim of a literal translation is to provide the subsequent writer with a current and reliable linguistic transposition along with contextual information relevant to its theatrical setting. When assessing such translations it is essential to understand why they were commissioned, if their value in the overall process is to be recognized.

Theatrical literal translation also bears the characteristics of what the philosopher Kwame Anthony Appiah has labelled 'thick translation': 'Translation that seeks with its annotations and its accompanying glosses to locate the text in a rich cultural and linguistic context' (2012: 341). The overt annotations and framing contextual information constitute a reminder of the translation process that has taken place. As Theo Hermans comments, 'Thick translation contains within it both the acknowledgement of the impossibility of total translation and an unwillingness to appropriate the other through translation even as translation is taking place' (2007: 150). The literal translation process overtly places the translator outside the translated text, Christopher Campbell's description exemplifying the impressions given by most of the theatre practitioners I interviewed: 'Flat, unaffected, uninflected, as neutral as possible ... it is harder than doing a [direct] translation'. There must be an unwillingness to impose oneself on the literal translation if it is to be useful for the indirect translator. Furthermore, the process of which a literal translation forms a part contributes to a wider conformity with Hermans's analysis of thick translation: 'As a highly visible form of translating, it flaunts the translator's subject-position, counteracting the illusion of transparency or neutral description, and instead introducing a narrative voice into the account and supplying it with an explicit viewpoint' (2007: 151). The indirect translator's presence in the text depends on the literal translator's attempts at self-exclusion, the subjectivity of the former permitted by the assumed 'neutrality' of the latter. However, the exclusion of voice is impossible, and the care with which literal translators are selected implicitly validates their personal approaches to the text, and recognizes their contribution to the multiple collaboration that is signified by the performance text.

Literal translators are language specialists. The translators I interviewed studied the languages from which they translate in detail. Bamborough and Pyke have lived and worked in Norway and Russia respectively, and have a connection with those languages through a parent. Scardifield attributes his linguistic ability in three languages (French, German and Spanish) to a 'misspent adolescence doing homework', but was described to me by Jack

Bradley as a 'brilliant linguist'. Pyke and Scardifield informed me that they consult other translations to measure their own linguistic choices, and carry out extensive background research on the playwright and the play's context. This research is evidenced not only by the notes accompanying their translations, but also the inclusion of their research in theatre programmes for plays on which they have worked. For example, Pyke contributed a timeline and short biography of Gorky to the Almeida Theatre programme for the play *Enemies* (in a 2006 version by David Hare). Scardifield's essay, 'Don Juan – 350 years of offensive charm', was included in the programme for the Donmar Theatre's 2006 *Don Juan in Soho*, by Patrick Marber, after Molière. In both cases, the contributions were attributed, accompanied by the writers' credentials as literal translators. Pyke's photograph was even included in the programme cast biographies, an unusual acknowledgement of her engagement in the project.

A specific area of translation emphasized by my interview subjects was the speakability of the lines they wrote. Bamborough stressed her awareness of dialogue in her approach to translating, insisting on the importance of her theatre background and her work in television and media. Pyke and Scardifield both felt that their acting experience informed their translations. Pyke revealed that 'I ask whether it flows, I say it out loud', commenting that her acting training in St Petersburg had given her the additional experience of speaking on stage in Russian. Scardifield explained, 'As an actor, I like to write something which I'd like to speak', and referred to Richard Pevear's exhortation to retain an author's idiosyncratic repetitions, in his discussion of translating Tolstoy's 'drops dripped' (2007: 29–30). 'If I really can't get it into my mouth, I have to find a different solution, but I try to respect that', Scardifield insisted, revealing the constant negotiation between speakability and closeness to text which preoccupied all my interviewees. This, I would say, is what marks out a theatrical literal translation from the side-by-side translation, foregrounding scholarly textual accuracy, which is epitomized by the Loeb Classical Library: the translators are acutely aware that the final product to which they are contributing will be spoken and performed. Even though it may not be their own words which issue from the actors' mouths, their influence over the staged text is paramount when translating.

How does this influence communicate itself to the subsequent writer? For the plays in my sample, there was very little correspondence between indirect and literal translator. Bamborough was not even aware that Richard Eyre was using her literal translation, although she gave me the impression that she had discussed it with Christopher Hampton, the first user. Pyke never met David Farr, was not credited in the programme and recalled going to press night only to find that no tickets had been reserved for her. Scardifield

remembered receiving an email from David Hare thanking him for the translation and asking a few questions, but no extensive communication. They had each worked more closely with writers on other translations, however, and the perception was that this tended to take place in smaller theatres. Pyke pointed out that at the National Theatre there could be at least a year between commissioning the literal translation and rehearsal, so that by the time the lines were spoken on stage the writer would already have gone through many drafts and 'moved on from the two-text stage, mine and his'. All the translators were frustrated by this closure to their involvement, characterized by Bamborough as 'You do your job and goodbye'. Pyke and Scardifield have both created direct translations, valuing their continuing involvement throughout the process. Pyke spoke of the 'luxury' of making later changes. Scardifield enjoyed the feeling of 'working alongside the author, and always asking myself, would they be happy?' But the fact that these translators have each supplied many literal translations and, in the case of Pyke and Scardifield, have gone on to create direct translations for production, demonstrates that their efforts are valued and in demand by the literary departments and writers who use their work. It is not only literary departments who return to trusted translators to commission translations for their own theatre: writers may also request a particular translator. Thus Simon Scardifield has translated for Tanya Ronder at the RSC (*Peribanez*, 2003) and the Almeida Theatre (*Blood Wedding*, 2005). David Eldridge pointed out that his lack of communication with Charlotte Barslund, who provided the literal translations for his reworking of two plays by Ibsen, was 'a testament to the clarity of her work'. Although copies of literal translations are not widely available, the few I have seen provide extensive linguistic, cultural and theatrical information to their user, suggesting that literal translation is more than simply a linguistic resource.

If collaboration is largely a-synchronic, with little communication between the translator and the subsequent writer, it might be expected that the scant public acknowledgement of literal translation reflects the limited translational interaction. There does not appear to be any consistency of approach in this matter, however. When asked, most practitioners agree that literal translators should receive credit in the programme and published text. Indeed, a programme credit is included in the pro forma contract currently used by the National Theatre. Karin Bamborough was very firm that she would always be credited for her translation. Scardifield and Pyke had both experienced occasions where they were not acknowledged, however. Pyke put this down to her own inexperience with regard to her first translation, *The Government Inspector*. When she discovered the lapse, she contacted Jack Bradley, who apologized and included her name on the National

Theatre's website. Scardifield had been surprised to have been omitted from the credits at another theatre, even though he knew the director well and had suggested potential writers for the project. Both Pyke and Scardifield commented that David Hare had been generous in acknowledgement of their work with him, and I have since noted that Hare's translators are prominently credited, a recent example being his *Young Chekhov* collection of new versions of *Platonov, Ivanov* and *The Seagull* for the Chichester Festival Theatre and the National Theatre in 2015–2016, for which the literal translators Helen Rappaport and Alex Wilbraham received credits in the programme and published text (Chekhov 2015).

A writer of Hare's stature can afford to share credit. Frank McGuinness similarly credits his literal translators: the front page of his published version of Euripides's *Hecuba* reads 'In a new version by Frank McGuinness from a literal translation by Fionnuala Murphy' (Euripides 2004). Richard Eyre is very open in his introduction to the published text of *Hedda Gabler* that he used the Bamboroughs's literal translation (Ibsen 2005: 9). David Farr, however, does not mention Charlotte Pyke, although he thanks an assortment of people in the published text of *The UN Inspector* (2005: np). Mike Poulton acknowledges that he uses literal translations, but does not identify the occasion or the provider (Poulton 2005: xiii–xiv). However, his claim that translators do not always want to be mentioned is supported in part by a small discovery of my own. When I was sent the literal translation of *The House of Bernarda Alba*, I was surprised to find it authored by Simon Taylor. In answer to my query, Scardifield explained that he had originally preferred to use his stage name – Scardifield – only for acting; he translated under his given name, because 'actors are not expected to do other things apart from acting'. Later translations have been professionally claimed by Scardifield, however, with his professional website devoting a section to his 'translating and writing' (Scardifield 2016).

This fluctuating relationship with the activity of translation is reminiscent of the academic hesitation described earlier by Susan Bassnett: perhaps translators themselves may be in part responsible for perpetuating the perception of translation as a low-status profession. If translators do not admit to their abilities, why should anyone else hold them in esteem? Pyke, however, made a powerful case for the recognition of the literal translator: in addition to a failure to acknowledge the extent of her own work, she felt that the concealment of the literal translator undermined the original writer, 'because there is no recognition of the transition between what [the original author] wrote and what [the subsequent writer] wrote. It is a long process which should be recognised … the literal translation is the beginning of an important writing process'. Pyke's words reveal her understanding of her own role

among the multiple voices in the lengthy and collaborative practice of theatre translation. Although often downplayed or overlooked by its own practitioners in addition to the intermediate users and eventual audiences, theatrical literal translation is recognized as an essential, specialist task by the literary departments, writers and directors who programme plays in translation and commission appropriate practitioners. An appreciation of this role should be made more apparent to practitioners and audiences alike.

Playwrights

Only three of the plays in my sample were derived from living playwrights and one of these, *Festen*, had been collaboratively constructed in the course of the film production, described by Claire Thomson as 'a story whose authorship can be accredited to so many actors in the saga' (2013: 122). I was unable to arrange a meeting with Roland Schimmelpfennig, the author of *The Woman Before*, but Juan Mayorga agreed to discuss the translation of his play *Way to Heaven*. The discussion of translated playwrights that follows therefore focuses on Mayorga's account of his own plays in translation, his relationship with his translators and his approach to translating the works of other playwrights, an activity in which he engages with some frequency. However, I have also been able to draw upon the published observations of other playwrights connected to my sample.

Setting *Festen* aside as a collaboratively authored original, the two single-authored contemporary plays in my sample share many similar hallmarks. They were both directly translated, both marketed as 'translations', and both produced at the Royal Court, which identifies itself as a writer's theatre. In my opinion, as I discussed in Chapter 3, they are also both constructed in such a way as to render themselves amenable to translation. I therefore asked Mayorga whether he wrote his plays thinking that they would be translated. Speaking, as he said, for 'most playwrights', his response was that 'we know our audience can be anywhere' and therefore 'we try to communicate with any audience.'[27] Mayorga gave the example of one of his earlier plays which relied upon the audience's knowledge – in this case of the Spanish Civil War; *The Scorched Garden* was performed as a rehearsed reading at the theatre upstairs at the Royal Court in 1997 (Mayorga 1999). Since then, he has focused on 'subjects, topics, historic moments that can be more easily got by the audience'. Mayorga, whose interest in Benjamin has continued beyond his doctoral thesis, describes the interrogation of translation as something that 'me

habita, me preocupa permanentemente' (permanently inhabits and preoccupies me).[28] Many of his plays, including *Way to Heaven*, reflect upon the practices and ethics of translation. Mayorga pointed out that the Commandant's germanization of the character Gottfried's name from Gershom to Gerhard (Mayorga 2005: 47) 'closes the other' in a decision not to see their alterity. He gave this instance as an example of the tensions arising in translation:

Si la traducción es capaz de aceptar unos riesgos, y aceptar elementos que puede haber algo intraducible, que puede despertar una nostalgia del otro, es una cosa. Pero si la traducción persigue una plana, simplifica, reduce, es no querer ver al otro.

(If translation is capable of accepting risks, and accepting elements which may contain something untranslatable, which may awaken a nostalgia for the other, that's one thing. But if translation pursues a plan, simplifies, reduces, that's refusing to recognize the other.)

However, Mayorga accepts and even invites the localization of names of his own characters. The translator (Calderón) and the final destination of the Berlin train (Madrid) in his play *Blumemberg's Translator* (2001), for example, 'must be adapted to the local name' to reflect the theme of 'how fascism changes language', which can be relevant to any audience. Mayorga also welcomed the different treatments of *Way to Heaven*'s original title *Himmelweg* in productions around the world, including Spanish-speaking countries, which varied between giving the Spanish translation in parentheses, as in Madrid, and the German-language title in parentheses, as in Buenos Aires: 'This instability of the title has something to do with the play. It's a play about a giant euphemism. For me, this instability is productive.' Nevertheless, Mayorga was aware of the potential for a perceived colonialism in localization. He described the Royal Court's decision to omit the German-language title as 'conservative', a feature he recognizes generally in the theatre world. He sees the theatre as a site of conflict between 'el escenario y el patio de butacas' (the stage and the stalls), but one which must be negotiated. However, he countered any charge of colonialism with regard to the identification of the Red Cross Representative as a national of the receiving country with the observation that a spectator was thinking less of nationality and more 'yo podría ser él' (that could be me). This was in fact Mayorga's desired effect, at one point inserting a stage direction for the little Girl to look at the spectators (2005: 40), thus drawing them into the identity of the Red Cross Representative.

[28] My interview with Mayorga was conducted partly in English and partly in Spanish. Direct quotations are his words, with my translations in parentheses where he spoke in Spanish.

Mayorga's engagement with translation in conversation and writing and his recognition of the inherent tensions between the translatable and untranslatable may be attributable to his academic training, but an acceptance of translational conflict is evident among playwrights within and beyond my sample. For example, Mark Ravenhill, writing about the wide translation of his plays, admits to worrying that he might be perpetuating the Royal Court's sometime designation as 'the Starbucks of playwriting' and be seen as 'just another manager of a global franchise'. However, he concludes, 'Resonance for me now lies in the international. I am fascinated by the way a work mutates and is reborn through translation and re-production.' For Ravenhill, the potential disadvantages of translation, practically and ideologically, are outweighed by 'the exchange of ideas with theatre workers and audiences around the world and the exposure to varying theatre practices' which will make him a better writer and 'challenge theatre-makers in other countries to make better work themselves' (2009: xiii). The favourable outlook on translation by playwrights is echoed time and again. Thomson demonstrates how Mogens Rukov's reaction to the request to translate and adapt *Festen* for the stage swings from an initial 'How can it be so important?' to the eventual 'A London Opening, my God, what are the horizons?' (2013: 127–29). Ibsen's papers equally demonstrate his desire to be translated, and his preoccupation with the result. James Walter McFarlane provides a translated extract of Ibsen's letter, written in German, to his publisher, expressing his 'genuine pleasure and satisfaction' at the 'wide distribution' of his works, and requesting communication with the translator of *Hedda Gabler* 'with reference to a number of alterations which I think are desirable for a German public' (Ibsen 1966: 500). The playwright's willingness to submit to and amend for translation reveals his engagement in the process and his acceptance, like Mayorga, that 'theatre is dialectic'.

Ibsen's letter also displayed his dependence on the translator. Similarly, Mayorga's interview revealed his detailed consideration of this relationship. 'It's important to have confidence in the translator', he insisted, proceeding to compliment David Johnston as 'a playwright and a poet' who 'knows my plays very well, sometimes better than me'. He also named his preferred French and Italian translators, Yves Lebeau and Antonella Caron, explaining that he liked to have a relationship with his translators: 'It's important to have a permanent dialogue, someone who has an overall perspective, knows your obsessions'. Mayorga reads English, French and German, and therefore is able to sustain a bilingual dialogue in these languages, sustaining and controlling the degree of instability of his text. I asked him whether he was able to adopt a similar attitude when translated into an unknown language, a recent instance being the Korean-language production of *La Tortuga de Darwin* (*Darwin's Tortoise*) by the Seoul Metropolitan Theatre Company (2009).

The translator was a Spanish scholar, who had made the initial approach to Mayorga, and had the necessary contacts to facilitate the Korean production. Mayorga declared himself 'happy' with the translation and the 'marvellous performance, very poetic', explaining that, even though he could not understand the result, 'Theatre is translation. The director translates it to a space, his ideas are translated by the actors, the audience experiences the translation. It is even more radical when there is a change of language.' Mayorga trusted the translator, and was able to evaluate that trust in his reception of the performed translation, beyond text. This acceptance is underscored by his Benjaminian interpretation of the act of translation:

> I don't look just for communication ... If a language is just used to communicate, that has nothing to do with the important things ... We cannot reduce [a moment] to an easy sentence. But at the same time it says something to us about mankind, the human being.

Echoing Benjamin's exposition that 'whatever in translation is more than communication' points to the realm of 'a higher and purer climate of language' (1968: 86), Mayorga subscribes to the mystery of translation.

All the living writers in my sample speak English and engage in translation; they are equipped to assess the results of their translators into English, but they are also familiar with the process of translation itself. Both Schimmelpfennig and Mayorga have translated Shakespeare into their mother tongue. Mayorga described the process he adopted for *King Lear*, making a first draft from the original then reading as many other translations as he could find, including into Latin American Spanish, French and German. He explained that he was 'not trying to capture the best literary version, but to catch the poetic flower' of the original, and that other versions assisted him in identifying the strength of the text. 'I am an adaptor, not a translator', Mayorga insisted, his commissions generated by his dramaturgical rather than language knowledge: 'I am asked because they know my work, they require my creativity'. For this reason, Mayorga refuses to translate contemporary playwrights, who, he considers, require language expertise and 'big fidelity'. He prefers to work with classic plays, already well known to the audience, because then, 'I am in dialogue with the director. I can take some freedoms. We can change things, and I must balance between fidelity to the original text and fidelity to our audience here.' Even in such cases, he detects fine ethical distinctions, distinguishing his approach to Chekhov's *Platonov*, 'porque no es una obra conocida por el público español' (because it is not well known to the Spanish audience), from his translation of Ibsen's *Un enemigo del pueblo* (*An Enemy of the People*). In the latter, he felt able to take 'más libertades' (more liberties). Mayorga's descriptions of his practices

embody his location of the translator or adaptor, working in 'the risk zone', constantly negotiating a line between the source language and the target language, the text and the audience, an amplifying (ensanchador) or reductive (reductor) task.

My conversation with Mayorga illustrates his understanding of the implications of translation, both as a writer and translator. His Spanish text opens itself to translation and justifies Ramin Gray's privileging of the original writer as the contributor of theatricality, discussed above in the section on directors. However, the importance of Johnston's role as translator in so much of what is ultimately performed is made abundantly clear by Mayorga. The collaborative input in the early stages of rehearsal is significant, but also, as Mayorga explains, Johnston understands his 'obsessions'. The relationship between the playwright and translator is therefore essential for him in the transference of the text between cultures. Tushingham is also very familiar with the work of Schimmelpfennig. This is the key point that distinguishes the translator of a living playwright from the translator of a classic text: the ability both to conduct a textual dialogue and also a dialectic connection with the original author.

Power and collaboration

My interview process was intended to delve into the perception of translation by theatre practitioners, and examine how such translations are consequently transmitted to audiences. I wanted to examine why, on the one hand, there is the apparent negation of Venuti's paradox, the culturally violent invisible translator (2008: 1–42), by the promotion of a named theatre translator while, on the other hand, there is the disappearance of the literal translator who facilitates an anglicized version by a monolingual writer. Then there is the issue of whether translation is actually labelled as such, and to what extent adaptations and versions can be accepted as part of the translation genre. Reviewing the outcome of my interview conversations, I return to Adrian Hamilton's criticism of the mainstream London theatre translation process as 'a form of cultural imperialism' (2005: 406) and examine the argument that visible, high-profile writers and directors who use literal translations to create performed translated texts are culturally appropriating the work of both the original writer and the literal translator.

First, I suggest that literal translators are part of a larger contributing team made up of a range of practitioners from my interview groupings, including the artistic director, the director, the literary manager plus additional creative personnel mentioned by my interviewees, such as the

designer and the actors. All these agents add to the overall impression of the work transmitted to the audience. It seems to me that a team is necessarily required if it is to fulfil Venuti's prescription for producing a translation 'that is both readable and resistant to a reductive domestication': expert knowledge of the source-language culture; commanding knowledge of the diverse cultural discourses in the target language, past and present; and an ability to write (2008: 267). How often are all those qualities, along with an understanding of theatrical constraints, found in one individual? But it is not only translation that necessitates such a team: the very concept of performance is dependent on communal activity. A theatre translation emanates from a community, and every member of this team, including the writer and translator, submits to change and compromise during the process of creating a production. This theme, above all, has emerged in my interviews with theatre practitioners, and can perhaps be summarized in the words of Christopher Campbell, the literary manager of the Royal Court Theatre, as 'the conversations that take place every day and everywhere in the theatre'. So even when there is a controlling vision, such as that of the director Michael Grandage, who features as a strong personality through this interview process, a collaborative act takes place; its visibility is refracted through the production.

Second, when I consider the direct translations in my sample, I see similar cultural negotiations to those taking place in the creation of an indirect translation, the distinction being that they might be conducted between a smaller number of agents because the cultural tensions are distributed differently. David Johnston notes Juan Mayorga's 'willingness to work collaboratively with new directors, actors and translators, to re-assess as new sensibilities engage with his plays' (Mayorga 2009: 14). The agents I interviewed in connection with directly translated new plays were as concerned to balance the obligations between audience and playwright as those in the remainder of my sample. They were to some extent released from the pressures of filling seats both by the theatrical site (the Theatre Upstairs, venue for *Way to Heaven*, holds a maximum audience of ninety) and the fact that they were produced in a specialist theatre, the Royal Court, with a knowledgeable constituency. As I discuss in Chapter 3, *Hecuba*, the only direct translation among the retranslations, mirrored the negotiations of the indirect translations with regard to the persona of the agents and the commercial pressures, and cannot be singled out from the other plays in the sample as being in some way a 'purer' form of translation due to its more direct translation process.

Third, the practitioners move around the field, taking on different roles informed by their overall experience. Thus Mayorga moves from writer

to indirect translator, Poulton from indirect translator to direct translator, Scardifield from literal translator to direct translator, Byam Shaw from literary associate to producer and so on. Each text, each production differs in its requirements, but the cumulative experience applies to every assignment. Even so, every engagement carries a risk of failure and no amount of experience or planning can mitigate the possibility that a production may not meet with the approval of the critics or the audience. This adds to the tension, pushing the agents to combine previously successful techniques with an element of novelty.

Box office sales lead to the fourth element emerging from my interviews: financial imperatives. Producers and artistic directors have to consider the saleability of any production and a corresponding requirement to maintain expenditure within budget, which may be seen as artistic compromise. However, the impression I gained through my interviews was that finance was secondary to artistic endeavour. The 'moneybags' producers were as concerned as the directors and writers to create a high-quality production that would engage audiences. There was also an acknowledgement that, while strong box office revenues were desirable and career-enhancing, critical and artistic success was financially unpredictable and unquantifiable; a secret ingredient that could not be identified but was most likely to emerge from a collaborative team in an appropriate environment.

A fifth issue arising from these discussions is the perception and role of the literal translation as an independent piece of writing. On the one hand, the emphasis on matching writing talents rather than linguistic abilities when commissioning translations creates an impression that a literal translation, and even language ability, is a disposable commodity. An unwanted literal translation simply remains unused, a sign of the immateriality of its cost to the overall project. If a literal translation were expensive, more cultural value would attach to the intellectual and artistic elements of its creation. Theatre is not alone in undervaluing the work of translators. On the other hand, literal translators are selected with careful regard for their aptitude for the task and their experience, both linguistic and theatrical. Commissioners implicitly acknowledge the significance of the literal translator's role when they search for a suitable individual, calling on literary and academic contacts for advice (I myself am asked to recommend suitable literal translators from time to time), and reviewing the personnel in previous projects. If writers are brought onto the project before the literal translation is commissioned, they will request a translator with whom they have had a positive experience in the past. David Eldridge, from this sample, worked with a second literal translation from Charlotte Barslund when he adapted *John Gabriel Borkman* after his well-received version of *The Wild Duck*, both for the Donmar Theatre.

This pattern is regularly repeated among writers and translators, another indication of the worth attributed to teamwork.

Lastly, the issue of visibility of original writers and literal translators is another factor in the tensions arising around all the negotiations taking place in theatre translation. This was largely acknowledged by my participants, and it was asserted that literal translators should be credited. Any absence of credit was on the whole by oversight rather than design. The original writer is always acknowledged, and repeatedly referenced by the translator, direct, indirect or literal, in explaining their approach to the task. In retranslation there is a desire to present a new reading of the text, differentiating it from what has gone before, and this seems to be the principal reason for commissioning a new literal translation where needed. The literal translator therefore contributes to the 'new' in the same way as the indirect translator, and is aware of that requirement – indeed motivated by it. My impression was that each agent hoped to improve upon what had gone before and provide a more accurate reading of the original. For the first translation of a new play, the priorities are different: the play itself provides the 'new', so that the translator can focus on other areas. Even so, the translators and all members of the production team have in mind their prospective audience, and the fact that the responsibility of the new writer's introduction to the public lies with them.

The results of my interviews suggest a re-evaluation of what collaboration means in the process of translation, enlarging the field to include other, sometimes less visible, theatre practitioners, and setting the translation in the context of its place and time. My summaries of the approach of certain practitioners demonstrate how there may on occasion be a controlling vision which dominates the performed outcome of a translation, but that vision is always mediated by the other members of the enlarged team, and may even originate with a determined facilitator, acknowledged only in small print, like Marla Rubin. In the same way, the role of the literal translator may be underplayed and undervalued, particularly to the outsider, but the theatre industry implicitly validates the importance of this role by commissioning new literal translations from experts, and increasingly credits the literal translator more prominently. When a translation has been created by both literal and indirect translators, the issues of moral ownership of the translated product and responsibility for its cultural transfer become more complex. But even where there is no literal translation, a visible translator may be the figurehead around which other members of the cast and creative team gather to intercede. This is more likely to occur in a retranslation. The named translator also acts as gatekeeper and arbitrator for the ultimate transmission. Eva Espasa argues 'for putting theatre ideology and

power negotiation at the heart of performability' (2000: 58); my interviews suggest that the interrogation of collaborative techniques exposes the power negotiations implicit in all theatre translation. Vision and visibility fluctuate around a wide circle of participants. But this variety culminates neverthe-less in a single production, illustrating the substantially cooperative nature of translation.

5

5

Conclusion: Translation Theory in the Theatre

Where is the translator?

Translators do not 'just translate'. They translate in the context of certain conceptions of and expectations about translation, however much they may take them for granted or come to regard them as natural. Within this context translators make choices and take up positions because they have certain goals to reach, personal or collective interests to pursue, material and symbolic stakes to defend. That is where the concrete interplay of the personal and the collective takes place. (Hermans 1999a: 60)

The preceding chapters have analysed the role of theatre translators in the context of the sites in which they operate, the teams in which they participate and the products they generate. My aim was to map the processes of translation, attempting to identify the choices and positions of the agents, in order to assess the extent to which the interplay of the personal and the collective is demonstrable in theatrical translation, as a theoretical concept, but also as a perceptible activity. Analysis of the circumstances surrounding the translations of these plays reveals the effect of extra-textual theatrical phenomena on cultural transference in the translation of plays for performance. Nevertheless, in all cases, consideration of context not only suggests reasons for why certain translational decisions were made, but also reveals the strategic importance of non-textual factors in directing the textual form of a translation. My preceding reviews of theatrical site, financial and marketing imperatives, and the possibilities for interaction between original author, literal translator and translator (as affected by copyright obligations) show the complexities beyond the text which have to be negotiated by the translator in the portrayal of another culture to an English-speaking audience. They also promote factors affecting translation as intersemiotic activity which have an application beyond the theatre. Thus the contextual study of

theatre translation can furnish particularly visible examples of sociocultural pressures on translation.

Furthermore, while non-textual factors may affect the content of a translated text, where a text is to be performed, translational issues may become visible and communicate themselves through non-textual means. Because theatre is a multi-agency medium, the external factors imposed on the translator by other agents can appear more overt, such as in the translation of *Himmelweg* (the title) as *Way to Heaven* for the English market or the splendour of the atypical scenery for *The House of Bernarda Alba*. Publicity materials, programmes and reviews, set design, costumes and direction may all supplement or even replace the text for the target audience in the same way that the translated text supplements the original. The translator within a team of theatre practitioners has to address these issues. In 1982, André Lefevere reviewed successive translations into English of Brecht's *Mother Courage* for a New York audience between 1941 and 1972, declaring that 'the degree to which the foreign writer is accepted into the native system will ... be determined by the need that native system has of him in a certain phase of its evolution' (1982: 7). My investigations of these eight productions in 2005 show that even for a sophisticated, internationally inclined audience, such as at the Royal Court, a rapprochement to the target culture is still perceived as needed to bring the audience to the play. Thus the translator's negotiation of culture may be influenced by many external factors, not limited to a relationship with the original text but also affected by the theatrical translation policy, the expectation of the audience and the marketing and funding requirements. As I have shown, the counter-intuitive result can be that new plays like *The Woman Before* and *Way to Heaven*, whose originals lend themselves to translation, are received into the English-speaking repertoire with little comment on their source; on the other hand, the extensive acculturation of *The House of Bernarda Alba* or *Hecuba* foregrounds translation by generating comparisons with other productions and the original sources. The translator thus performs a paradoxical role, both highlighting and suppressing cultural difference.

I began this book by asking, where is the translator? The answers vary. Sometimes very prominently in the text, as I demonstrate in relation to the indirect translator, David Hare, and the direct translator, Tony Harrison, whose voices are so clearly heard through their translations. But even such strong and recognizable authorial presence was tempered by the collaborative fields in which these agents were operating. I provided specific examples of how Simon Scardifield's literal translation influenced Hare's choices, and how Vanessa Redgrave intervened in Harrison's script. The personal and the collective combined to produce these visible translations, and this collaborative

interplay is also evident in the remaining six plays of my sample. The quantities of ingredients in the overall mixture may vary, but the elements remain remarkably similar.

The public face of translation

The name of the translator signals to the audience that a translation process has taken place. In the SOLT small advertisements from where I drew my sample, only the five retranslations had translating names attached alongside the original author, and each of these productions was labelled as a transposed text, although never using the term 'translation'. The three plays shown in English for the first time, *Festen*, *The Woman Before* and *Way to Heaven*, neither named their translators nor identified their translational status (although, as 'festen' is not an English word, this might have provided some indication). Visible translators promote visible translations, suggesting that interpretation extends beyond the stage performance to the text itself. Thus, even within the potential limitations of terminology and cultural appropriation, the prominent names of individuals connected with a textual revision for production foreground a transformative engagement with the original text. This could perhaps also be considered as staking a claim to shared ownership of the text, but, if so, only for this specific production, as transposition is so clearly signposted, both by the adaptation or version label and the signifier 'new'. Of the five retranslations, only *The UN Inspector* was not promoted as new; instead, the novelty of the title was tempered by a reference to the original – 'Freely adapted from Gogol's *The Government Inspector*' – so that the link between the texts was maintained. However, visibility issues arise with regard both to the term 'translation' and the involvement of the literal translator. In these cases, the activity and the agent are masked in their presentation, hidden behind the public face of the translating team, the celebrity translator.

The theatrical function of celebrity

The focal point for all the agents in the translating field is the named translator, who also assumes responsibility for the text, including the contributions of others. My *Hecuba* case study demonstrates Tony Harrison's role as gatekeeper of the translation, deciding which members of the collaborative team may engage in revisions of the text. Harrison's public status, his celebrity, bestows this power on him, but it also forces him to bear the consequences

of negative criticism. The reception of his *Hecuba* distinguished between his writing and Redgrave's acting, to his disadvantage. Similarly, the reception of *The House of Bernarda Alba* sought to differentiate between Hare's version and Lorca's original. Hare's celebrity, bringing with it a widespread recognition of his authorial style, made it possible for the audience to draw comparisons, again not necessarily to his advantage. But responsibility for the text tends to fall on the named writer, even when celebrity might lie elsewhere in the production. David Eldridge's description of the rehearsal procedure in the development of *Festen* reveals the contributions of the other agents in the room: the director, the actors, the lighting designer and so forth. But Eldridge's name is on the cover of the published text, so that he effectively acts as moderator for the translation: rejecting an actor's suggestion, accepting the director's views and adapting the structure of a scene to comply with lighting technicalities. At that point in his career, Eldridge was still considered a newcomer (he accepts that *Festen* assisted his reputation as a playwright) and any celebrity in the production team was attributable to the cast, principally Jane Asher as Else.

So who is the celebrity? As we have seen, the famous name in the production may belong to the direct or indirect translator, but it may also be that of another agent, such as the actors Vanessa Redgrave (*Hecuba*) or Derek Jacobi (*Don Carlos*), or the director, in the example of Richard Wilson for *The Woman Before*. The implication that a celebrity translator is selected on the basis of an unethically commercial motivation to sell tickets disregards the circularity of the phenomenon whereby mainstream theatrical recognition, or 'celebrity', usually results from critical and box office success, indicating that the individual is an accomplished practitioner. Although there are exceptions in which a practitioner may achieve celebrity through a degree of notoriety, theatre practitioners are more likely to become ticket-selling 'names' if they have a history of artistic and professional achievements. Furthermore, well-known names tend to feature generally in productions aiming for large audiences, whether or not translation is involved; celebrity is not therefore a mechanism to mask translation, but one of the elements influencing theatrical creative decisions.

Of the eight productions in my sample, most cast lists included names known to theatre and television audiences and most of the creative lists were made up of individuals who had built up a reputation in theatrical circles. *Way to Heaven*, in a small theatre, had a somewhat lower cast and creative profile than, say, *Hecuba*, but the translator of the former, David Johnston, quite apart from his status as a professor of Spanish, was already known in theatrical circles for his previous well-received stage translations when he was commissioned to translate Juan Mayorga's plays for the Royal Court.

Indeed, his 2004 translation of Lope de Vega's *The Dog in the Manger* has been described as 'the hit of the Royal Shakespeare Company's season of Golden Age plays' (Dixon 2010: 621). Celebrity is relative, but within that relativity it performs a function in theatrical composition which extends beyond selling tickets.

Collaboration and visibility

Celebrity may be relative, but its imbalances are particularly marked in the agencies of the literal and indirect translators. Who is actually translating? The unwillingness to use the term 'translation', even when a direct translation is created by practitioners like Tony Harrison or Mike Poulton (who translates directly from Italian, although in this sample he is the indirect translator of *Don Carlos*), suggests that its creative status is lower than that of the writer, or that it is perhaps seen as a less 'theatrical' activity. Harrison was identified as the translator in the published text of *Hecuba*, but as the writer of a new version in the programmes. Poulton was first named as a translator in the Sheffield programme for *Don Carlos* but had become the adaptor by the time it reached London. Mathew Byam Shaw suggested that the word 'translation' did not provide sufficient dramaturgical respect for the work of the theatre translator, in contrast to the use of 'version' or 'adaptation'. The Royal Court Theatre maintains the label 'translator' for the agents who carry out the work of transposition but does not include either the task or the agent in its SOLT advertisements, thus ensuring that the focus remains on the original writer rather than a shared credit with the translator. Therefore, both direct and literal translators are pushed behind the living writer whether that writer is the source-language playwright or the creator of a 'new version'. The activity known as 'translation' in the theatre is not perceived as sufficiently creative for celebrity billing, whereas the product known as the 'adaptation' or 'version' has a recognized existence alongside the original source text. The translated product is privileged while the translation process is overlooked.

The level of status accorded to translating agents is linked with the area of their participation, although there may be a mutual endowment of status. For example, the playwright Caryl Churchill, whose new work is always heralded with a degree of excitement and expectation, translated the play *Felicité* (2007) by Olivier Choinière, a young French-Canadian playwright, which was performed as *Bliss* at the Royal Court Theatre Upstairs in 2008. Churchill's participation not only ensured production in London, but also introduced the play to the anglophone Canadian stage, receiving a new production at the Toronto Summerworks Festival in 2010, which was then

revived in Toronto and Montreal in 2012. In this case, Choinière's career was enhanced by Churchill's 'celebrity'. Barely discernible literal translators can also emerge from behind their translation; Simon Scardifield worked on the literal translation for Howard Brenton's version of Georg Büchner's *Danton's Death* at the National Theatre in 2010, but the following year was named as the adaptor of the same play broadcast on BBC Radio Three.

These are two examples to add to the multifunctioning theatre practitioners in my sample, which I have highlighted throughout. These agents move between roles, sometimes occupying two simultaneously. Scardifield is an example of an actor who can also create literal translations and write translations and adaptations. Mike Poulton translates directly and indirectly. Richard Eyre and David Farr are directors and indirect translators. Tony Harrison directs and writes direct translations and adaptations. Is it possible to draw a line between translation and the practice of other stage skills? Is it possible to draw a line between different types of translation? I am not entirely comfortable with Manuela Perteghella's assertion that a literal translation is a 'first draft of a collaborative project', because the literal translations I have seen are not first drafts, but the result of painstaking and detailed work. They are not created to be 'improved' by indirect translators, but to provide a working 'source text' from which the indirect translator fashions a new translation. Literal and indirect translations are prepared with different purposes, and do not conflate into a direct translation. I do, however, agree with Perteghella that the literal translation is 'the beginning of a process, of what you see at the end on stage' (Meth, Mendelsohn and Svendsen 2011: 209). Because they are part of the process, they deserve greater acknowledgement. Charlotte Pyke put forward a further argument for recognition of her agency as a literal translator: the original author is undermined when the literal translator is not credited, through the failure to recognize the long transition between what was originally written and what is performed on stage. In other words, acknowledgement of the process recognizes the agency of all the participants, apportioning the value of the finished product across the team. And this teamwork, in my opinion, *provided that it is exposed to view*, brings the act of translation into focus, reminding the user of the intercultural shift taking place.

This book asserts the function of the translation team as of key importance in the production of a staged translation. As I have discussed, the team gathers around one named focal point, but the driver of the overall activity may be a different agent from the visible team leader. The director Michael Grandage and the producer Marla Rubin are examples of agents whose initiatives colour the project in addition to keeping it in motion. However, power and visibility rarely vest in one individual in the process. Indeed, on investigation,

the influences on translation are many and diverse and include agents who may not have any detailed connection with the written translation or ability in the language of the source text, but who affect not only the manner of its composition but also the tone of its content. It is notable that all the translations in my sample originated in theatres which prioritize commissioning and new writing and employ personnel whose specific task is to provide literary support. Interviews with these practitioners reveal the contributions of a sometimes extensive group of individuals, as, for example, in the originating of the contemporary slant of *The UN Inspector*. Nevertheless, the process of translation locates the named translator at the centre of an influential group. For the purposes of translation, the team leader makes the gate-keeping decisions. This applies as much for the professional language-specialist direct translator David Tushingham as it does for the celebrity indirect translator David Hare, both of whom have to negotiate the demands of performance, the actors and the director, as they compose their translation.

Literal translators inform these decisions through the translation choices they have already made in the composition of their own translation, but they do not have the last word. The literal translators I interviewed were fully aware of this fact, and accepted that this was their role in the collaborative process. The Russianist Helen Rappaport describes herself as 'cynical and discouraged about the position of the much-underrated literal translator' (2007: 75); these feelings are largely attributable to her public 'disappearance' in the translation process, although she also appears to be frustrated by what she sees as an increasing distance of new versions from the original. She asks whether we are 'coming to the point where new versions are commissioned just for the sake of it, when there are often more than enough good translations or versions already in existence' (2007: 74). Although not among my subjects for interview, Rappaport was nevertheless named by several practitioners as a good example of an effective literal translator, suggesting that she is not underrated within the theatre profession even though she feels that may be the case with respect to the public at large. Her views on the overpopulation of translations and versions were not echoed by the literal translators I interviewed, who appeared to support the idea of a 'fresh' approach bringing out different aspects of a canonical text and to enjoy their part in the production. There was, however, consensus that the rewards, both monetary and by way of recognition, did not reflect the degree of effort and participation in the whole project. In my view, this area displays a limitation in the collaborative achievement. It is a defect that could be overcome systemically, by following the example of the Almeida's credit for Charlotte Pyke in the programme for its 2006 production of Maxim Gorky's *Enemies*, in a version by David Hare. Pyke's name was clearly displayed next to Hare's, with her photograph and

biography appearing in the programme with the remainder of the leading creative cast. This should be standard practice, marking the extent of collaboration in the translation process.

Signposting translation

What is it about theatre that provides an effective site for the study of translation? Susan Bassnett and Peter Bush complain that 'with the written text, read individually, or the performed play, seen by an audience, the illusion of the unmediated word has traditionally to be maintained' (2006: 1). I do not agree that theatre strives to project such an illusion. On the contrary, the visibility of theatre translation, as a result of the appointment of high-profile individuals, points to overt intervention in the translation process. The strong voice of the celebrity translator queries the act of translation as mediation and these agents engage visibly with the original author. My case studies show how the foregrounding of Hare's voice liberates the source text for new possibilities of interpretation, a practical demonstration of translation's theoretical comment and momentum. Harrison's agency as translator displays the shifting interpretations which characterize translation, while his *Hecuba* production illustrates the process of collaboration in translation and its effect on participating agents and the eventual product. However, the cooperative act of translation can be foreshortened, with other collaborators remaining hidden. This relates particularly to literal translators, but also underestimates the editorial interventions of producers, directors, literary staff and actors, along with additional theatre practitioners who enter and leave the process along the way.

Theatre provides overt displays of translation's cultural negotiations, through both direct and indirect translations. Both methods interpose knowingly between the playwright and the audience, tailoring the content to reflect its current environment but generally with a self-awareness that alerts the receiver to the process that is taking place. The living source-language playwrights in my sample demonstrate a willingness to transpose or write for a new audience. But this is not a novel characteristic of theatre translation, as Ibsen's concern with his German translations revealed over one hundred years ago. Perhaps theatre enables this focus on the receiving culture because of the homogeneity of the audience language identified by Carlson (2006: 3)? Or it may be that the smaller groupings of theatre audiences, even though they are differently reconstituted on a nightly basis, engender a sense of communal reception which permits precision targeting for translation. As my studies suggest, the distinction between direct and indirect translation seems less relevant than that between 'first' and 'new'.

The phenomenon of retranslation is a more significant feature than the presence of a direct or indirect translator. Classical reception studies demonstrate the appropriation of texts as society moves through time. Charles Martindale asserts that 'our current interpretations [of ancient texts] whether or not we are aware of it, are in complex ways constructed by the chain of receptions through which their continued readability has been effected. As a result we cannot get back to any originary meaning wholly free of subsequent accretions' (1993: 7). But those cumulative accretions combine to present meaning. Hans-Georg Gadamer uses translation as an example and a metaphor for the understanding of meaning, albeit 'an extreme case of hermeneutical difficulty' (2003: 387). For him, the translator carries out and embodies the interpretive dialogue between the text and the reader, and demonstrates the essentiality of language. He writes, 'The linguisticality of understanding is *the concretion of historically effected consciousness*' (2003: 389), suggesting that an attempt to create a historical reconstruction of meaning will not necessarily result in understanding, but that cognition born of historical and linguistic experience enables the interaction which brings about understanding. This describes the process taking place when translators intervene between the audience and the original text: their personal narrative informs their choices in translation, and this can include their absorption of previous translations, along with their political and social allegiances.

Translation perpetuates some underlying meaning in a text, possibly even by way of contradiction. Theatre trials the efficacy of this tension in its experimental pairing of translators with texts. Two of the commissioning practitioners interviewed, Christopher Campbell and Michael Grandage, highlighted the potentialities of unorthodox matches, finding unexpected synchronicities between the source- and target-language writers. David Hare was not an obvious fit with Lorca, and yet his verbatim style of dialogue resonates with Lorca's desire to create a documentary record. Hare's production presented Lorca in a different light, even though it did not meet with universal acclaim. And in theatre, if the results are unsatisfying, there is always the possibility of another attempt, as can be seen from the number of retranslations created of *The House of Bernarda Alba* even since I began work on this volume.

One of the complaints about Hare's production was its domestication of the source text, reflecting Venuti's concerns about the cultural violence perpetrated by Anglo-Saxon translation methods (2008). Visibility issues have been discussed throughout this study, and I also raised the domestication/foreignization dichotomy with my interviewees. Rufus Norris took the view that foreignization could amount to confounding the receivers' expectations, forcing them to question what is being delivered.[1] If this is the case, 'new',

[1] Rufus Norris, Interview with Geraldine Brodie (London, 7 March 2011).

even when, or especially when, relocating a source text to the receiver's environment, can still offer a reminder that the original lies elsewhere. Norris, however, is a director, not a linguist, whose influence on the construction of a translation reveals another feature of theatre which is relevant in translation theory: the participation of commissioners in moulding the translation outcome. The choices both of texts to be translated, and the context of the site and accompanying texts framing that translation, generally lies beyond the scope of the translator. Theatre presents the opportunity to examine the significance of the commissioning process in translation via its listing of the agents involved in all aspects of production. Its visible procedures provide material enabling reflection on translation for the theorist, and the potential to raise awareness of translation for the practitioner.

I have suggested that London theatre provides a model of translation that does not necessarily conform to Venuti's equation of the invisible with the dominant. This model has its own invisibilities and power imbalances, but it also displays translation as an activity in which visible participators combine to comment critically on their own environment while paying tribute to the source text as their inspiration. Is this cultural appropriation? Certainly, but it acknowledges this practice and offers the audience many variations as a reminder of the inherent instability and interpretive qualities of translation. Such reminders would be more powerful if the detailed practice of translation via a literal route were regularly and clearly signposted, preferably applying the term of 'translation' so that receivers were left in no doubt as to the provenance of the source. Venuti, instructing readers how to read a translation, insists that a translation 'ought to be read differently from an original composition precisely because it is not an original' (2004). Retranslation in mainstream London theatre in many ways complies with this instruction, but there are opportunities in theatre to highlight translation further, along with societal awareness of its implications. We should take them on.

Appendix 1

Sample Play Data

The following pages contain data gathered concerning each of the plays in the research sample. *Starred* data marks information that was presented in the Society of London Theatre small advertisements. Data for other translators into English is indicative of the extent to which translations have been carried out, but is not exhaustive. Literary translations are included.

1a: *Don Carlos*

Title	*Don Carlos*
Author	*Friedrich Schiller*
Original title	*Don Carlos*
Language	German
Translator	*Mike Poulton*
Literal translator	Undisclosed
Translation type	Indirect/*adaptation*
Original copyright	Expired
Translation copyright (date)	Mike Poulton (2005)
Publisher	Nick Hern Books
Theatre	Gielgud
Original theatre	Crucible, Sheffield Theatres
Director	*Michael Grandage*
Artistic director (Sheffield)	Michael Grandage
Producer (West End)	Matthew Byam Shaw
Literary associate (Sheffield)	Matthew Byam Shaw
Dates of West End run	28 January–30 April 2005
Principal actor	Derek Jacobi – Philip II
Date of original	1787
Date of this translation	2004
Date of 1st English-language translation	1798
1st English-language translator(s)	Georg Heinrich Noehden and Sir John Stoddart

Other translators into English (dates)	John Russell (1822)
	John Towler (1843)
	Charles Herbert Cottrell (1844)
	R. D. Boylan (1846–1849)
	Thomas Selby Egan (1867)
	Andrew Wood (1873)
	James Kirkup (1959)
	Graham Orton (1967)
	J. Maxwell (1987)
	Peter Oswald (1992)
	Hilary Collier Sy-Quia (1999)
	Robert David MacDonald (2005)

1b: *Festen*

Title	*Festen*
Author	Thomas Vinterberg
Original title	*Festen*
Language	Danish
Translator	David Eldridge
English translator	Bo hr. Hansen (English script from play based on Danish film)
Translation type	Indirect
Original copyright (date)	Thomas Vinterberg, Mogens Rukov and Bo hr. Hansen (2004) [Stage play]
Translation copyright (date)	'This edition of *Festen*, first reprinted in 2005, incorporates revisions made to the text in rehearsal and should be regarded as the definitive version.' (Vinterberg, Rukov and Hansen 2004: np)
Publisher	Methuen Publishing
Theatre	Lyric
Original theatre	*Almeida*
Director	Rufus Norris
Artistic director (Almeida)	Michael Attenborough
Producer	Marla Rubin
Artistic associate (Almeida)	Jenny Worton (from 2005)
Dates of West End run	15 September 2004–16 April 2005
Principal actors	Jane Asher – Else; Jonny Lee Miller – Christian
Date of original	1998 (screenplay)
Date of this translation	2004
Date of 1st English-language translation	2004
1st English-language translator	David Eldridge
Other translators into English (dates)	N/a

1c: *Hecuba*

Title	*Hecuba*
Author	*Euripides*
Original title	*Hecuba*
Language	Ancient Greek
Translator	*Tony Harrison*
Literal translator	N/a
Translation type	Direct/*version*
Original copyright (date)	Expired
Translation copyright (date)	Tony Harrison (2005)
Publisher	Faber and Faber
Theatre	Albery
Original theatre	Royal Shakespeare Theatre, Stratford-upon-Avon (cancelled)
Director	Laurence Boswell (London)
	Tony Harrison (tour)
Artistic director (RSC)	Michael Boyd
Producer (West End)	*Royal Shakespeare Company*
Dramaturg (RSC)	Paul Sirett
Dates of West End run	7 April–7 May 2005
Principal actor	*Vanessa Redgrave* – Hecuba
Date of original	423 BCE
Date of this translation	2005
Date of 1st English-language translation	1726
1st English-language translator	Richard West
Other translators into English (dates)	Thomas Morell (1749)
	D. Spillan (1825)
	John Richardson Major and Richard Porson (1826)
	Robert Potter (1827)
	Frederick Apthorp Paley (1876)
	Michael Woodhull (1888)
	Thomas Nash (1892)
	William Henry Balgarbie and Thomas Theophilus Jeffery (1899)
	Gilbert Murray (1902)
	St. George William Joseph Stock (1902)
	John Tresidder Sheppard (1924)
	Hugh Owen Meredith (1937)
	David Grene and Richmond Lattimore (1958)
	Arthur S. Way (1959)
	Peter Douglas Arnott (1969)
	John W. Ambrose Jr (1981)
	J. Michael Walton, D. Taylor and Peter D. Arnott (1991)
	Kenneth J. Reckford and Janet Lembke (1991)

Christopher Collard (1991)
Joel Tansey and Kiki Goundaridou (1995)
David Kovacs (1995)
Kenneth McLeish (1995)
Eleanor Wilner and Marilyn Nelson (1998)
Edward P. Coleridge and William-Alan
 Landes (1998)
Richard Rutherford and John Davie (1998)
Stephen Daitz (1998)
Philip Velacott (1999)
Robert Emmet Meagher (1999)
James Morwood (2000)
John Harrison (2004)
Frank McGuinness (2004)
Marianne McDonald (2005)
Robin Mitchell-Boyask (2006)
Marina Carr (2015)

1d: *Hedda Gabler*

Title	*Hedda Gabler*
Author	*Henrik Ibsen*
Original title	Hedda Gabler
Language	Norwegian
Translator	*Richard Eyre*
Literal translators	Karin and Ann Bamborough
Translation type	Indirect/*version*
Original copyright	Expired
Translation copyright (date)	Richard Eyre (2005)
Publisher	Nick Hern Books
Theatre	Duke of York's
Original theatre	Almeida
Director	Richard Eyre
Artistic director (Almeida)	Michael Attenborough
Producer (West End)	Robert Fox
Artistic associate (Almeida)	Jenny Worton (from 2005)
Dates of West End run	27 May–6 August 2005
Principal actors	Eve Best – Hedda; Iain Glen – Judge Brack
Date of original	1890
Date of this translation	2005
Date of 1st English-language translation	1890
1st English-language translators	Edmund Gosse and William Archer.

Other translators into English (dates)	Una Ellis-Fermor (1950)
	Peter Watts (1950)
	Eva Le Gallienne (1957)
	Arthur Miller (1957)
	Alan S. Downer (1961)
	Rolf Fjelde (1965)
	Edward T. Byrnes (1965)
	John Gassner (1965)
	M. Faber (1966)
	Christopher Hampton (1972)
	John Osborne (1972)
	Kai Jurgensen and Robert Schenkkan (1975)
	John Lingard and Ken Livingstone (1975)
	Michael Meyer (1977)
	James McFarlane and Jens Arup (1981)
	Per K. Brask (1991)
	Nicholas Rudall (1992)
	R. Farquharson Sharp (1992)
	Kenneth McLeish (1995)
	Jon Robin Baitz and Anne-Charlotte Hanes Harvey (2001)
	Doug Hughes (2001)
	Reg Mitchell (2002)
	Thomas Parry and R. H. Hughes (2003)
	Brian Johnston (2003)
	Andrew Upton (2004)
	Alyssa Harad (2005)
	Mike Poulton (2006)
	Lucy Kirkwood (2008)
	Brian Friel (2008)
	Robin French, as *Heather Gardner* (2013)
	Patrick Marber (2016)

1e: *The House of Bernarda Alba*

Title	**The House of Bernarda Alba**
Author	**Federico García Lorca**
Original title	*La casa de Bernarda Alba*
Language	Spanish
Translator	*David Hare*
Literal translator	Simon Scardifield
Translation type	Indirect/*version*

Original copyright (date)	Herederos de Federico García Lorca (1946)
Translation copyright (date)	David Hare and Herederos de Federico García Lorca (2005)
Publisher	Faber and Faber
Theatre	Lyttelton, National Theatre
Original theatre	N/a
Director	Howard Davies
Artistic director	Nicholas Hytner
Literary manager	Jack Bradley; Christopher Campbell (Deputy, 2004–2010).
Dates of run	5 March–30 July 2005
Principal actors	Penelope Wilton – Bernarda; Deborah Findlay – Poncia.
Date of original	1936
Date of this translation	2005
Date of 1st English-language translation	1947
1st English-language translator	Richard L O'Connell and James Graham-Lujan
Other translators into English (dates)	Tom Stoppard (1973)
	Sue Bradbury (1977)
	Robert David MacDonald (1986)
	Michael Dewell and Carmen Zapata (1987)
	Dennis Klein (1991)
	Christopher Maurer (1992)
	Gwynne Edwards (1998)
	Emily Mann (1998 and 2012)
	Rona Munro (1999)
	Caridad Svich (2005)
	Rebecca Morahan, Auriol Smith and Robert David MacDonald (2007)
	Michael Jones and Salvador Ortiz-Carboneres (2007)
	David Johnston (2008)
	Sudha Bhuchar, as *The House of Bilquis Bibi* (2010)
	Jo Clifford (2012)

1f: *The UN Inspector*

Title	*The UN Inspector*
Author	Nikolai *Gogol*
Original title	*Revizor*
Language	Russian
Translator	*David Farr*
Literal translator	Charlotte Pyke

Translation type	Indirect/*free adaptation of *The Government Inspector**
Original copyright (date)	Expired
Translation copyright (date)	David Farr (2005)
Publisher	Faber and Faber
Theatre	Olivier, National Theatre
Original theatre	N/a
Director	David Farr
Artistic director	Nicholas Hytner
Literary manager	Jack Bradley; Christopher Campbell (Deputy, 2006–2010).
Dates of run	7 June–5 October 2005
Principal actors	Michael Sheen – Gammon; Kenneth Cranham – The President; Geraldine James – Anna Andreyevna
Date of original	1835
Date of this translation	2005
Date of 1st English-language translation	1916 as *The Inspector-General*
1st English-language translator	Thomas Seltzer
Other translators into English (dates)	Constance Garnett(1926)
	D. J. Campbell (1947)
	Peter Raby (1967)
	L. Ignatieff (1973)
	Guy R. Williams (1980)
	Adrian Mitchell (1985)
	E. Bentley (1987)
	Aleksander Segeyvich Griboyedov, Alexander Nikolaevich Ostrovsky and Joshua Cooper (1990)
	John Byrne (1998)
	Christopher English (1999)
	Stephen Mulrine (1999)
	Alistair Beaton (2005)
	Robert Maguire and Ronald Wilks (2005)
	David Harrower (2011)

1g: *Way to Heaven*

Title	*Way to Heaven*
Author	*Juan Mayorga*
Original title	*Himmelweg*
Language	Spanish
Translator	David Johnston
Literal translator	N/a
Translation type	Direct
Original copyright (date)	Juan Mayorga (2004)
Translation copyright (date)	David Johnston (2005)

Publisher	Oberon Books
Theatre	Royal Court Upstairs
Original theatre	N/a
Director	Ramin Gray
Artistic director	Ian Rickson
International director	Elyse Dodgson
Literary manager	Graham Whybrow; Ruth Little (2005–2010); Christopher Campbell (from 2010)
Dates of run	16 June–9 July 2005
Principal actors	Jeff Rawle – Red Cross Representative; Dominic Rowan – Commandant
Date of original	2004
Date of this translation	2005
Date of 1st English-language translation	2005
1st English-language translator	David Johnston
Other translators into English (dates)	N/a

1h: *The Woman Before*

Title	*The Woman Before*
Author	*Roland Schimmelpfennig*
Original title	*Die Frau von früher*
Language	German
Translator	David Tushingham
Literal translator	N/a
Translation type	Direct
Original copyright (date)	2004
Translation copyright (date)	2005
Publisher	Oberon Books
Theatre	Royal Court Downstairs
Original theatre	N/a
Director	Richard Wilson
Artistic director	Ian Rickson
Associate director International	Elyse Dodgson
Literary manager	Graham Whybrow; Ruth Little (2005–2010); Chris Campbell (from 2010)
Dates of West End run	12 May–18 June 2005
Principal actors	Saskia Reeves – Claudia; Helen Baxendale – Romy Vogtländer
Date of original	2004
Date of this translation	2005
Other translators into English (dates)	Melanie Dreyer, as *Woman from the Past* (2005)

Appendix 2

Archives

Archive	Play	Material	Date
Archive of Performances of Greek and Roman Drama, Oxford.	*Hecuba*	Draft script, programmes, reviews.	12 March 2012
British Library Sound Archive, London.	*Way to Heaven; The Woman Before*	Sound recording.	21 April 2010
Brooklyn Academy of Music Archive, New York.	*Hecuba*	Video recording, prompt book, programme, production files, reviews.	19 May 2011
National Theatre Archive, London.	*The House of Bernarda Alba; The UN Inspector*	Literal translations, prompt book, video recordings, programmes, production files, reviews.	23 October 2008
Royal Court Theatre, London.	*Way to Heaven; The Woman Before*	Prompt books, production files.	15 April 2009
Shakespeare Birthplace Trust, Stratford-upon-Avon.	*Hecuba*	Prompt book, programme, production files, reviews.	30 October 2008
Sheffield Theatres Archive, Sheffield	*Don Carlos*	Programme.	23 March 2011 (by email and post)
V&A Theatre and Performance Archives, London	*Don Carlos; Hedda Gabler*	Video recordings, reviews.	19 November 2008; 7 October 2011

Bibliography

Aaltonen, Sirkku (2010), 'Drama Translation', in Yves Gambier and Luc van Doorslaer (eds), *Handbook of Translation Studies* Volume 1, 94–104, Amsterdam: John Benjamins.

Alberge, Dalya (2004), 'Understudies to Take their Turn in the Limelight', *The Times*. Available online: http://www.timesonline.co.uk/tol/news/uk/article1007160.ece (accessed 5 July 2011).

Allain, Paul and Jen Harvie (2006), *The Routledge Companion to Theatre and Performance*, Abingdon: Routledge.

Almeida Theatre Company (2005), *Report and Financial Statements Year Ended 31 March 2005*, London: Almeida Theatre Company.

Almeida Theatre Company (2006), *Enemies*, Theatre Programme, London: Almeida Theatre Company.

Almeida Theatre Company (2009), 'Summary Information Return of Aims, Activities and Achievement 2009'. Available online: http://www.charitycommission.gov.uk/SIR/ENDS67/0000282167_SIR_09_E.PDF (accessed 21 October 2010).

Almeida Theatre Company (2010a), 'About Us'. Available online: http://www.almeida.co.uk/aboutus/default.aspx (accessed 20 October 2010).

Almeida Theatre Company (2010b), 'Artistic Vision'. Available online: http://www.almeida.co.uk/aboutus/artisticvision.aspx (accessed 20 October 2010).

Almeida Theatre Company (2015), *Report and Financial Statements for the Year Ended 31 March 2015*, London: Almeida Theatre Company.

Ambassador Theatre Group Holdings (2015), *Directors' Report and Financial Statements for the 52 Week Period Ended 28 March 2015*, London: Ambassador Theatre Group Holdings.

American Association of Community Theatre (2011), 'Artistic Director'. Available online: http://www.aact.org/people/artistic.html (accessed 15 September 2011).

Anderman, Gunilla (2006), *Europe on Stage: Translation and Theatre*, London: Oberon Books.

Andrews, Richard (2006), *Box Office Data Report*, London: Society of London Theatre.

Andrews, Richard (2008), *Box Office Data Report*, London: Society of London Theatre.

Appiah, Kwame Anthony (2012), 'Thick Translation', in Lawrence Venuti (ed.), *The Translation Studies Reader*, 3rd edn, 331–43, London: Routledge.

Arts Council England (2005), *Annual Review Grant-in-Aid Accounts*, London: Arts Council England.

Arts Council England (2009a), 'Regular Funding Organisations'. Available online: http://www.artscouncil.org.uk/funding/regular-funding-organisations/ (accessed 11 November 2009).

Arts Council England (2009b), 'Royal Court Theatre'. Available online: http://www.artscouncil.org.uk/rfo/english-stage-company-royal-court-theatre/ (accessed 21 October 2009).

Arts Council England (2009c), 'Royal National Theatre'. Available online: http://www.artscouncil.org.uk/rfo/royal-national-theatre/ (accessed 21 October 2009).

Assis Rosa, Alexandra, Hanna Pięta and Rita Bueno Maia (2017), 'Theoretical, Methodological and Terminological Issues Regarding Indirect Translation: An Overview', *Translation Studies*, 10:2, 113–32.

Aston, Elaine and Mark O'Thomas (2015), *Royal Court: International*, London: Palgrave Macmillan.

ATC (2011), 'About Us'. Available online: http://www.atc-online.com/index. php?pid=34 (accessed 23 November 2011).

Baker, Mona (2005), 'Narratives in and of Translation', *SKASE Journal of Translation and Interpretation*, 1: 4–13.

Bamborough, Karin, Interview with Geraldine Brodie (London, 8 February 2011).

Barslund, Charlotte (2011), 'The Translation of Literary Prose', in Kirsten Malmkjaer and Kevin Windle (eds), *The Oxford Handbook of Translation Studies*, 139–52, Oxford: Oxford University Press.

Bassett, Kate (2002), 'Festen', *Independent*, 3 November. Available online: http://www.independent.co.uk/arts-entertainment/theatre-dance/reviews/our-house-cambridge-theatre-london-brhome-and-beauty-lyric-shaftesbury-london-brthe-price-tricycle-london-brfesten-sadlers-wells-london-603290. html (accessed 13 April 2011).

Bassett, Kate (2004a), 'Festen', *Theatre Record*, 24: 396.

Bassett, Kate (2004b), 'Hecuba', *Theatre Record*, 19: 1170.

Bassnett, Susan (1991), 'Translating for the Theatre: The Case against Performability', *Traduction, Terminologie, Rédaction: Etudes sur le texte at ses transformations*, 4: 99–111.

Bassnett, Susan and Peter Bush (2006), 'Introduction', in Susan Bassnett and Peter Bush (eds), *The Translator as Writer*, 1–8, London: Continuum.

BBC (2004), 'Transcript of the John Tusa Interview with David Hare'. Available online: http://www.bbc.co.uk/radio3/johntusainterview/hare_transcript. shtml (accessed 20 March 2010).

BBC (2016), 'Radio 4 Today Programme, Running Order 13 July 2016'. Available online: http://www.bbc.co.uk/programmes/b07jyvzs (accessed 10 August 2017).

Benjamin, Walter (1968), 'The Task of the Translator', trans. James Hynd and E. M. Valk, *Delos*, 1: 76–96.

Berrigan, Hanna (2005), *The UN Inspector Background Pack*, London: Royal National Theatre.

Bill Kenwright Ltd (2012), 'About Bill Kenwright Ltd'. Available online: http://www.kenwright.com/index.php?id=578 (accessed 4 January 2012).

Billington, Michael (2004), 'Festen', *Theatre Record*, 24: 397.

Billington, Michael (2007), *State of the Nation: British Theatre since 1945*, London: Faber and Faber.

Billington, Michael (2008), 'Hamlet's Sitting Tennant Breaks the Myth of the Understudy', *The Guardian*, 10 December. Available online: http://www.guardian.co.uk/stage/theatreblog/2008/dec/10/rsc-shakespeare-hamlet-david-tennant-understudy (accessed 5 July 2011).

Billington, Michael (2010), 'King Lear', *The Guardian*, 8 December. Available online: http://www.guardian.co.uk/stage/2010/dec/08/review-king-lear-derek-jacobi (accessed 7 July 2011).

Bourdieu, Pierre (2000), *Pascalian Meditations*, trans. Richard Nice, Redwood City: Stanford University Press.

Boyle, Catherine (2005), 'Translating Sor Juana Inés de la Cruz: Reflections on a Process and a Season', *Translating Today*, 4: 20–23.

Boyle, Catherine (2007), 'Perspectives on Loss and Discovery: Reading and Reception', in Catherine Boyle and David Johnston (eds), *The Spanish Golden Age in English: Perspectives on Performance*, 61–74, London: Oberon.

Bradley, Jack, Interview with Geraldine Brodie (London, 28 April 2010).

Branigan, Tania (2004), 'Disillusioned with Politics? Vote Redgrave!', *Guardian*, 17 November. Available online: http://www.guardian.co.uk/uk/2004/nov/17/humanrights.arts (accessed 18 January 2012).

Brecht, Bertolt (2009), *The Caucasian Chalk Circle*, trans. Alistair Beaton, London: Methuen.

British Theatre Guide (2011), 'Uncle Vanya'. Available online: http://www.britishtheatreguide.info/reviews/vanuaarcola-rev (accessed 5 July 2017).

Brodie, Geraldine (2010), '*The House of Bernarda Alba*: Translation as Political Metaphor', *CTIS Occasional Papers*, 6: 54–66.

Brodie, Geraldine (2012), 'Theatre Translation for Performance: Conflict of Interests, Conflict of Cultures', in Brigid Maher and Rita Wilson (eds), *Words, Images and Performances in Translation*, 63–81, London: Bloomsbury Continuum.

Brodie, Geraldine (2013), 'Schiller's Don Carlos in a Version by Mike Poulton, Directed by Michael Grandage: The Multiple Names and Voices of Translation', in Hanne Jansen and Anna Wegener (eds), *Authorial and Editorial Voices in Translation 1 – Collaborative Relationships between Authors, Translators, and Performers*,119–40, Montréal: Éditions Québécoises de l'Oeuvre.

Brodie, Geraldine (2014), 'Translation in Performance: Theatrical Shift and the Transmission of Meaning in Tony Harrison's Translation of Euripides' Hecuba', *Contemporary Theatre Review*, 24 (1): 53–65.

Brodie, Geraldine (2016), 'The Sweetheart Factor: Tracing Translation in Martin Crimp's Writing for Theatre', *Journal of Adaptation in Film and Performance*, 9 (1): 83–96.

Brodie, Geraldine (2018), 'Performing the Literal: Translating Chekhov's Seagull for the Stage', in Jean Boase-Beier, Hiroko Furukawa and Lina Fisher (eds) *The Palgrave Literary Translation Handbook*, forthcoming, Basingstoke: Palgrave Macmillan.

Brodie, Geraldine and Emma Cole (2017), 'Introduction', in Geraldine Brodie and Emma Cole (eds), *Adapting Translation for the Stage*, 1–18, London: Routledge.

Bureau of Labor Statistics (2011), 'Actors, Producers, and Directors'. Available online: http://www.bls.gov/oco/ocos093.htm (accessed 9 November 2011).

Byam Shaw, Matthew, Interview with Geraldine Brodie (London, 5 April 2011).

Caines, Michael (2010), 'All Dressed Up', *The Times*, 19 February. Available online: http://entertainment.timesonline.co.uk/tol/arts_and_entertainment/the_tls/Subscriber_Archive/Other_Categories_Archive/article7032152.ece (accessed 20 February 2010).

Campbell, Christopher, Interview with Geraldine Brodie (London, 10 January 2011).

Carlson, Marvin (1985), 'Theatrical Performance: Illustration, Translation, Fulfillment, or Supplement?' *Theatre Journal*, March: 5–11.

Carlson, Marvin (1989), *Places of Performance: the Semiotics of Theatre Architecture*, London: Cornell University Press.

Carlson, Marvin (2006), *Speaking in Tongues: Language at Play in the Theatre*, Ann Arbor: University of Michigan Press.

Cavendish, Dominic (2011), 'One Man, Two Guvnors Interview: James Corden: "It's the best fun I've ever had"'. Available online : http://www.telegraph.co.uk/culture/theatre/theatre-features/8875088/One-Man-Two-Guvnors-interview-James-Corden-Its-the-best-fun-Ive-ever-had.htm (accessed 9 November 2011).

Chamberlain, Lori (2012), 'Gender and the Metaphorics of Translation', in Lawrence Venuti (ed.), *The Translation Studies Reader*, 3rd edn, 254–68, London: Routledge.

Chekhov, Anton (2007), *The Seagull*, version by Christopher Hampton, London: Faber and Faber.

Chekhov, Anton (2015), *Young Chekhov: Platonov, Ivanov, The Seagull*, version by David Hare, London: Faber and Faber.

Christ's Hospital (2011), 'About Christ's Hospital'. Available online: http://www.christs-hospital.org.uk/foundation-about-christs-hospital.php (accessed 23 March 2011).

Clapp, Susannah (2004), 'Festen', *Theatre Record*, 24: 398.

Clayton, J. Douglas and Yana Meerzon (2013), 'Introduction: The Text and its Mutations: On the Objectives of the Volume', in J. Douglas Clayton and Yana Meerzon (eds), *Adapting Chekhov: The Text and Its Mutations*. 1–11, New York: Routledge.

CNN (2005), 'Larry King Live: Interview with Vanessa Redgrave'. Available online: http://transcripts.cnn.com/TRANSCRIPTS/0506/18/lkl.01.html (accessed 11 February 2009).

Cooter, Maxwell (2000), 'Don Carlos (RSC)', *What's On Stage*, 21 January. Available online: http://www.whatsonstage.com/reviews/theatre/london/ E01533598828/Don+Carlos+(RSC).html (accessed 7 July 2011).

Costa, Maddy (2005), 'The Next Stage'. *Guardian*, 30 May. Available online: http:// www.theguardian.com/artanddesign/2005/may/30/1 (accessed 25 March 2017).

Delfont Mackintosh Theatres (2011), 'About Us'. Available online: http://www. delfontmackintosh.co.uk/About/ (accessed 25 May 2011).

Delgado, Maria M. (2008), *Federico García Lorca*, Abingdon: Routledge.

Delgado, Maria M. and Paul Heritage (1996), 'Introduction', in Maria M. Delgado and Paul Heritage (eds), *In Contact with the Gods? Directors Talk Theatre*, 1–13, Manchester: Manchester University Press.

Delgado, Maria M. and Dan Rebellato (2010), 'Introduction', in Maria M. Delgado and Dan Rebellato (eds), *Contemporary European Theatre Directors*, 1–27, Abingdon: Routledge.

Derrida, Jacques (1995), *Archive Fever: A Freudian Impression*, Chicago: University of Chicago Press.

Devlin, Es (2011), 'Gallery'. Available online: http://www.esdevlin.com (accessed 27 April 2011).

Dixon, Victor (2010), 'Vega (Carpio), Lope de', in Dennis Kennedy (ed.), *The Oxford Companion to Theatre and Performance*, 620–21, Oxford: Oxford University Press.

Dodgson, Elyse, Interview with Geraldine Brodie (London, 4 August 2010).

Donmar Warehouse (2010), 'About Us'. Available online: http://www.donmar-warehouse.com/p5.html (accessed 21 October 2010).

Eaton, Kate (2012), 'Turnips or Sweet Potatoes ...?', in Laurence Raw (ed.), *Translation, Adaptation and Transformation*, 171–87, London: Continuum.

Edwards, Gwynne (2005), 'Lorca on the London Stage: Problems of Translation and Adaptation', *New Theatre Quarterly*, 21: 382–94.

Eldridge, David (2000), *Under the Blue Sky*, London: Methuen Drama.

Eldridge, David, Interview with Geraldine Brodie (London, 26 January 2011).

English Stage Company (2006), *Annual Report for the Year Ended 31 March 2006*, London: English Stage Company.

Espasa, Eva (2000), 'Performability in Translation: Speakability? Playability? Or just Saleability?', in Carol-Anne Upton (ed.), *Moving Target: Theatre Translation and Cultural Relocation*, 49–62, Manchester: St. Jerome.

Euripides (2004), *Hecuba: A New Version by Frank McGuinness from a Literal Translation by Fionnuala Murphy*, London: Faber and Faber.

Euripides (2005), *Hecuba*, trans. Tony Harrison, London: Faber and Faber.

Eyre, Richard (2004), *National Service: Diary of a Decade at the National Theatre*, London: Bloomsbury.

Faber and Faber (2009), 'David Hare'. Available online: http://www.faber.co.uk/author/david-hare/ (accessed 3 February 2009).

Farr, David (2005), *The UN Inspector*, London: Faber and Faber.

Farrell, Joseph (1996), 'Servant of Many Masters', in David Johnston (ed.), *Stages of Translation*, 45–55. Bath: Absolute Classics.

Festen (1998), [Film] Dir. Thomas Vinterberg, Frederiksberg: Nimbus Film.

Financial Times (2010), '59E59 Theatre', Advertisement, Life & Arts Section, 6/7 November: 9.

Fischer-Lichte, Erika (2011), 'Introduction', in Erika Fischer-Lichte, Barbara Gronau and Christel Weiler (eds) *Global Ibsen*, 1–16, New York: Routledge.

Fornes, Maria Irene (2008), 'The Summer in Gossensass', in Maria Irene Fornes, *What of the Night?: Selected Plays*, 47–97, New York: PAJ Publications.

Gadamer, Hans-Georg (2003), *Truth and Method*, trans. W. Glen-Doepel, 2nd edn, trans. revised by Joel Weinsheimer and Donald G. Marshall, New York: Continuum.

García Lorca, Federico (2004), *La Casa de Bernarda Alba*, Madrid: Editorial Espasa Calpe.

García Lorca, Federico (2005a), *The House of Bernarda Alba*, version by David Hare, London: Faber and Faber.

García Lorca, Federico (2005b), *The House of Bernarda Alba*, trans. Simon Scardifield [unpublished].

Gielgud Theatre (2005), *Don Carlos*, Theatre Programme, London: Gielgud Theatre.

Göbels, Bettina (2007), 'In the Bard's Shadow: Shakespearian Affinities as an Obstacle to the Reception of Schiller's Plays in Britain, 1945–2005', *Modern Language Review*, 102: 427–39.

Göbels, Bettina (2008), 'The German Classics on the British Stage', PhD diss., University of Cambridge.

Goethe Institut (2011), 'New German Dramatic Art'. Available online: http://www.goethe.de/kue/the/nds/nds/enindex.htm (accessed 6 July 2011).

Gogol, Nikolai (2005), *The Government Inspector*, trans. Charlotte Pyke [unpublished].

Gogol, Nikolai (2011), *Government Inspector*, version by David Harrower, London: Faber and Faber.

Grandage, Michael, Interview with Geraldine Brodie (London, 28 May 2010).

Grandage, Michael (2011), 'Michael Grandage'. Available online: http://www.michaelgrandage.com/index.php?pid=14 (accessed 7 July 2011).

Gray, Ramin, Interview with Geraldine Brodie (London, 6 May 2010).

Grose, Carl, Anna Maria Murphy, Emma Rice and Kneehigh Theatre (2005), 'Tristan and Yseult', in *The Kneehigh Anthology: Volume 1*, 13–59 London: Oberon.

Hamilton, Adrian (2005), 'Quote of the Fortnight', *Theatre Record*, 25: 406.

Hardwick, Lorna (2000), *Translating Words, Translating Cultures*, London: Duckworth.

Hardwick, Lorna (2010), 'Negotiating Translation for the Stage', in Edith Hall and Stephe Harrop (eds), *Theorising Performance: Greek Drama, Cultural History and Critical Practice*, 192–207, London: Duckworth.

Hare, David (1998), *The Blue Room*, London: Faber and Faber.

Hare, David (2006), 'Gorky's Play for Today', *Telegraph*, 1 May. Available online: http://www.telegraph.co.uk/culture/theatre/3652029/Gorkys-play-for-today.html (accessed 29 July 2010).

Hare, David (2016), 'How I Learned to Love Adaptation', *Guardian*, 23 January. Available online: https://www.theguardian.com/stage/2016/jan/23/davidhareadaptationsthemasterbuilderchekhovoldvic (accessed 23 September 2016).

Harrison, Tony (2008), *Fram*, London: Faber and Faber.

Hepple, Peter (2005), 'The House of Bernarda Alba'. Available online: http://www.thestage.co.uk/reviews/review.php/6984/the-house-of-bernarda-alba (accessed 25 February 2008).

Hermans, Theo (1999a), 'Translation and Normativity', in Christina Schäffner (ed.), *Translation and Norms*, 50–71, Clevedon: Multilingual Matters.

Hermans, Theo (1999b), *Translation in Systems: Descriptive and System-Oriented Approaches Explained*, Manchester: St. Jerome.

Hermans, Theo (2007), *The Conference of the Tongues*, Manchester: St. Jerome.

Hochschild Jennifer L. (2009), 'Conducting Intensive Interviews and Elite Interviews. Workshop on Interdisciplinary Standards for Systematic Qualitative Research'. Available online: http://scholar.harvard.edu/jlhochschild/publications/conducting-intensive-interviews-and-elite-interviews (accessed 14 June 2015).

Holdsworth, Nadine (2010), *Theatre and Nation*, Basingstoke: Palgrave Macmillan.

Hutcheon, Linda (2013), *A Theory of Adaptation*, 2nd edn, London: Routledge.

Hytner, Nicholas (2011), 'The Diary', *Financial Times: Life and Arts*, 24/25 June: 2.

Ibsen, Henrik (1966), *The Oxford Ibsen*, Vol. VII, ed. James Walter McFarlane, London: Oxford University Press.

Ibsen, Henrik (2005), *Hedda Gabler*, version by Richard Eyre, London: Nick Hern.

Ibsen, Henrik (2008), *An Enemy of the People*, version by Rebecca Lenkiewicz, London: Faber and Faber.

Ibsen, Henrik (2016), *Hedda Gabler*, version by Patrick Marber, London: Faber and Faber.

Jackson, Angus (2006), 'Director Angus Jackson in Conversation with Mike Poulton', in *The Father*, Theatre Programme, Chichester: Chichester Festival Theatre.

Jakobson, Roman (1959), 'On Linguistic Aspects of Translation', in Reuben Bower (ed.) *On Translation*, 232–39, Cambridge, MA: Harvard University Press.

Johnston, David, ed. (1996), *Stages of Translation*, Bath: Absolute Classics.

Johnston, David (2007), 'Interview with Laurence Boswell', in Catherine Boyle and David Johnston (eds), *The Spanish Golden Age in English: Perspectives on Performance*, 148–54, London: Oberon.

Johnston, David, Interview with Geraldine Brodie (Belfast, 1 June 2010).

Kennedy, Dennis, ed. (2010), *The Oxford Companion to Theatre and Performance*, Oxford: Oxford University Press.

Krebs, Katja (2012), 'Translation and Adaptation – Two Sides of an Ideological Coin', in Laurence Raw (ed.), *Translation, Adaptation and Transformation*, 42–53, London: Continuum.

Kultiversum (2011), 'Roland Schimmelpfennig'. Available online: http://www.kultiversum.de/All-Kultur-Koepfe/Roland-Schimmelpfennig.html (accessed 6 July 2011).

Laera, Margherita (2014), 'Introduction: Return, Rewrite, Repeat: The Theatricality of Adaptation', in Margherita Laera (ed.) *Theatre and Adaptation: Return, Rewrite, Repeat*, 1–17, London: Bloomsbury.

Latour, Bruno (2005), *Reassembling the Social: An Introduction to Actor-Network-Theory*, Oxford: Oxford University Press.

Lefevere, André (1982), 'Mother Courage's Cucumbers: Text, System and Refraction in a Theory of Literature', *Modern Language Studies*, 12 (4): 3–10.

Lichtenfels, Peter and Lynette Hunter (2002), 'Seeing through the National and Global Stereotypes: British Theatre in Crisis', in Maria M. Delgado and Caridad Svich (eds), *Theatre in Crisis? Performance Manifestos for a New Century*, 31–53, Manchester: Manchester University Press.

Little, Ruth and Emily McLaughlin (2007), *The Royal Court Theatre Inside Out*, London: Oberon.

MacKenzie, Scott (2003), 'Manifest Destinies: Dogma 95 and the Future of the Film Manifesto', in Mette Hjort and Scott MacKenzie (eds), *Purity and Provocation*, 48–57, London: British Film Institute.

Mann, Emily (2017), 'Multiple Roles and Shifting Translations', in Geraldine Brodie and Emma Cole (eds), *Adapting Translation for the Stage*, 263–75, London: Routledge.

Manson Jones, Rebecca and Sarah Dickenson (2006), *Festen Projects Pack*, London: Almeida Theatre Company.

Manson Jones, Rebecca, Sarah Dickenson and Joanna Ingham (2005), *Hedda Gabler Projects Pack*, London: Almeida Theatre Company.

Marinetti, Cristina (2013), 'Transnational, Multilingual, and Post-Dramatic: Rethinking the Location of Translation in Contemporary Theatre', in Silvia Bigliazzi, Peter Kofler and Paola Ambrosi (eds), *Theatre Translation in Performance*, 27–37, Abingdon: Routledge.

Martindale, Charles (1993), *Redeeming the Text: Latin Poetry and the Hermeneutics of Reception*, Cambridge: Cambridge University Press,

May, Simon (2005), 'The House of Bernarda Alba', *Online Review London*. Available online: http://www.onlinereviewlondon.com/reviews/Bernarda.html (accessed 25 February 2008).

Mayorga, Juan (1999), *The Scorched Garden*, trans. Nick Drake, in Elyse Dodgson and Mary Peate (eds), *Spanish Plays*, 55–104, London: Nick Hern.

Mayorga, Juan (2003), *Revolución Conservadora y Conservación Revolucionaria. Política y Memoria en Walter Benjamin (Conservative Revolution and Revolutionary Conservation. Politics and Memory in Walter Benjamin)*, Barcelona: Anthropos.

Mayorga, Juan (2004), *Himmelweg*, Málaga: Diputación de Málaga, Área de Cultura y Educación.

Mayorga, Juan (2005), *Way to Heaven*, trans. David Johnston, London: Oberon.

Mayorga, Juan (2006), *Himmelweg*, trans. Yves Lebeau, Besançon: Les Solitaires Intempestifs.

Mayorga, Juan (2009), *Nocturnal*, trans. David Johnston, London: Oberon.

Mayorga, Juan, Interview with Geraldine Brodie (Madrid, 2 November 2010).

Meth, Jonathan, Katherine Mendelsohn and Zoë Svendsen (2011), 'Roundtable on Collaborative Theatre Translation Projects: Experiences and Perspectives', in Roger Baines, Christina Marinetti and Manuela Perteghella (eds), *Staging and Performing Translation: Text and Theatre Practice*, 200–11, Basingstoke: Palgrave Macmillan.

Michael Grandage Company (2017), 'Michael Grandage Company'. Available online: http://www.michaelgrandagecompany.com (accessed 25 March 2017).

Minier, Márta (2014), 'Definitions, Dyads, Triads and Other Points of Connection in Translation and Adaptation Discourse', in Katja Krebs (ed.), *Translation and Adaptation in Theatre and Film*, 13–35, New York: Routledge.

Minors, Helen, ed. (2012), *Music, Text and Translation*, London: Bloomsbury.

Monks, Aoife (2010), *The Actor in Costume*, Basingstoke: Palgrave Macmillan.

Mumford, Meg (2009), *Bertolt Brecht*, Abingdon: Routledge.

Munday, Jeremy (2012), *Introducing Translation Studies: Theories and Applications*, 3rd edn, Abingdon: Routledge.

National Library of Norway (2014), 'Repertoire Database'. Available online: http://ibsen.nb.no/id/2953.0 (accessed 25 March 2017).

New Century Theatre Company (2015), 'Festen'. Available online: http://www.wearenctc.org/#!festen/c21m1 (accessed 24 August 2016).

Nimax Theatres (2011), 'About Us'. Available online: http://www.nimaxtheatres.com/about/ (accessed 25 May 2011).

Norris, Rufus, Interview with Geraldine Brodie (London, 7 March 2011).

Online Review London (2005), 'Opera 2004–5'. Available online: http://www.onlinereviewlondon.com/opera/2004–5 (accessed 6 July 2011).

O'Thomas, Mark (2013), 'Translation, Theatre Practice, and the Jazz Metaphor', *Journal of Adaptation in Film & Performance* 6 (1): 55–64.

Pavis, Patrice (1992), *Theatre at the Crossroads of Culture*, trans. Loren Kruger, London: Routledge.

Pavis, Patrice (2013), *Contemporary Mise en Scène: Staging Theatre Today*, trans. Joel Anderson, Abingdon: Routledge.

Perteghella, Manuela (2004a), 'A Descriptive-Anthropological Model of Theatre Translation', in Sabine Coelsch-Foisner and Holger Klein (eds), *Drama Translation and Theatre Practice*, 1–24, Frankfurt: Peter Lang.

Perteghella, Manuela (2004b), 'A Descriptive Framework for Collaboration in Theatre Translation', PhD diss., University of East Anglia.

Perteghella, Manuela (2008), 'Adaptation: Bastard Child or Critique? Putting Terminology Centre-Stage', *Journal of Romance Studies*, 8: 51–65.

Pevear, Richard (2007), *Translating Music*, Lewes: Sylph Editions.

Pickering, Kenneth and Mark Woolgar (2009), *Theatre Studies*, Basingstoke: Palgrave Macmillan.

Poulton, Mike (2005), 'A Note on the Adaptation', in Friedrich Schiller, *Don Carlos*, xiii–xiv, London: Nick Hern.

Poulton, Mike, Interview with Geraldine Brodie (Stratford-upon-Avon, 26 May 2010).

Premier Public Relations (2004), 'Festen – Almeida Theatre'. Available online: http://www.premierpr.com/press (accessed 26 April 2009).

Prescott, Paul (2005), 'Inheriting the Globe: The Reception of Shakespearean Space and Audience in Contemporary Reviewing', in Barbara Hodgdon and W. B. Worthen (eds), *A Companion to Shakespeare and Performance*, 359–75, Oxford: Blackwell.

Pyke, Charlotte, Interview with Geraldine Brodie (London, 14 July 2010).

Radosavljević, Duška (2013), *Theatre-Making: Interplay between Text and Performance in the 21st Century*, Basingstoke: Palgrave Macmillan

Rappaport, Helen (2007), 'Chekhov in the Theatre: The Role of the Translator in New Versions', in Gunilla Anderman (ed.), *Voices in Translation: Bridging Cultural Divides*, 66–77, Clevedon: Multilingual Matters.

Rappaport, Helen (2017), 'Helen Rappaport'. Available online: http://www. helenrappaport.com/index.html (accessed 2 April 201).

Ravenhill, Mark (2009), 'Foreword', in Dan Rebellato, *Theatre and Globalization*, ix–xiv, Basingstoke: Palgrave Macmillan.

Richard Wilson Archive (2011), '5th June, 2005. Exclusive Interview with Richard'. Available online: http://www.richardwilsonarchive.com/ (accessed 6 July 2011).

Royal Court Theatre (2005a), 'Way to Heaven'. Available online: http://www. royalcourttheatre.com/archive_detail.asp?play=396 (accessed 3 July 2009).

Royal Court Theatre (2005b), *The Woman Before: Post-Show Talk*, British Library Sound Archives.

Royal Court Theatre (2007), 'Upstairs Downstairs: The Ugly One'. Available online: http://www.royalcourttheatre.com/whats-on/upstairs-downstairs-the-ugly-one (accessed 6 July 2011).

Royal Court Theatre (2009a), 'About Us'. Available online: http://www.royal-courttheatre.com/about.asp?ArticleID=14 (accessed 13 May 2009).

Royal Court Theatre (2009b), 'International'. Available online: http://www.royal-courttheatre.com/international.asp (accessed 28 October 2009).

Royal National Theatre (1992), *Platform Papers 1: Translation*, London: Royal National Theatre

Royal National Theatre (2005), 'The UN Inspector'. Available online: http://www.nationaltheatre.org.uk/The%20UN%20Inspector+12005.twl (accessed 31 January 2008).

Royal National Theatre (2006), *Annual Report & Financial Statements for the 52 Weeks Ended 2 April 2006*, London: Royal National Theatre.

Royal National Theatre (2009), 'Artistic Aims'. Available online: http://www.nationaltheatre.org.uk/1419/faqs/artistic-aims.html (accessed 11 May 2009).

Royal National Theatre (2011a), 'Online Tour'. Available online: http://www.nationaltheatre.org.uk/39432/online-tour/discover-online-tour.html (accessed 6 October 2011).

Royal National Theatre (2011b), 'Three Theatre Spaces'. Available online: http://www.nationaltheatre.org.uk/38351/three-theatre-spaces/three-theatre-spaces.html. (accessed 29 September 2011).

Royal National Theatre (2017), 'About the National Theatre'. Available online: http://www.nationaltheatre.org.uk/about-the-national-theatre (accessed 30 March 2017).

Royal Opera House (2006), *Promise Fulfilled: Royal Opera House Annual Review 2005/06*, London: Royal Opera House.

Royal Shakespeare Company (2005a), *Annual Report and Accounts 2004/2005*, Stratford-upon-Avon: Royal Shakespeare Company.

Royal Shakespeare Company (2005b), *Hecuba*, Theatre Programme, Stratford-upon-Avon: Royal Shakespeare Company.

Royal Shakespeare Company (2006), *Report and Consolidated Accounts for the Year Ended 31 March 2006*, Stratford-upon-Avon: Royal Shakespeare Company.

Royal Shakespeare Company (2010a), 'Facts and Figures'. Available online: http://www.rsc.org.uk/about-us/our-work/facts-and-figures.aspx (accessed 27 October 2010).

Royal Shakespeare Company (2010b), 'Summary Information Return 2009'. Available online: http://www.charity-commission.gov.uk/SIR/ENDS81/0000212481_SIR_09_E.PDF (accessed 27 October 2010).

Rubin, Marla, Interview with Geraldine Brodie (London, 15 July 2010).

Samuelsen, Eric, Cheng-yu Xiong and Nola D. Smith (1992), *Henrik Ibsen's Hedda Gabler: A Study Guide*, Provo, UT: Brigham Young University.

Scardifield, Simon, Interview with Geraldine Brodie (London, 30 June 2010).

Scardifield, Simon (2016), 'Simon Scardifield'. Available online: http://www.simonscardifield.co.uk/Simonscardifield.co.uk/Welcome.html (accessed 24 August 2016).

Schiller, Friedrich (1912), *Don Carlos, Infant von Spanien, ein dramatisches Gedicht*, New York: Oxford University Press.

Schiller, Friedrich (2005), *Don Carlos*, version by Mike Poulton, London: Nick Hern.

Schimmelpfennig, Roland (2002), *Arabian Night*, trans. David Tushingham, London: Oberon.

Schimmelpfennig, Roland (2005), *The Woman Before*, trans. David Tushingham, London: Oberon.

Schimmelpfennig, Roland (2011), *The Golden Dragon*, trans. David Tushingham, London: Oberon.

Segal, Victoria (2005), 'Hecuba', *Theatre Record*, 25: 447.

Sharpe, Lesley (2005), 'Schiller's "Don Carlos" 'in Friedrich Schiller, *Don Carlos*, vii–xi, London: Nick Hern.

Sheffield Theatres (2004a), 'An Interview with Adam Cork – Music and Sound Score Composer'. Available online: www.sheffieldtheatres.co.uk/creative-developmentprogramme/productions/doncarlos/music.shtml (accessed 23 March 2011).

Sheffield Theatres (2004b), 'An Interview with Paule Constable – Lighting Designer'. Available online: www.sheffieldtheatres.co.uk/creativedevel-opmentprogramme/productions/doncarlos/lighting.shtml (accessed 23 March 2011).

Sheffield Theatres (2004c), 'Rehearsal Diary: Fifth Rehearsal'. Available online: www.sheffieldtheatres.co.uk/creativedevelopmentprogramme/pro-ductions/doncarlos/fifth.shtml (accessed 23 March 2011).

Sheffield Theatres (2004d), 'Rehearsal Diary: First Rehearsal'. Available online: www.sheffieldtheatres.co.uk/creativedevelopmentprogramme/pro-ductions/doncarlos/first.shtml (accessed 23 March 2011).

Sheffield Theatres (2011), 'What We Do'. Available online: http://www.sheffield-theatres.co.uk/creativedevelopmentprogramme/whatwedo.asp (accessed 26 May 2011).

Shellard, Dominic (2004), *Economic Impact Study of UK Theatre*, London: Arts Council England.

Shuttleworth, Ian, ed. (2004), 'Hecuba', *Theatre Record*, 19: 1170–74.

Shuttleworth, Ian, ed. (2005a), 'Hecuba', *Theatre Record*, 25: 442–47.

Shuttleworth, Ian, ed. (2005b), 'The UN Inspector', *Theatre Record*, 25: 816–21.

Shuttleworth, Ian, ed. (2005c), 'Way to Heaven', *Theatre Record*, 25: 849–52.

Shuttleworth, Ian, ed. (2005d), 'The Woman Before', *Theatre Record*, 25: 648–52.

Sierz, Aleks (2011), *Rewriting the Nation*, London: Methuen.

Singh, Anita (2017), ' "Big Four" Arts Bodies Face Cut to Funding in Name of Diversity', *The Telegraph*, 28 June. Available online: http://www.telegraph.co.uk/news/2017/06/28/big-four-arts-bodies-face-cut-funding-name-diversity/ (accessed 7 July 2017).

Sirett, Paul, Interview with Geraldine Brodie (London, 17 January 2011).

Society of London Theatre (2009), *Success and Foreboding: The Report of the Society of London Theatre*, London: Society of London Theatre.

Society of London Theatre (2011), 'The Society of London Theatre'. Available online: http://www.solt.co.uk/ (accessed 10 May 2011).

Society of London Theatre (2017a), 'About Us – SOLT'. Available online: http://solt.co.uk/who-we-are/about-us/ (accessed 30 March 2017).

Society of London Theatre (2017b), 'Official London Theatre Guide'. Available online: http://solt.co.uk/what-we-do/audience-development/official-london-theatre-guide/ (accessed 5 July 2017).

Society of London Theatre and Theatrical Management Association (2005), 'Memorandum Submitted by the Society of London Theatre and Theatrical Management Association'. Available online: http://www.publications.parliament.uk/pa/cm200405/cmselect/cmcumeds/254/5020106.htm (accessed 1 February 2012).

Stagework (2005), 'The Productions/UN Inspector/Literary Department'. Available online: http://www.stagework.org/webdav/harmonise?page/@ id=6007&Session/@id=D_3G (accessed 23 April 2008).

Stagework (2006), 'The Productions/UN Inspector/About the Play'. Available online: http://www.stagework.org/webdav/harmonise?page/@ id=6007&Session/@id=D_SV (accessed 11 October 2006).

Svich, Caridad (2002), 'Theatre in Crisis? Living Memory in an Unstable Time', in Maria M. Delgado and Caridad Svich (eds), *Theatre in Crisis? Performance Manifestos for a New Century*, 15–19, Manchester: Manchester University Press.

Tanitch, Robert (2007), *London Stage in the 20th Century*, London: Haus.

Thomson, C. Claire (2013), *Thomas Vinterberg's Festen*, Seattle: University of Washington Press.

Trencsényi, Katalin (2015), *Dramaturgy in the Making*, London: Bloomsbury.

Trussler, Simon (2000), *The Cambridge Illustrated History of British Theatre*, Cambridge: Cambridge University Press.

Turner, Cathy and Synne K. Behrndt (2008), *Dramaturgy and Performance*, Basingstoke: Palgrave Macmillan.

Tushingham, David (1995), *Not What I Am: The Experience of Performing*, London: Methuen.

Tushingham, David, Interview with Geraldine Brodie (London, 21 July 2010).

Vallejo, Juan (2008), 'El triunfo del autor'. Available online: http://www.elpais.com/articulo/arte/triunfo/autor/elpepuculbab/20080426elpbabart_13/Tes (accessed 5 June 2009).

Venuti, Lawrence (2004), 'How to Read a Translation'. Available online: http://wordswithoutborders.org/article/how-to-read-a-translation/ (accessed 20 October 2011).

Venuti, Lawrence (2008), *The Translator's Invisibility*, 2nd edn, London: Routledge.

Vermeer, Hans J. (2012), 'Skopos and Commission in Translational Action', trans. Andrew Chesterman, in Lawrence Venuti (ed.), *The Translation Studies Reader*, 3rd edn, 191–202, London: Routledge.

Versényi, Adam (2010), 'Dramaturgy/dramaturg', in Dennis Kennedy (ed.), *The Oxford Companion to Theatre and Performance*, 176, Oxford: Oxford University Press.

Vígszínház (2016a), 'Az Ünnep' (The Celebration). Available online: http://vigszinhaz.hu/szindarab/23+az+%C3%BCnnep/ (accessed 24 August 2016).

Vígszínház (2016b), 'Bemutatók' (Productions). Available online: http://vigsz-inhaz.hu/bemutatok/2014–2015/ (accessed 24 August 2016).

Vinterberg, Thomas, Mogens Rukov and Bo hr. Hansen (2004), *Festen*, version by David Eldridge, London: Methuen.

Walton, J. Michael (1991), 'Introduction', in Euripides, *Plays: Two: Hecuba, The Women of Troy, Iphigenia at Aulis, Cyclops*, ix–xxxi, London: Methuen.

Walton, J. Michael (2006), *Found in Translation: Greek Drama in English*, Cambridge: Cambridge University Press.

Way to Heaven the Play (2009), 'Way to Heaven'. Available online: http://www.waytoheaventheplay.com (accessed 29 October 2009).

Worton, Jenny, Interview with Geraldine Brodie (London, 22 June 2010).

Young, Toby (2005), 'Hedda Gabler', *Theatre Record*, 24: 702.

Index

Actors Touring Company (ATC) 96,
 125
adaptation 3–5, 9, 71–2, 77–8, 81,
 116, 123–4, 130, 134, 157, 158,
 159–60
 definition of 4
 free 3, 24, 53, 54–5, 56–7, 60, 67
 intercultural 4
 intertemporal 4
 theory 3–4
 and translation 3–4, 81, 95, 137,
 150
Aeschylus 82
Albery Theatre, *see* Noël Coward
 Theatre
Allain, Paul 57–8, 123
Almeida Theatre 10, 21, 30, 33–6, 38,
 42–3, 53, 59–60, 62, 64–6, 68–70,
 72–3, 77, 113, 114, 117, 121, 138,
 141, 143–4
Ambassador Theatre Group 21, 30–2,
 83, 109
Appiah, Kwame Anthony 142
Archer, Edmund 61, 64
archive 8, 11–13, 46, 47, 54, 58–9, 60,
 85–6, 138, 173
 British Sound Archives 124, 125,
 173
 Brooklyn Academy of Music
 (BAM) Archive 88–9, 173
 National Theatre Archive 12, 47, 54,
 58, 138
 UK Government Web Archive 54
Aristophanes 82
Asher, Jane 73, 158, 166
Associated Capital Theatres 83
Attenborough, Michael 34, 66, 69–70,
 113, 166, 168

Bamborough, Ann 10, 60, 66, 140, 168
Bamborough, Karin 10, 60, 66, 117,
 138–45, 168
Barbican Theatre 19–20, 39, 64–5,
 83, 129
 Pit Theatre 76
Barslund, Charlotte 29, 71, 131, 144,
 152
Bassnett, Susan 6, 21, 131, 145, 162
BBC 50, 98, 108, 115, 160
 Review Show 115
 Today Programme 108
Bean, Richard 98, 112, 139
 Harvest 98
 One Man, Two Guvnors 112
Beaton, Alistair 97, 128
Belgrade Theatre Coventry 95, 137
Bergman, Ingmar 121
 Through a Glass Darkly 121
Best, Eve 36, 62–6, 168
Billington, Michael 42–3, 54, 74, 78,
 84
Blythe, Alecky 123
Boswell, Laurence 10, 82, 84, 126, 167
Boucicault, Dion 139
 London Assurance 139
Boyd, Michael 83–4, 119, 167
Boyle, Catherine 15, 139–40
Bradley, Jack 109, 118–19, 130, 142–4
Bremner, Rory 128
Bridge Lane Theatre, Battersea 76
British Council 120
British Sound Archives 124–5
Brooklyn Academy of Music 88–9,
 134
Büchner, Georg 160
 Danton's Death 160
 Woyzeck 95

Bulgakov, Mikhail 58
 White Guard, The 58
Burns, Nica 32
Bush, Peter 162
Butterworth, Jez 98
 Winterling, The 98
Byam Shaw, Matthew 77, 81, 114–17,
 152, 159, 165

Campbell, Christopher 5, 11, 29,
 118–21, 141–2, 151, 163, 172
Centro Dramático Nacional, Madrid
 90, 95, 146, 147
 Teatro María Guerrero 90, 92, 95
Charity Commission 36, 40
Chekhov, Anton 29–30, 47, 50, 59, 63,
 97, 111–12, 126, 128, 145, 149
 Ivanov 145
 Platonov 145, 149
 Seagull, The 29–30, 59, 63, 97, 145
 Uncle Vanya 29, 111
Chichester Festival Theatre 15, 63, 77,
 81, 111, 129, 145
Christ's Hospital 30
Churchill, Caryl 128, 159–60
Comedy Theatre 30
Cork, Adam 79, 123
Crimp, Martin 59, 97, 128

Daldry, Stephen 113
 Inspector Calls, An 113
Davies, Howard 10, 54, 63, 119, 170
de Filippo, Eduardo 81, 129
 Sindaco del Rione Sanità, Il, see
 Syndicate, The
 Syndicate, The 81, 129
de la Cruz, Sor Juana Ines 140
 House of Desires 140
Delfont Mackintosh Theatres 21,
 30–2, 38, 83, 109
Delgado, Maria 12, 123
de Vega, Lope 112, 159
 Peribanez 144
Dodgson, Elyse 28, 120, 172
Dogme 68–70, 72–4, 132

Don Carlos, see Schiller, Friedrich;
 Poulton, Mike
Donmar Theatre 18–20, 34–5, 37, 43,
 54, 75–8, 85, 102, 109, 143, 152
dramaturgy, dramaturg 2, 8, 29, 54,
 95, 96, 110, 115–17, 119, 122,
 136, 149, 159, 167
Duke of York's Theatre, London 10,
 30–3, 60, 63, 168

Eaton, Kate 131
Edwards, Gwynne 49, 51, 170
Eldridge, David 9, 10, 68–74, 95, 110,
 113, 124, 127–34, 144, 152, 158,
 166
 Festen 9, 10, 30, 33, 35, 46, 68–74,
 82, 107, 113, 114, 121, 123–5,
 127, 129, 132, 133, 138, 146, 148,
 157, 158, 166
 Under the Blue Sky 70, 129
 Wild Duck, The, see Ibsen, Henrik
elite interviews 11
English Stage Company, *see* Royal
 Court Theatre
Euripides 10, 82, 84, 85, 87–9, 145,
 167
 Hecuba 10, 30, 38–41, 82–9, 101,
 107, 113, 119, 126, 134, 145, 151,
 156–9, 162, 167, 173
Eyre, Richard 8, 10, 60, 62–7, 74,
 113, 126, 128, 138, 141, 145,
 160, 168

Farr, David 10, 53–8, 74, 143, 145,
 160, 170–1
 UN Inspector, The 10, 22, 24, 30,
 53–8, 60, 63, 82, 101, 112, 138,
 145, 157, 161, 170, 173
Festen, see Eldridge, David
Fornes, Maria Irene 62
 Summer in Gossensass, The 62
Fox, Robert 66, 113, 168
Frayn, Michael 128
Frisch, Max 97
 Arsonists, The 97

García Lorca, Federico 10, 24, 33,
 46–53, 112–13, 126, 158, 163,
 169–70
 Blood Wedding 33, 47, 144
 House of Bernard Alba, The 10,
 22–4, 33, 46, 48–60, 95, 119, 138,
 145, 156, 158, 163, 169, 170, 173
Gate Theatre Notting Hill 96, 112,
 126, 135
Gielgud Theatre 10, 30–4, 41–2, 75,
 77–8
Gieselmann, David 98
 Mr Kolpert 98, 135
Göbels, Bettina 45–6
Gogol, Nikolai 10, 24, 53, 55–8, 157,
 170
 Government Inspector, The 10, 53–9,
 141, 144, 157, 171
Goldoni, Carlo 112, 139
 Servant of Two Masters, A 112, 139
Goold, Rupert 15
 Decade 15
Gordon, Mick 126–7
Gorky, Maxim 58–9, 143
 Enemies 161
 Philistines 58
Gosse, Edmund 61, 64, 168
Government Inspector, The, see Gogol,
 Nikolai
Grandage, Michael 10–11, 34, 42–3,
 75–80, 82, 106, 109–15, 121, 124,
 126–7, 129, 151, 160, 163, 165
Gray, Ramin 10, 67, 124–7, 136, 150,
 172
Guedalla, Louise 32

Hamlet, see Shakespeare, William
Hampton, Christopher 29–30, 63, 97,
 109, 128, 141, 143, 169
Hands, Terry 83
Hansen, Bo 10, 68, 70, 72, 74, 132,
 138, 166
Hare, David 10, 46–53, 59, 74, 95, 119,
 144–5, 156, 161, 163, 169–70
 Enemies, see Gorky, Maxim

House of Bernard Alba, The see
 García Lorca, Federico
 Permanent Way, The 47, 50
 Stuff Happens 47, 50
Harrison, Tony 10, 39–40, 82, 84–8,
 95, 107, 119, 134, 156–7, 159–60,
 162, 167–8
 Fram 82
Harvie, Jen 57–8, 123
Haydon, Christopher 112
Hecuba, see Euripides; Harrison, Tony
Hedda Gabler, see Ibsen, Henrik;
 Eyre, Richard
Heinemann, William 61
Hellman, Lillian 30
 Children's Hour, The 30
Hermans, Theo 7, 67, 74, 103, 142,
 155
Holman, Robert 130
House of Bernard Alba, The, see García
 Lorca, Federico; Hare, David
Hunter, Lynette 44
Hytner, Nicholas 22, 24, 34, 51–2,
 54–5, 58, 60, 63, 76, 105, 108,
 112–13, 119, 124, 170–1

Ibsen, Henrik 9–10, 29, 47, 61–2,
 64–7, 71, 81, 110, 112–13, 126,
 129, 141, 144–5, 148–9, 162, 168
 Enemy of the People, An 29, 149
 Hedda Gabler 9–10, 30, 33, 36,
 60–7, 82, 101, 113, 126, 138, 141,
 145, 148, 168, 173
 John Gabriel Borkman 110, 152
 Rosmersholm 81
 Wild Duck, The 110, 129–31, 152
Inspector Calls, An, see Daldry, Stephen
Ionesco, Eugène 97
 Rhinoceros 97

Jacobi, Derek 43, 78–80, 111, 115,
 158, 165
Jakobson, Roman 69, 128
James, Geraldine 63, 171
Jarzyna, Grzegorz 72

Johnston, David 7, 10, 29, 90–5,
 125–6, 134–8, 148, 150–1, 158,
 170–2

Kane, Sarah 133
 Blasted 133
Kaut-Howson, Helena 29
Kenwright, Bill 114

Lenkiewicz, Rebecca 29
Liber, Vera 29
Lichtenfels, Peter 44
literal translation 1, 2, 3, 6, 21, 24, 29,
 33, 47–9, 51, 53–6, 58, 59, 66, 68,
 77, 78, 80–2, 101, 107, 109, 110,
 118, 119, 121, 122, 126, 128–31,
 138–46, 150, 152, 153, 156, 160,
 173
Lloyd, Phyllida 76
London Road, see Norris, Rufus
London theatre
 funding and environment 43–4
 site and mission 15–16
 SOLT, *see* Society of London Theatre
 theatres, *see* Almeida Theatre;
 Crucible Theatre; Royal Court
 Theatre; Royal National Theatre;
 Royal Shakespeare Company;
 West End
Lyric Theatre, Hammersmith 53, 76
Lyric Theatre, London 10, 17, 30, 32,
 34, 42, 68, 114

McGuinness, Frank 85, 145, 168
MacNeil, Ian 113
Malik, Art 30
Mann, Emily 53, 170
Marber, Patrick 54, 55, 58, 66, 141,
 143, 169
 Closer 54
 Don Juan in Soho 54, 143
 Hedda Gabler 66
Mayorga, Juan 9–10, 29, 90–5, 97, 107,
 125, 135–7, 146–51, 158, 171

Blumemberg's Translator 92, 147
 Hamelin 92
 Himmelweg, see *Way to Heaven*
 Love Letters to Stalin 92
 Nocturnal 94, 135
 Premio Enrique Llovet 90
 Scorched Garden, The 146
 Tortuga de Darwin, La 148
 Way to Heaven 10, 25–6, 28–9,
 90–5, 97, 100–1, 124, 134–7,
 146–7, 151, 156–8, 171, 173
Mendes, Sam 75
Molière 54, 95, 137, 143
 Miser, The 95, 137
Morris, Tom 54
Motton, Gregory 125
Murphy, Fionnuala 145

National Film and Television School
 139
National Theatre 2, 6, 9–10, 12, 15,
 18–19, 21–8, 30, 33, 40–3, 47,
 49–54, 57–60, 62–3, 65–7, 96,
 102, 105–6, 108–10, 112–13, 117,
 119, 123–4, 138–9, 141, 144–5,
 160, 170–1, 173
 Archives 12, 58, 138
 Literary Department 2, 26, 39, 52,
 58, 96, 102, 106, 109, 110, 116–22,
 127, 138, 139, 140, 144, 146
 Lyttleton Theatre 24
 New Works Department, *see* Liter-
 ary Department
 Olivier Theatre 10, 24, 53, 63, 171
 Studio 24
New Century Theatre Company 132
Nimax Theatres 21, 30, 32, 109
Noël Coward Theatre (Albery
 Theatre) 10, 30, 38, 82–3, 88
Norris, Rufus 10, 22, 26, 33, 69–70,
 72–3, 108, 113, 123–7, 131–2,
 163–4, 166
 London Road 123
Nottara Theatre Company 129

Olivier Theatre, *see* National Theatre
One Man, Two Guvnors, see Bean,
 Richard
Ortiz Monasterio, Luis Enrique
 Gutiérrez 138, 170
 Girls of the 3 1/2 Floppies, The 138
Ostermeier, Thomas 63–5
Oswald, Peter 76, 166

Perteghella, Manuela 2, 4, 7–8, 105–7,
 117, 122, 160
Pevear, Richard 143
Pierre, DBC 123
 Vernon God Little 123
Pinter, Harold 30
 Betrayal 30
Pirandello, Luigi 33, 50
 Liolà 33
Poulton, Mike 10, 67, 75–81, 106,
 109, 111, 115, 127–33, 145, 152,
 159–60, 165, 169
Pyke, Charlotte 10, 54–60, 138–9,
 141–5, 160–1, 170

Queen's University Belfast 137

Rappaport, Helen 59, 110, 139, 145, 161
Ravenhill, Mark 138, 148
Really Useful Group (Really Useful
 Theatres) 21, 31–2, 32–4
Really Useful Theatres, *see* Really
 Useful Group
Rebellato, Dan 123
Redgrave, Vanessa 10, 39, 82, 84–7,
 89, 119, 131, 156, 158, 167
Reza, Yazmina 109
Rickson, Ian 29, 30, 172
Roberts, Julia 54
Robins, Elizabeth 61–2
Ronder, Tanya 33, 123, 144
Roundhouse 83
Royal Academy of Dramatic Arts 132
Royal Court Theatre 6, 10, 25–30, 33,
 35, 41, 42, 63, 90–2, 93, 94, 95,

96–100, 102, 117, 118, 119–21,
 123, 124–5, 129, 134, 135–6, 137,
 146–7, 151, 156, 158–9
International Department 28–9, 120
Jerwood Theatre Downstairs 25,
 28, 97
Jerwood Theatre Upstairs 25, 28,
 93, 97
Royal National Theatre, *see* National
 Theatre
Royal Shakespeare Company (RSC)
 6, 10, 21, 35, 38–43, 76, 78, 82–5,
 87–9, 113, 117, 119, 134, 140,
 144, 159, 167
Golden Age Season 2004 126, 140
Other Place 76
Rubin, Marla 68–70, 72–4, 113–14,
 116, 124, 127, 129, 153, 160, 166
Rukov, Mogens 10, 68, 70, 72, 129,
 132, 148, 166

Sadler's Wells Theatre 19–20, 33, 72, 96
Samuelsen, Eric 61
Scardifield, Simon 10, 33, 47–9, 54, 106,
 119, 138, 140, 144–5, 156, 160, 169
Schauspiel Frankfurt 135
Schiller, Friedrich 10, 75, 80, 165
 Don Carlos 10–11, 30–4, 41–3, 46,
 75–82, 97, 106, 109–11, 113–16,
 127, 129, 132, 134, 158–9, 165, 173
 Luise Miller 76
 Mary Stuart 76–7
Schimmelpfennig, Roland 10, 29,
 95–101, 135, 146, 150, 172
 Arabian Night 96, 100, 135
 Golden Dragon, The 29, 96, 100, 126
 Push Up 97
 Winter Solstice 96
 Woman Before, The 10, 25, 29, 46,
 95–101, 125, 134–5, 137, 146,
 156–8, 172–3
Scott Thomas, Kristin 30
Seoul Metropolitan Theatre Company
 148

Shakespeare, William 39, 40, 116
 Hamlet 30, 62, 84, 135
Sheen, Michael 30, 57, 60, 171
Sheffield Theatres 41, 165
 Crucible Theatre 10, 41–2, 75, 80,
 165
 Lyric Theatre 17
 Studio Theatre 76, 101
Sirett, Paul 117–18, 167
Society of London Theatre 9, 16–17,
 20, 165
Soho Theatre 117, 135
Sophocles 82
Spender, Stephen 76
Stevenson, Juliet 63–4
Stoll Moss 32
Strickland, Jon 29
Strindberg, August
 Father, The 81
Suzman, Janet 63
Svich, Caridad 43–4, 170

Tanitch, Robert 62–4, 76–7
Taylor, Simon 145
theatre
 London, *see* London theatre
 mainstream 6, 15, 16–21, 107, 158
Thomson, Claire 72, 146
Tolstoy, Leo 143
Trafalgar Studios 75
translation, translator
 celebrity 1–3, 14, 101–3, 128,
 157–62
 collaboration 5–7, 13, 82, 94, 95,
 105–6, 131, 144, 150–4, 159–62
 direct 3, 12, 29, 91, 94–7, 102, 120,
 121, 122, 125, 127, 128, 129, 131,
 134–8, 144, 151, 152, 156, 159,
 160, 161
 indirect 3, 6, 29, 49, 59, 74, 80, 81,
 94–5, 102, 103, 106, 113, 122,
 126–7, 128–33, 142, 151–3, 156,
 158–63

literal 1–3, 5–6, 8, 10, 12, 21, 24, 29,
 33, 47–51, 53–6, 58–60, 66, 68,
 71, 77, 78, 80–2, 101–2, 106–7,
 109–10, 116–19, 121–2, 126–31,
 136, 138–46, 150, 152–3, 155–7,
 159–62, 165, 167–73
terminology 1, 2–5, 11, 13, 81, 134,
 157
visibility 1, 2–5, 6–7, 75–82, 101–3,
 105, 118, 123, 134, 137, 151, 153,
 154, 157, 159, 160, 162, 163
translation agent/agency 1–2, 5–7,
 8–9, 11, 13–14, 45, 47
 artistic directors 11, 12, 24, 26,
 29, 33, 34, 42, 43, 53–5, 60, 62,
 63, 66, 69, 75, 83, 102, 105, 106,
 108–13, 118, 119, 123, 125, 126,
 150, 152, 165–8, 170–2
 directors 123–8
 direct translators 12, 102, 121, 122,
 125, 127, 134–8, 152, 156, 161
 indirect translators 12, 24, 59, 60,
 74, 80, 95, 101–3, 106, 107, 113,
 122, 126–7, 128–33, 142, 152–3,
 156, 158–61, 163
 literal translators 2, 5, 6, 8, 10, 12,
 33, 47, 49, 50, 58, 60, 66, 68, 71,
 80, 81, 101–2, 106, 107, 110,
 116–19, 122, 127, 128, 130, 131,
 136, 138–46, 150, 152–3, 155,
 157, 159–62, 165, 167–72
 literary departments 116–22
 playwrights 146–50
 power and collaboration 150–4
 practitioners and process 105–7
 producers 113–16
Traverse Theatre 138
Trencsényi, Katalin 24, 28, 117
tucker green, debbie 98
 Stoning Mary 98
Tushingham, David 10, 29, 95–8,
 100–1, 117, 125, 134–8, 150, 161,
 172

UN Inspector, The, see Farr, David

van Hove, Ivo 63, 66
Vermeer, Hans J. 142
Versényi, Adam 116
version 1, 4–6, 10, 29, 33, 46–51, 53,
 55–7, 59, 60, 62–7, 70–8, 81, 82,
 85, 91, 95, 97, 102, 107, 109, 116,
 119, 120, 129–32, 134, 137, 138,
 140, 141, 143, 145, 149–50, 152,
 157–61, 166–9
Vinterberg, Thomas 10, 68, 70, 72, 74,
 129, 132, 166
von Mayenburg, Marius 97
 Stone, The 97
 Ugly One, The 97

Walter, Harriet 63
Walton, J. Michael 82, 134, 167
Way to Heaven, see Mayorga, Juan;
 Johnston, David

Weitzenhoffer, Max 32
West End, London 1, 16, 18, 25, 30–3,
 35, 38, 43, 60, 62, 66, 68, 75, 82,
 109, 113, 114–15
Whitemore, Hugh 115
 God Only Knows 115
Wilbraham, Alex 145
Wild Duck, The, see Ibsen, Henrik;
 Eldridge, David
Wilson, Richard 10, 98–9, 125, 135,
 158, 172
Woman Before, The, see Schimmelp-
 fennig, Roland; Tushingham,
 David
Worton, Jenny 62–4, 68, 121–2, 166,
 168

Young Vic Theatre 30, 57, 65, 123

Zade, Maja 97
Zeller, Florian 109